NEW YORK LIFE AT THE

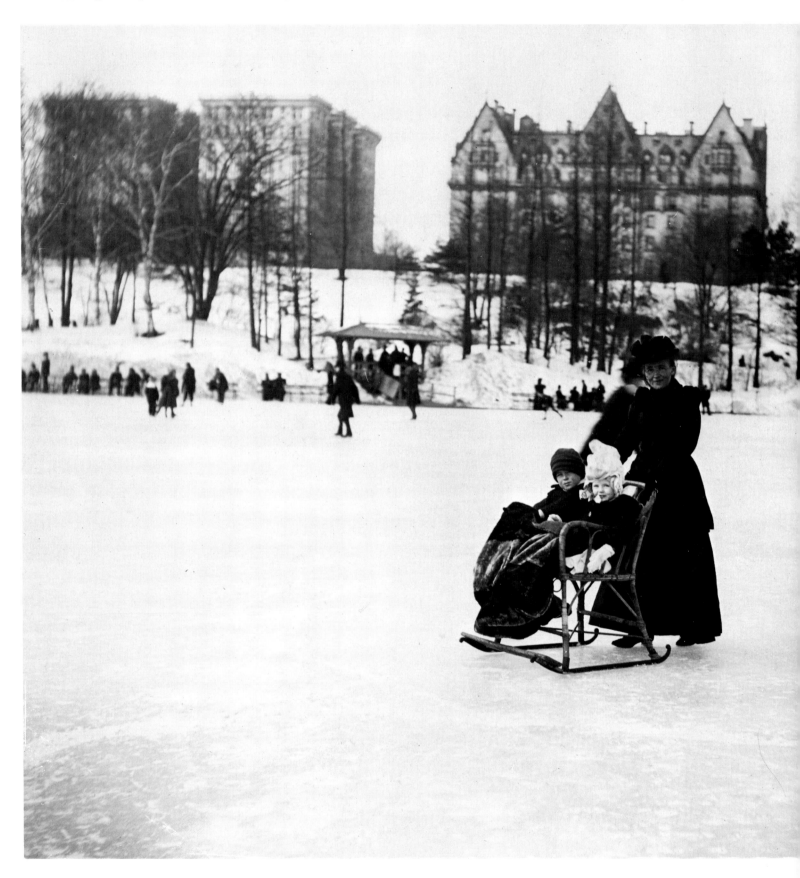

TURN OF THE CENTURY

IN PHOTOGRAPHS

by Joseph Byron

From the Byron Collection
of the Museum of the City of New York

Text by Albert K. Baragwanath

Published in Cooperation with
the Museum of the City of New York by
DOVER PUBLICATIONS, INC.
New York

New York Life at the Turn of the Century in Photographs is a new work, first published by Dover Publications, Inc., in 1985.

Manufactured in the United States of America
Dover Publications, Inc., 31 East 2nd Street, Mineola, N.Y. 11501

Library of Congress Cataloging in Publication Data

Byron, Joseph.
New York life at the turn of the century in photographs by Joseph Byron.

1. New York (N.Y.)—Description—Views. 2. New York (N.Y.)—Social life and customs—Pictorial works. I. Baragwanath, Albert K., 1917– . II. Museum of the City of New York. III. Title.
F128.37.B97 1985 974.7′1 84-21171
ISBN 0-486-24863-1

Preface

The Byron Company was established in England in 1844, when photography was in its infancy. In 1888 Joseph Byron brought his family to New York and set up business. At the age of 14 his oldest son, Percy, sold his first picture to the press: a view of Grant's Tomb under construction.

Although initially the firm specialized in pictures related to the theater, it soon included ship photographs. It has been said that for many years Percy Byron photographed every transatlantic liner to enter the port of New York. The firm's range of subjects continued to expand, covering almost every aspect of city life. Elegant mansions on Fifth Avenue, street scenes, hotels and restaurants, theaters, formal dinners, society weddings—these are but a few of the many subjects upon which Byron's cameras were focused.

In his foreword to *Once upon a City,* by Grace M. Mayer, Edward Steichen wrote of the Byrons: "Their only specialty was making photographs, photographs without opinion, comment, slant or emotion. . . . There is no pretense or artifice, no willful accent or suppression."

In 1942 Percy Byron closed the books on the 98-year-old firm and presented to the Museum of the City of New York a good part of the labor of two lifetimes—a collection of more than 10,000 prints. It is from this great resource that the present book has been created.

A. K. B.

Contents

1. The Eastern Hotel, Whitehall Street, ca. 1906.

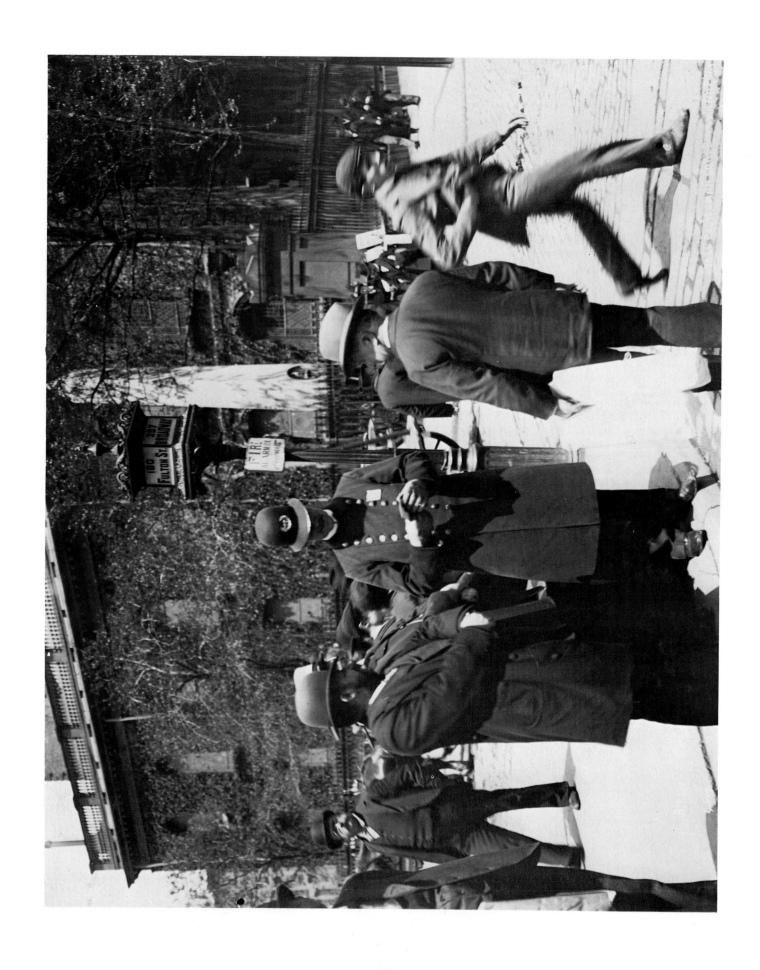

2. The Broadway Squad, Broadway and Fulton Street, ca. 1898.

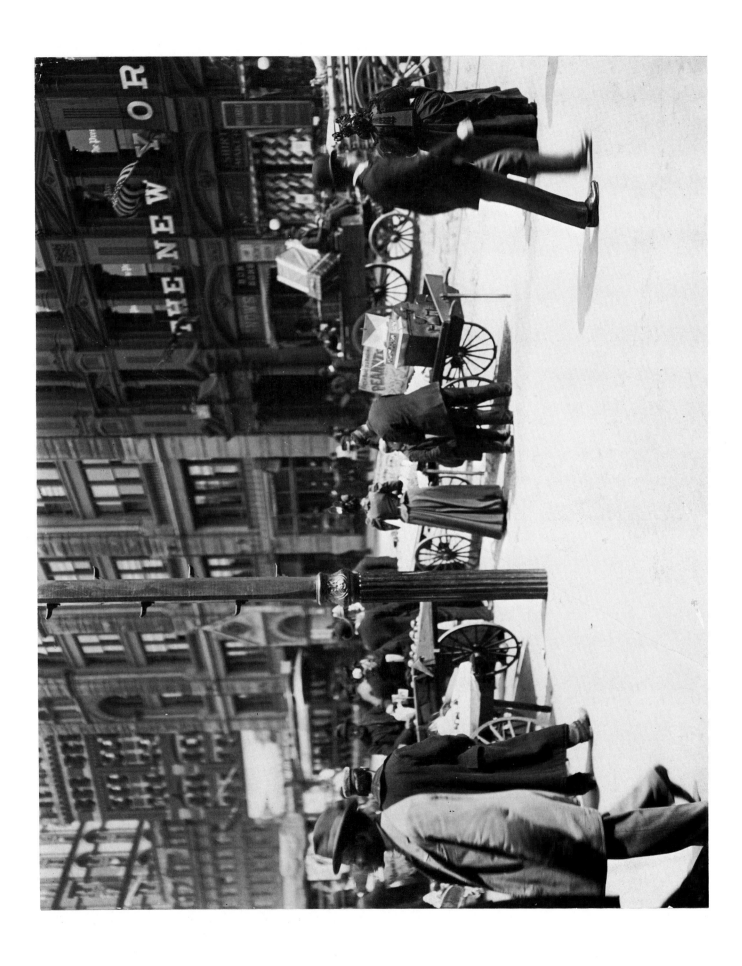

3. Park Row, 1895.

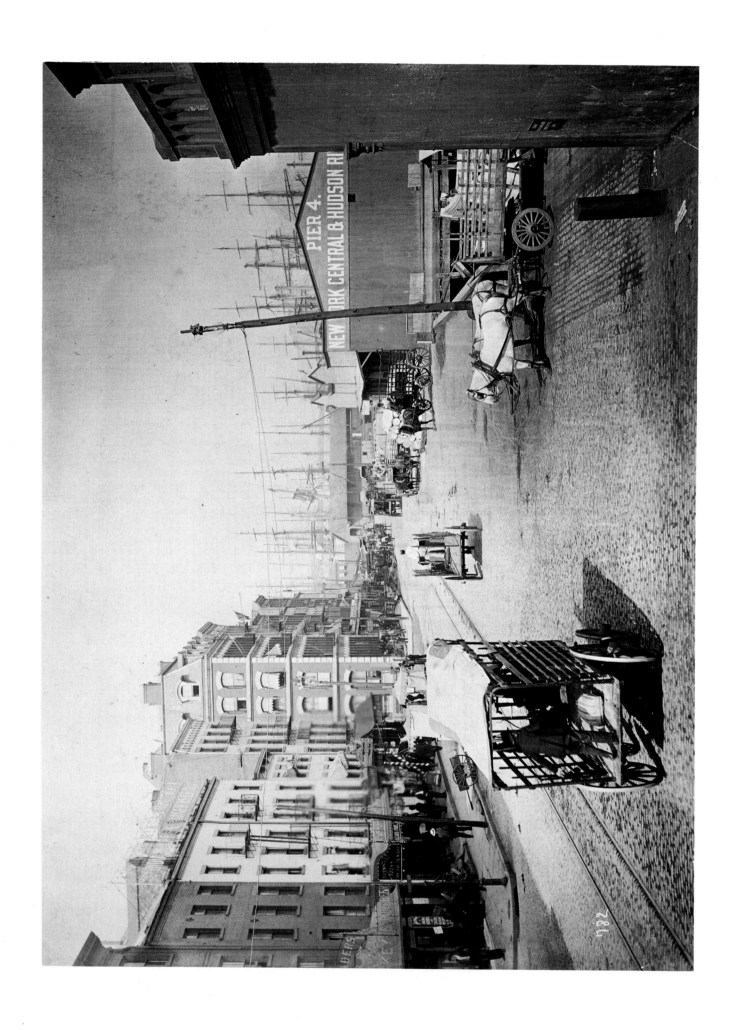

4. South Street, 1895.

5. BELOW: Grand Theatre, 1905.

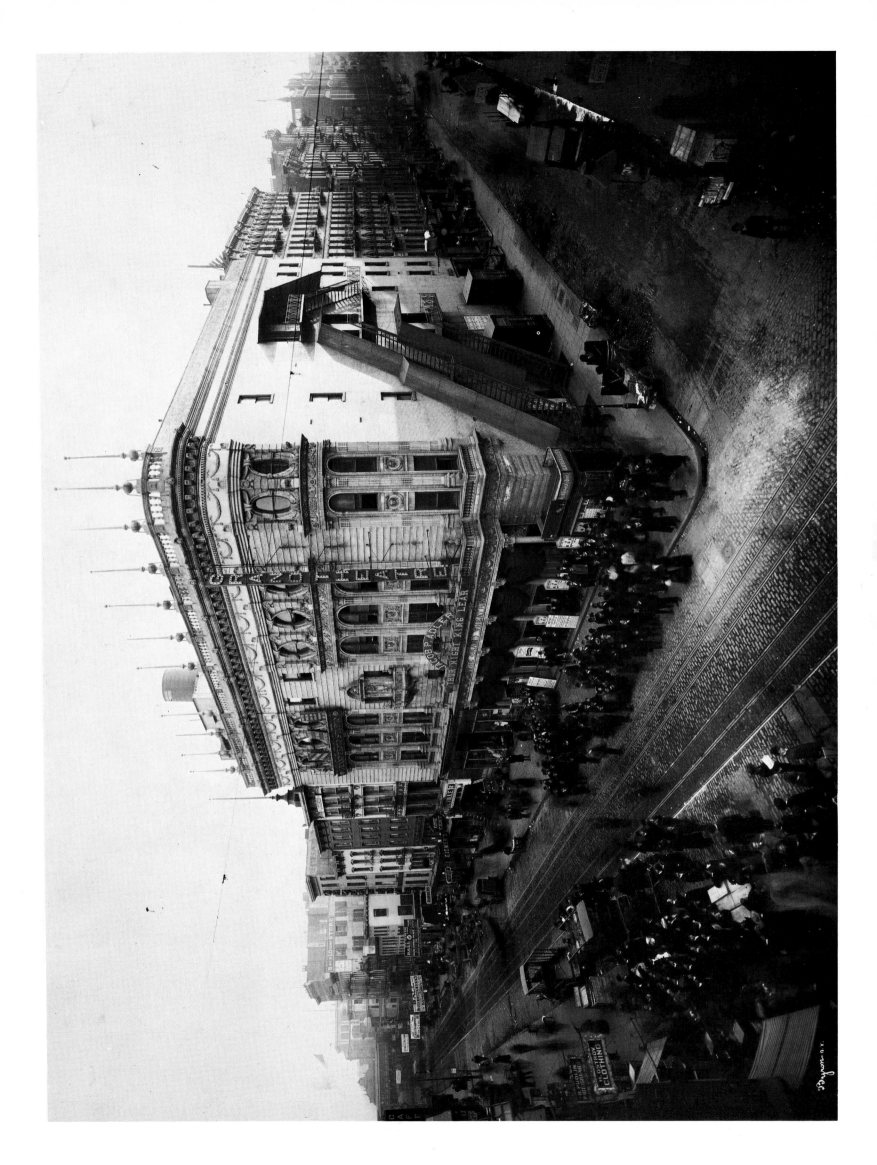

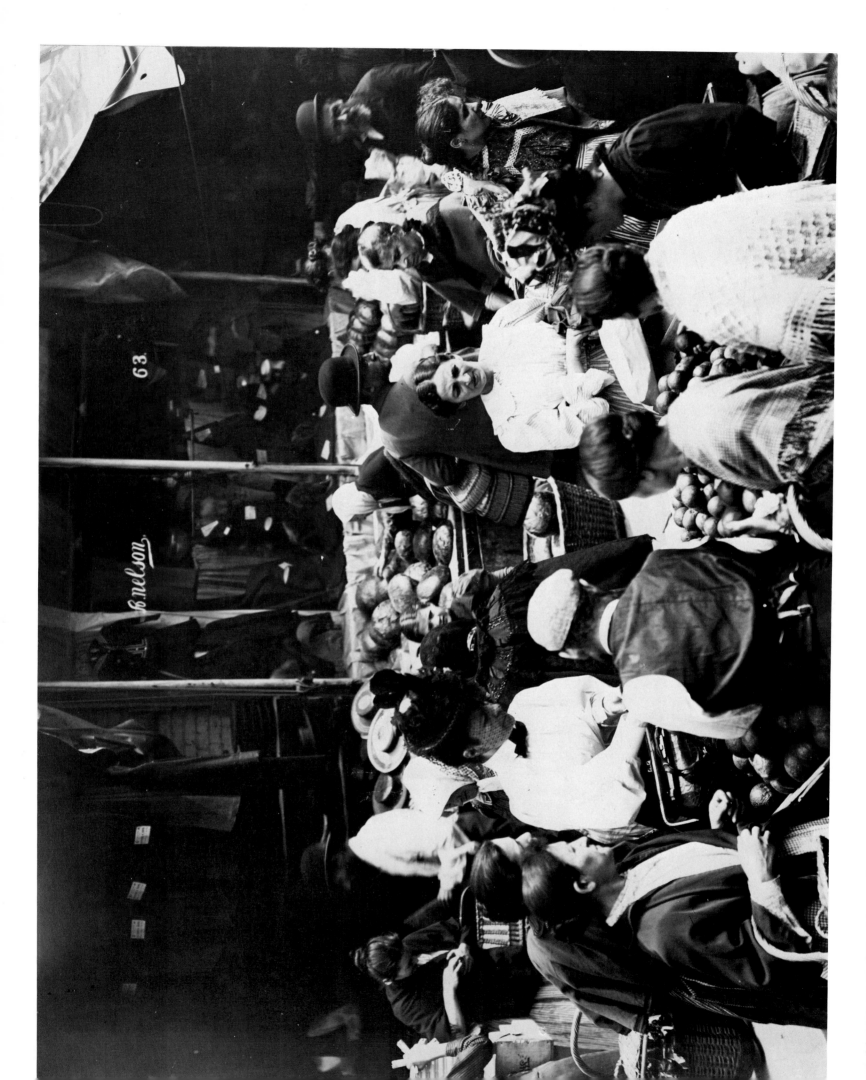

6. ABOVE: Hester Street, 1898.

7. Hester Street, 1898.

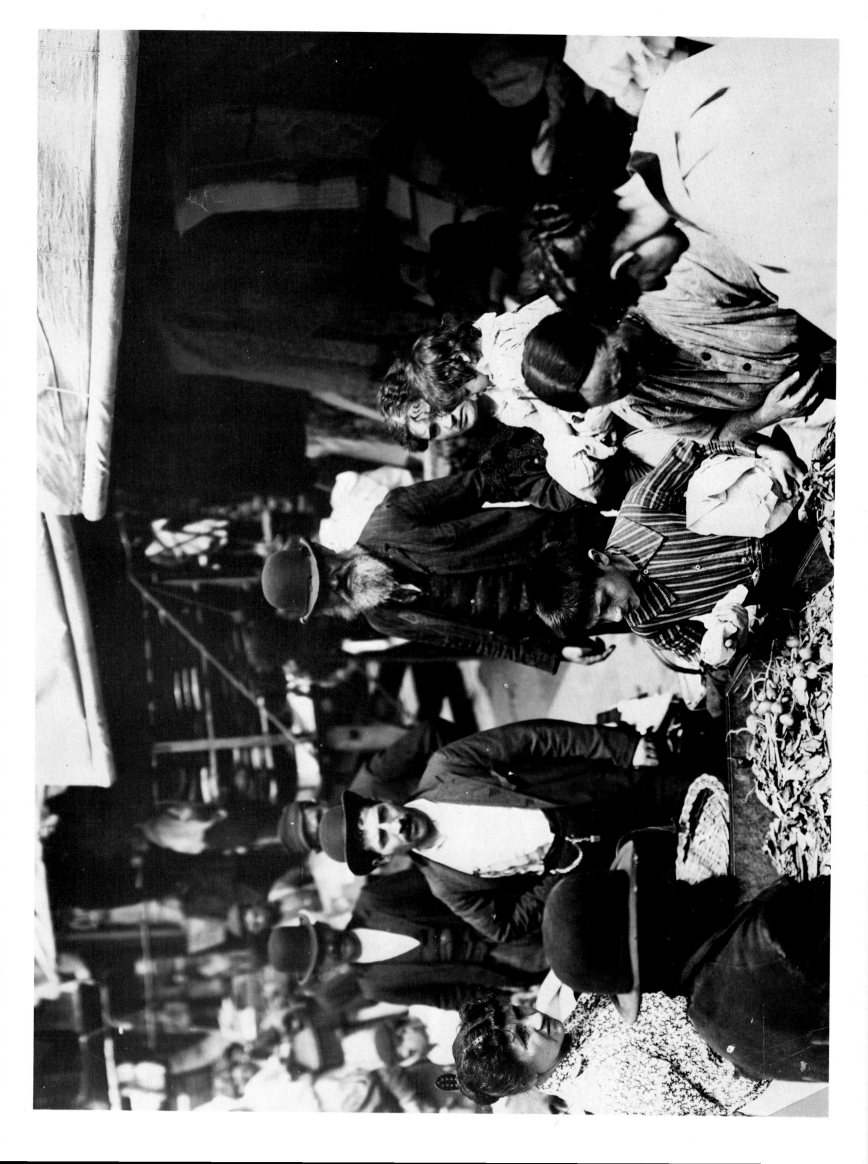

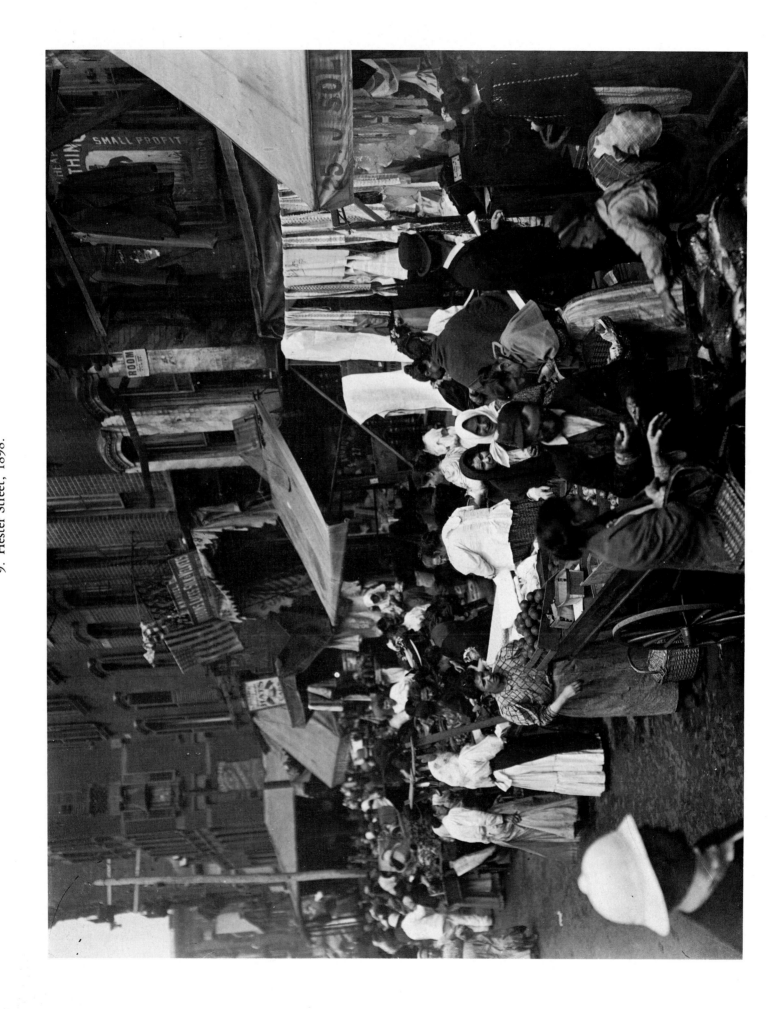

8. ABOVE: Hester Street, 1898.
9. Hester Street, 1898.

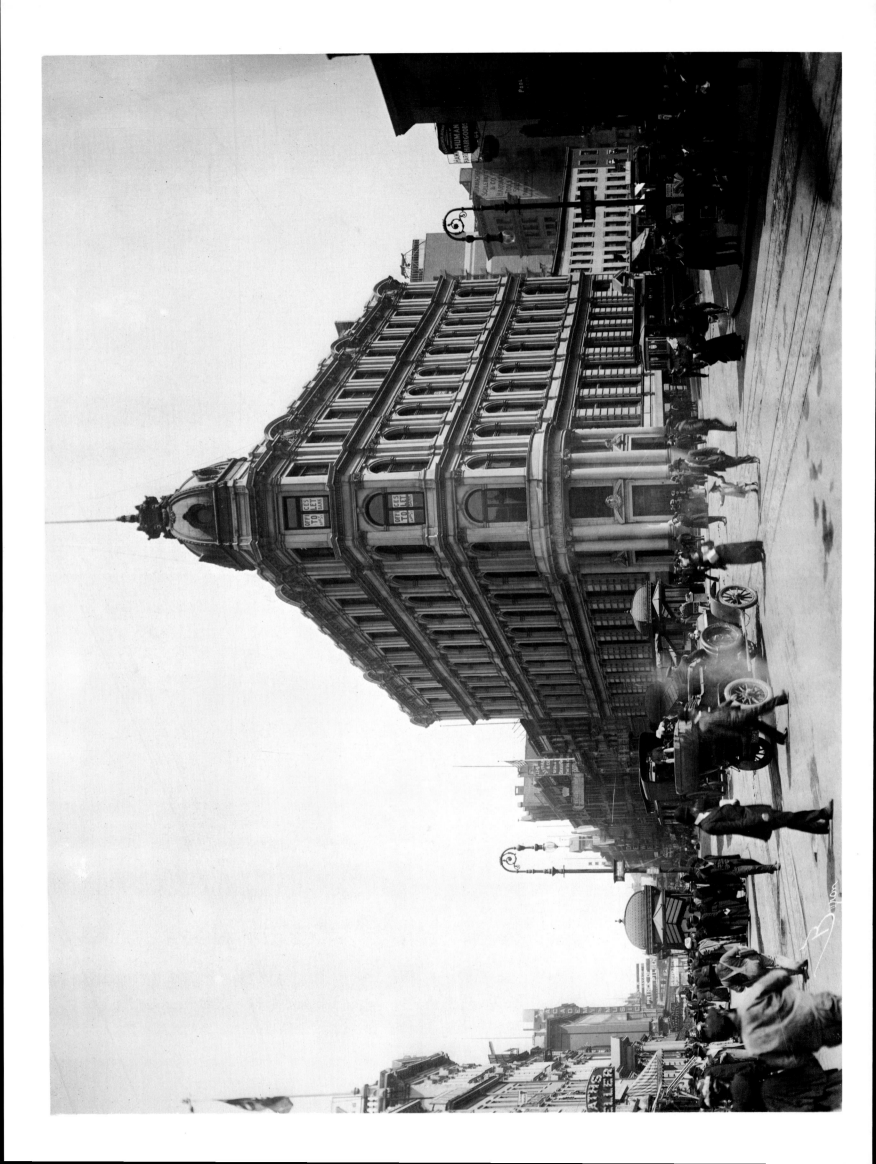

10. ABOVE: Fourth Avenue and East 14th Street, 1907.
11. Sixth Avenue, North from West 15th Street, 1895.

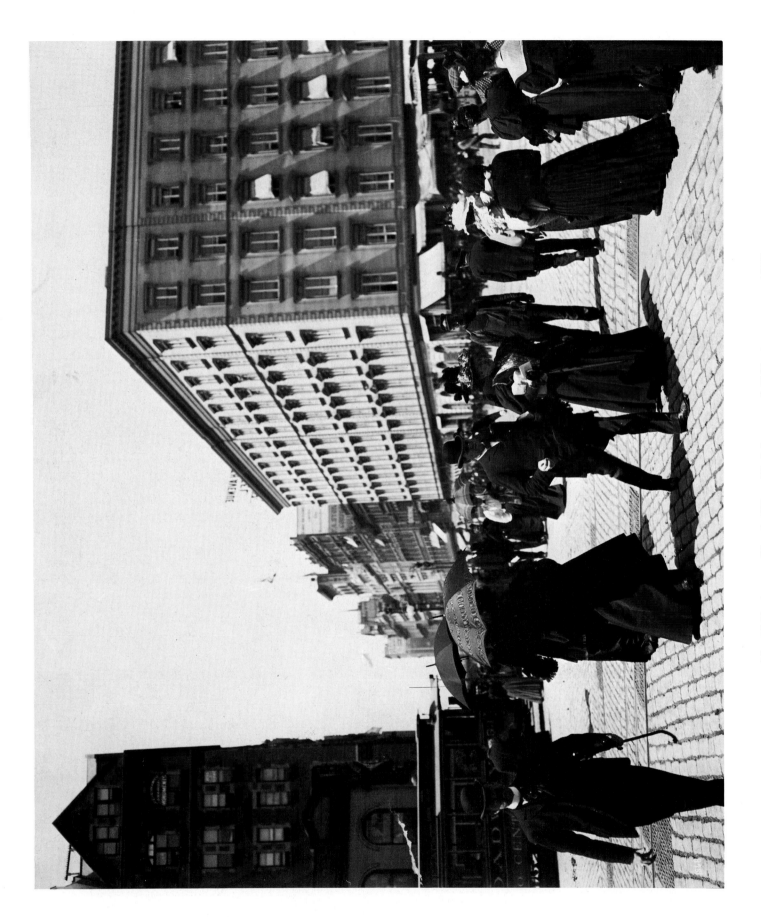

12. The Fifth Avenue Hotel, West 23rd Street and Fifth Avenue, ca. 1897.
13. BELOW: The Fifth Avenue Hotel, 1896.

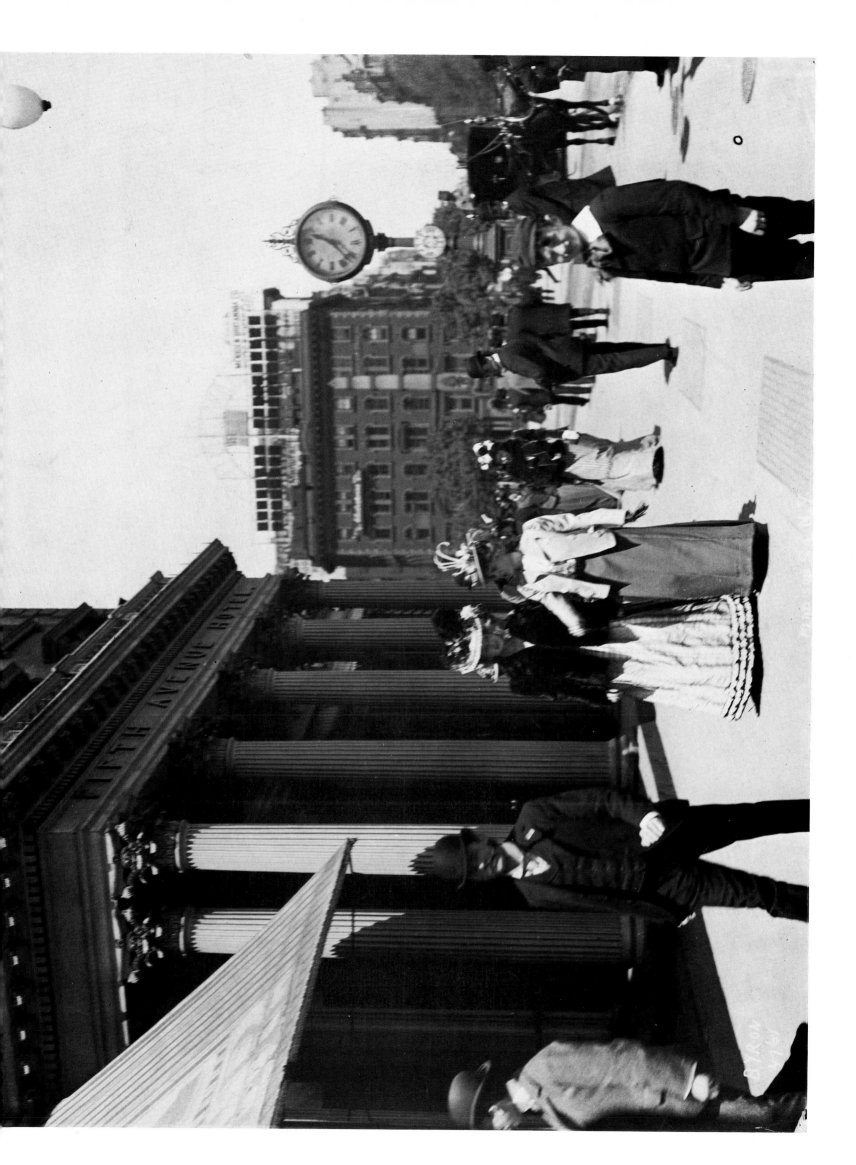

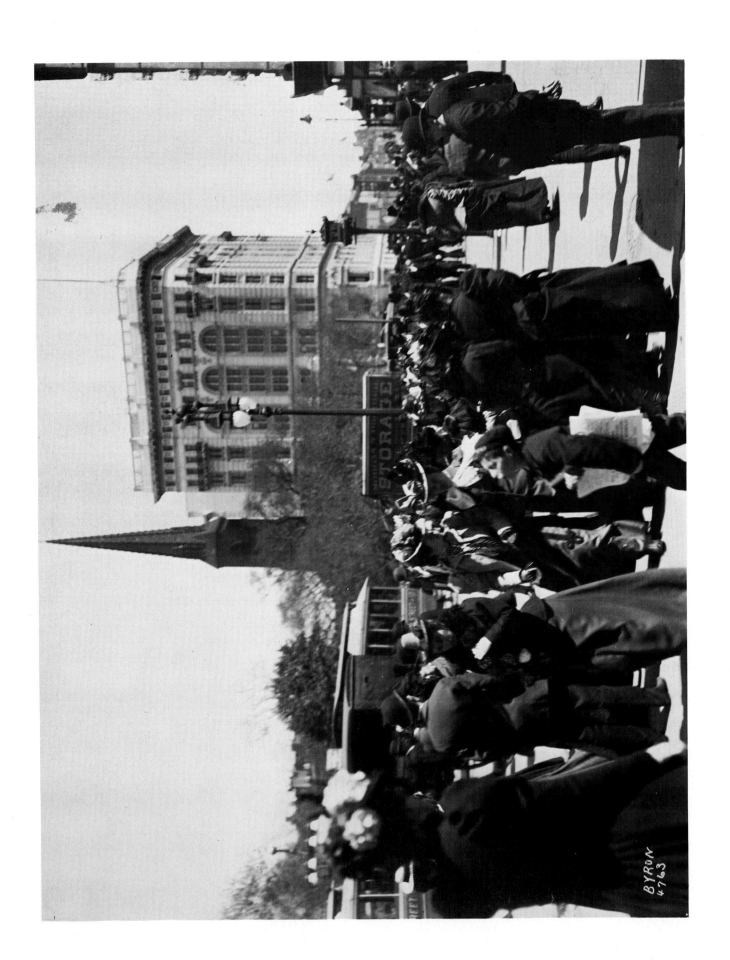

14. East 23rd Street, East from Fifth Avenue, 1898.
15. BELOW: Broadway and West 28th Street, 1898.

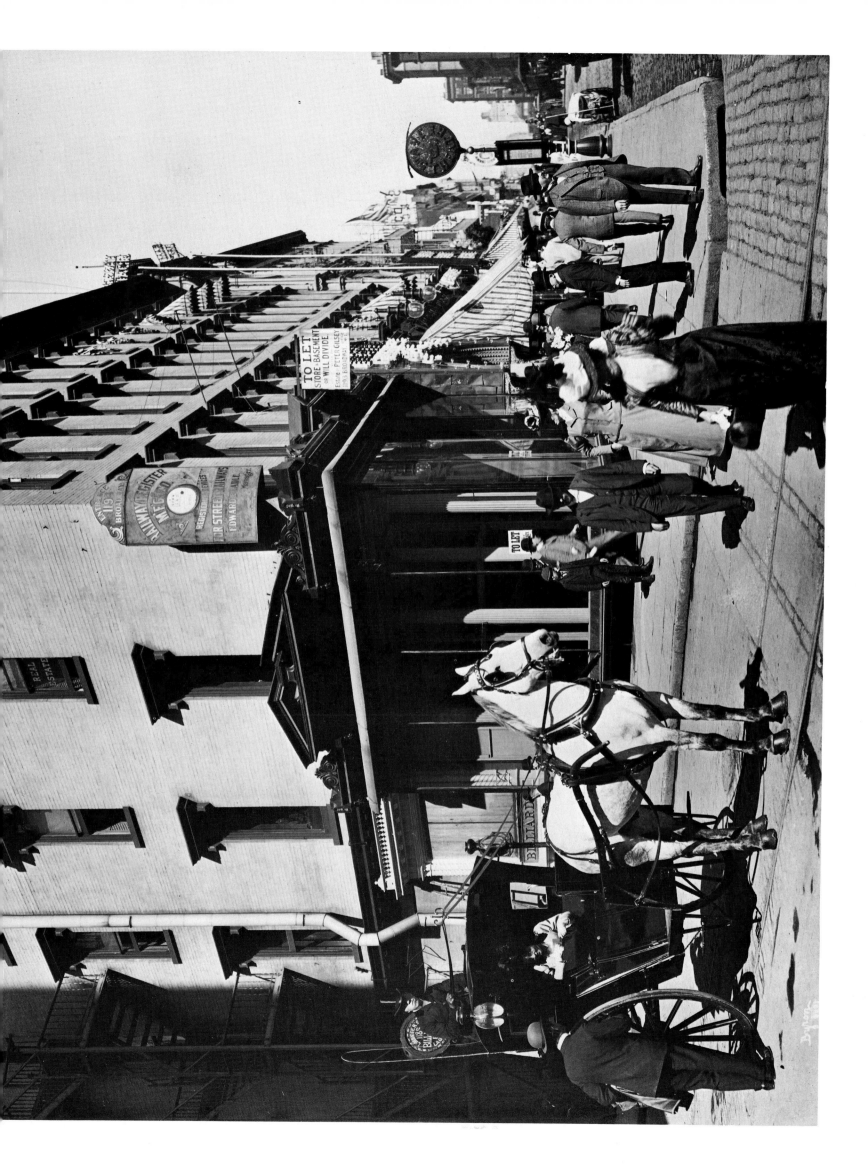

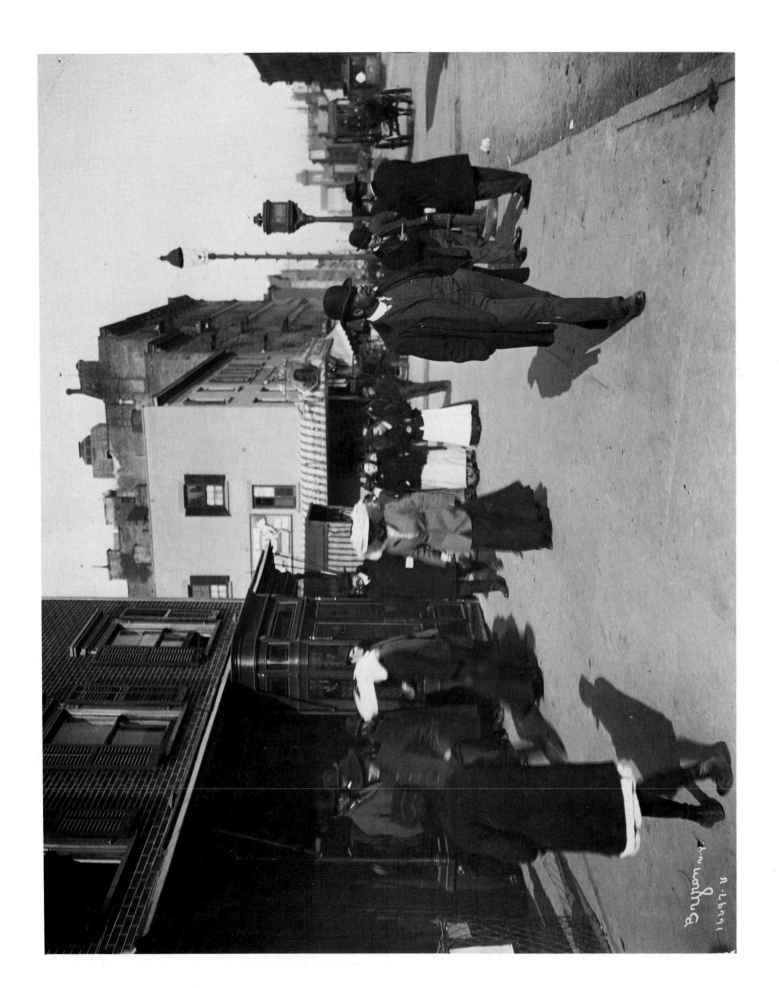

16. Seventh Avenue and West 30th Street, 1904.

17. BELOW: Seventh Avenue and West 30th Street, 1904.

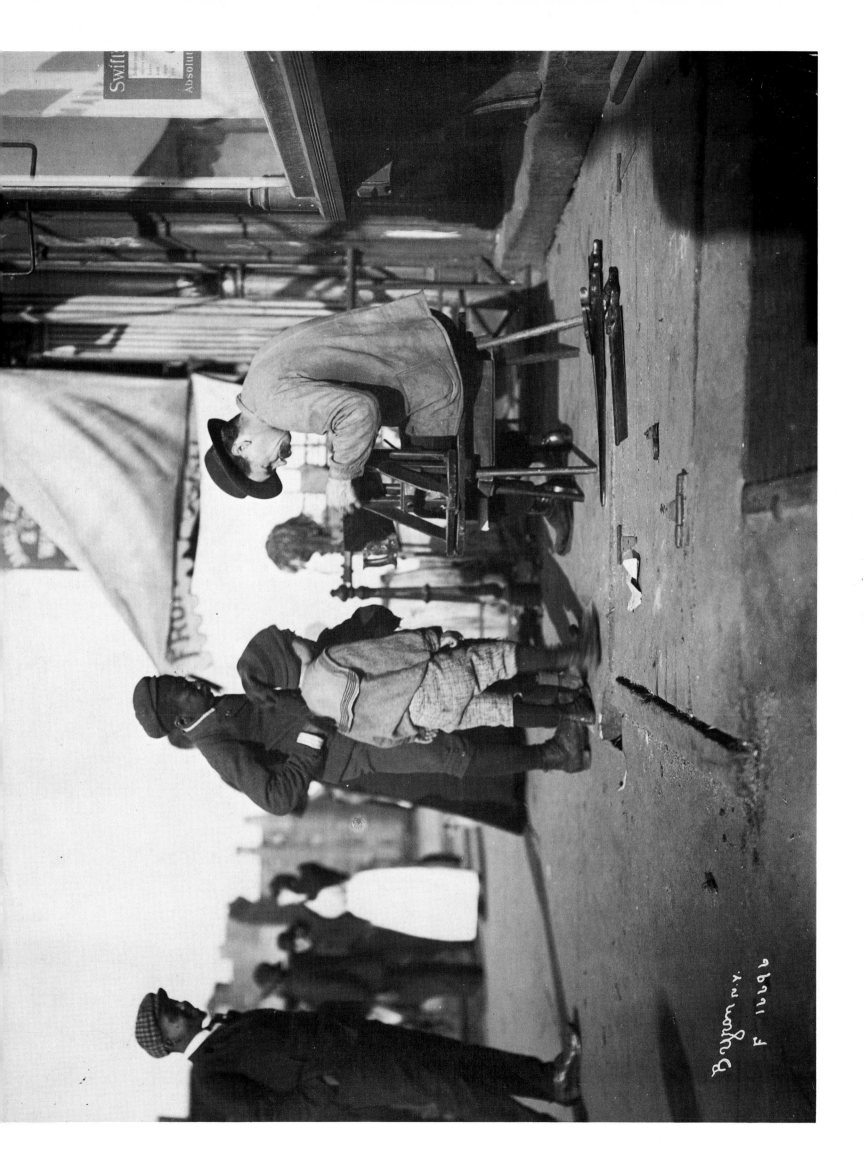

Byron N.Y.
F 1176q

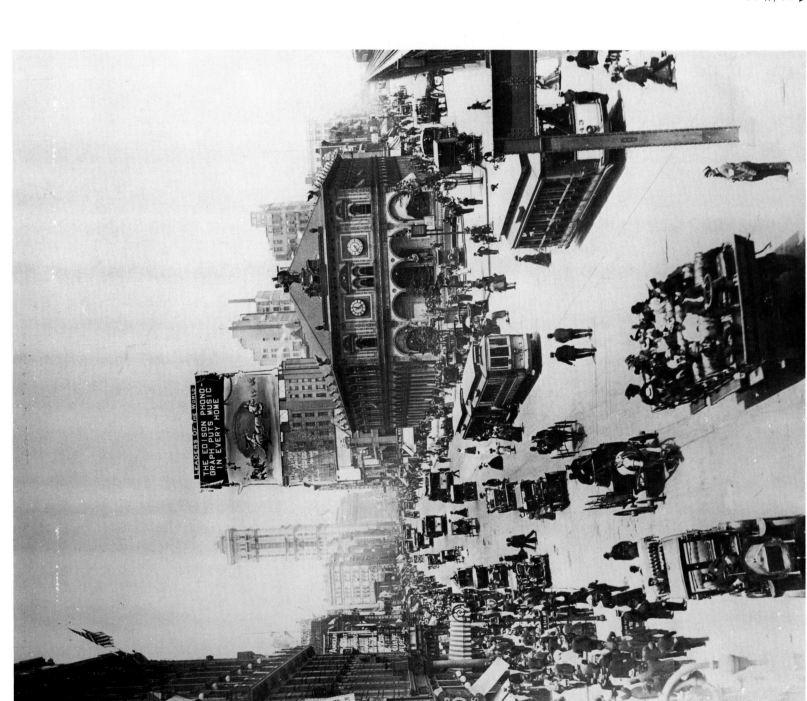

18. LEFT: Broadway, North from West 34th Street, 1909 and 1910.
19. BELOW: Peddlers, Sixth Avenue and West 34th Street, ca. 1898.

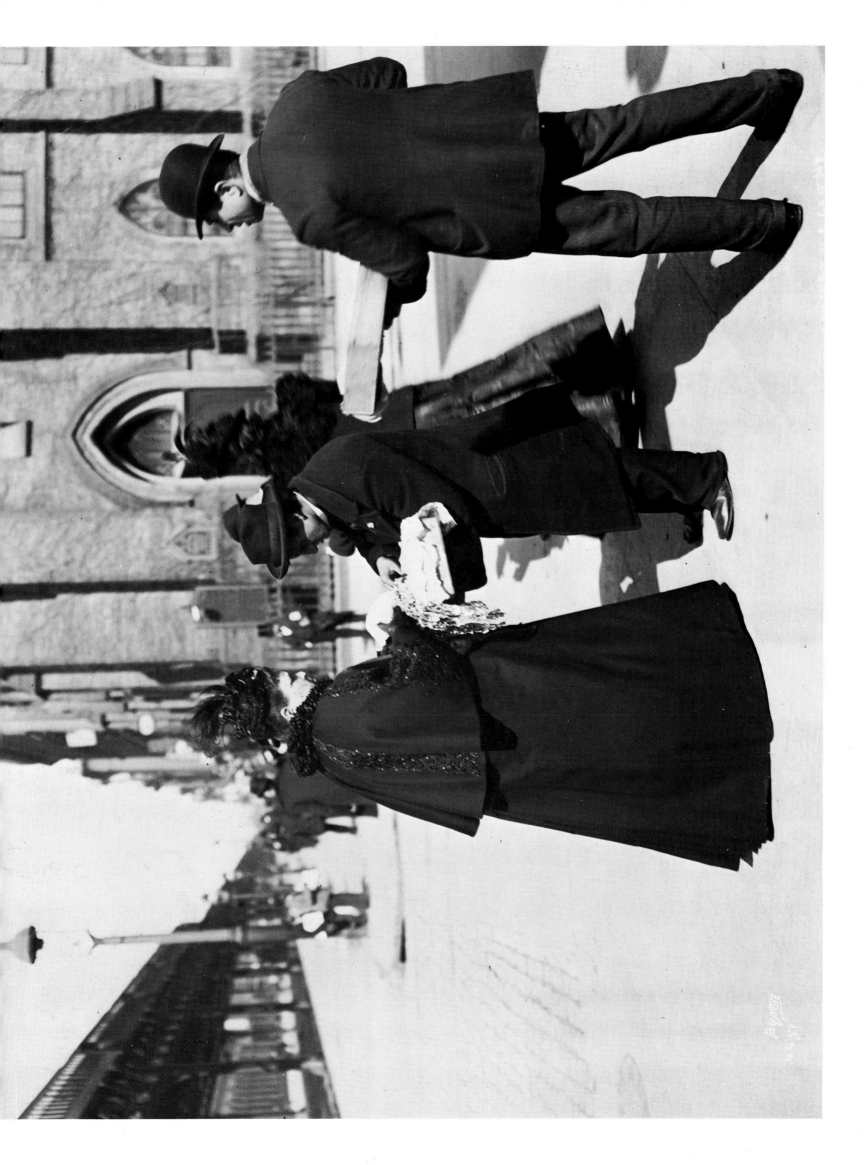

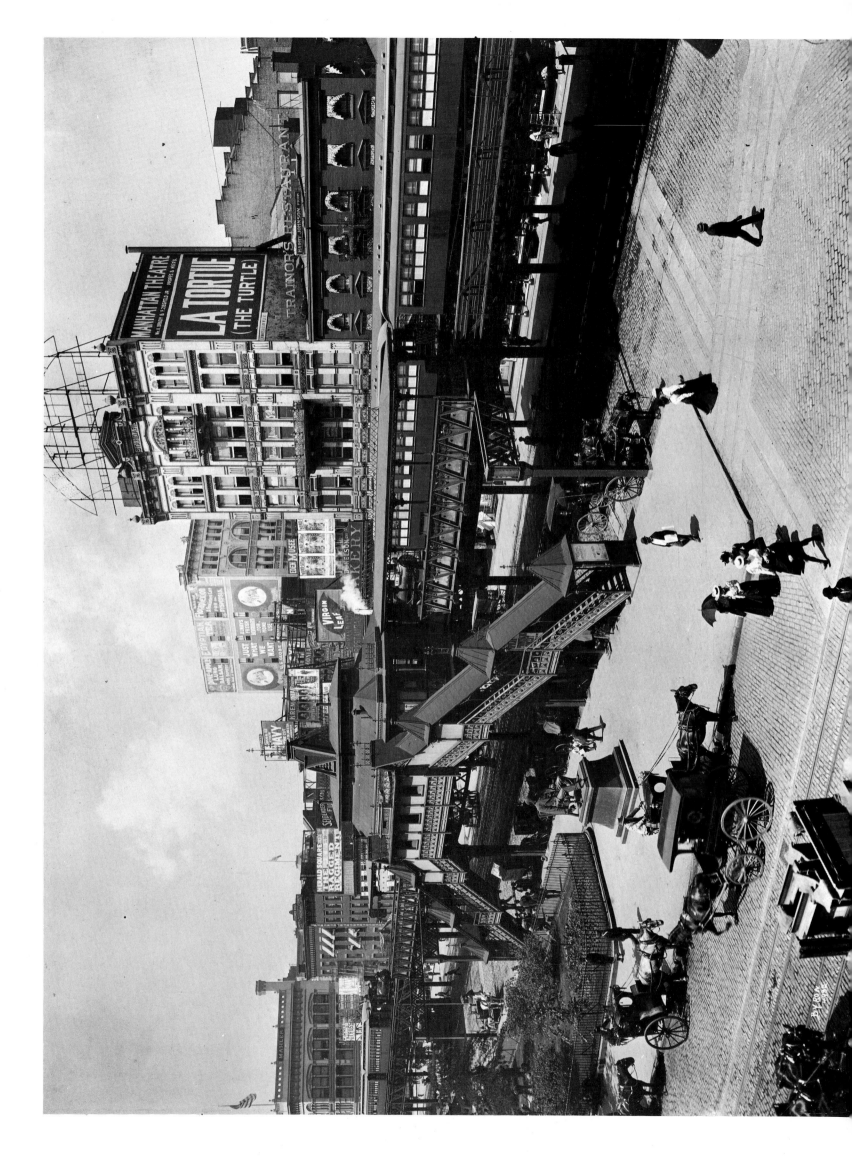

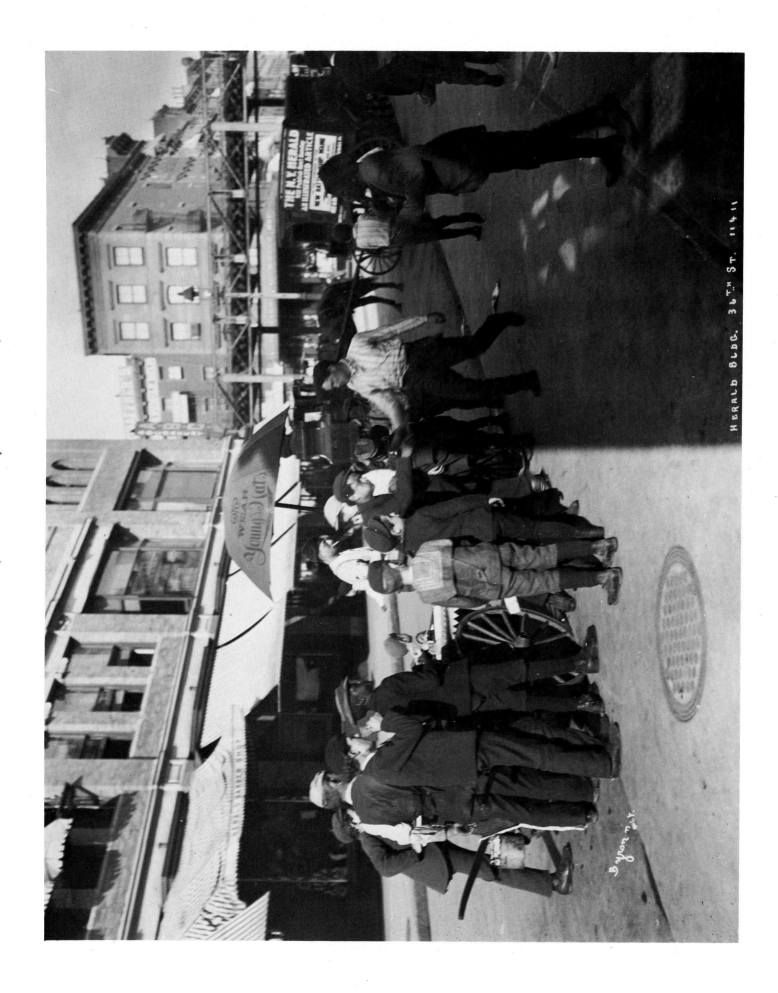

20. ABOVE: Greeley Square, 1898.

21. West 36th Street, between Broadway and Sixth Avenue, 1900.

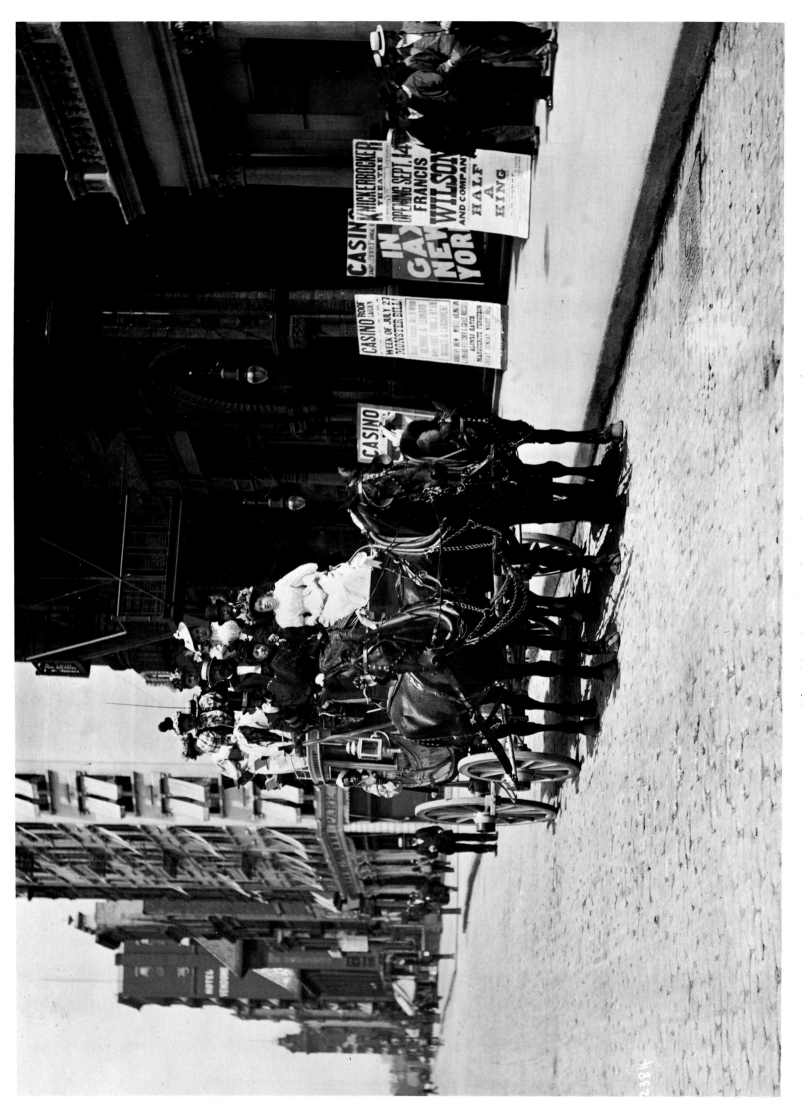

22. *Advertising Coach, Broadway and West 39th Street, 1896.*

23. Milbank Memorial People's Bath, No. 327 East 38th Street, 1904.

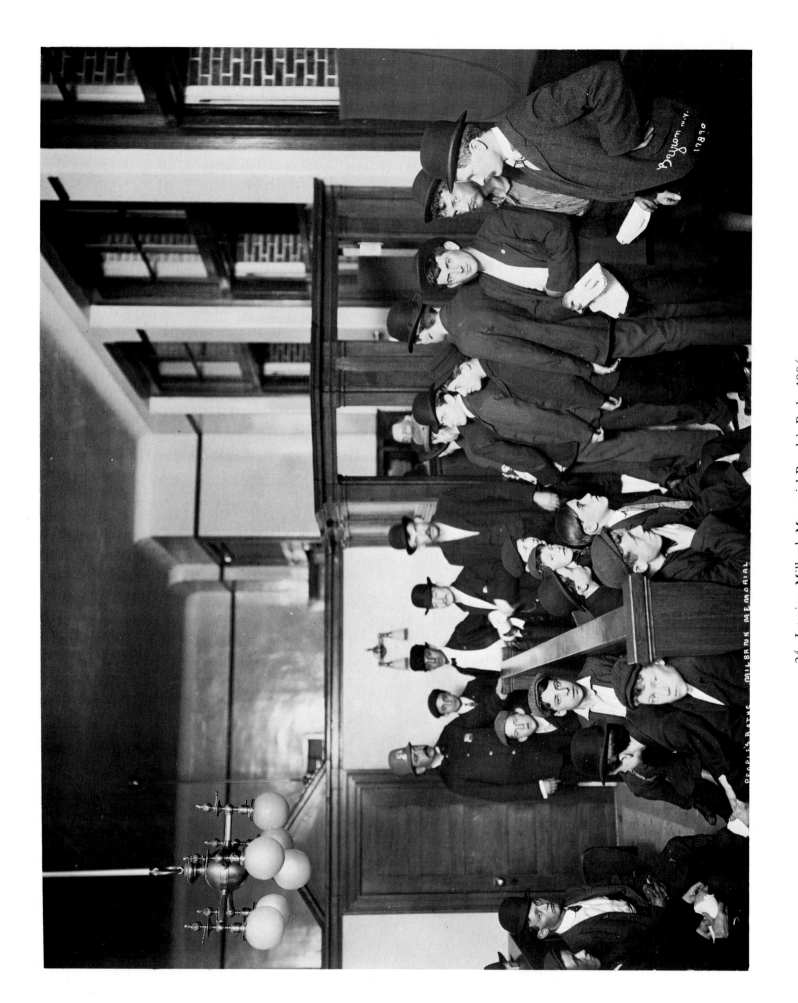

24. Interior, Milbank Memorial People's Bath, 1904.

25. BELOW: Stage Door of the Criterion Theatre, West 44th Street, 1904.

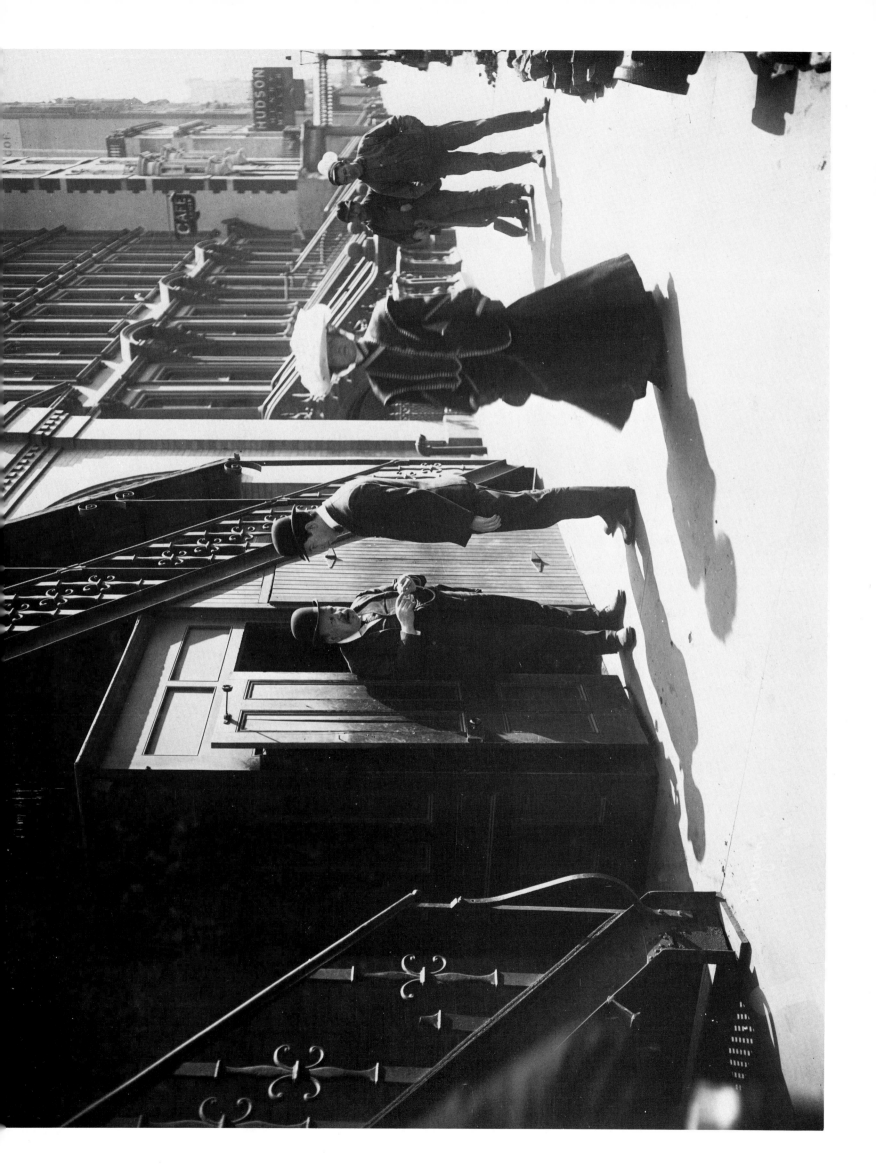

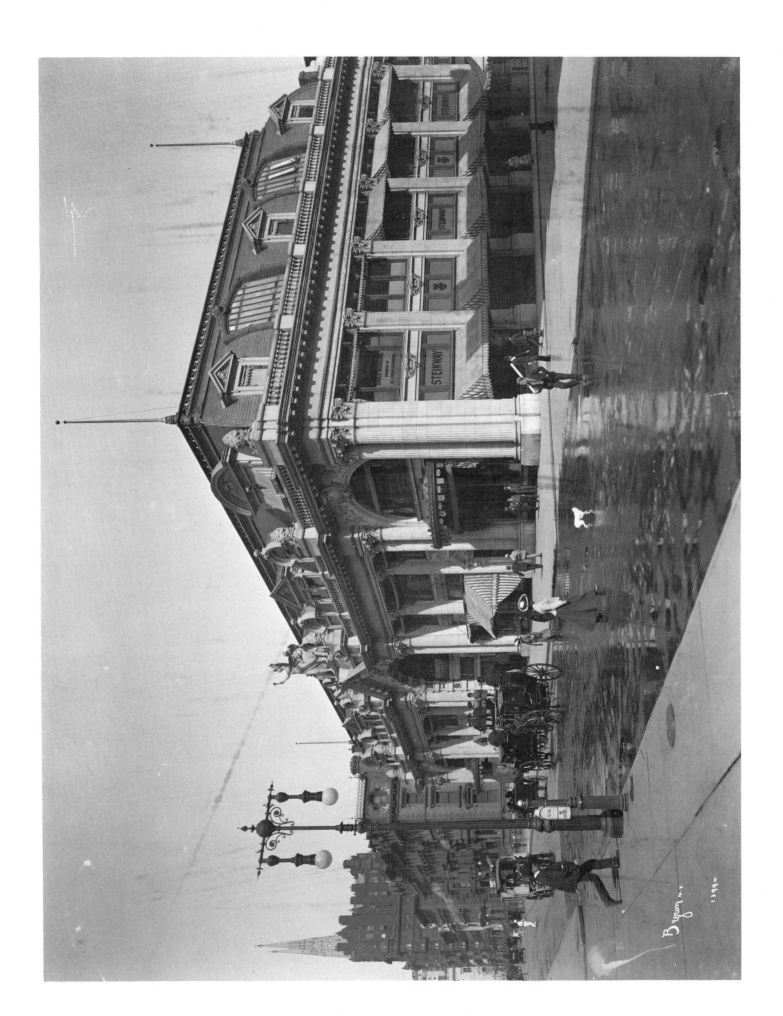

26. The Windsor Arcade, 1902.

27. BELOW: West 59th Street and Fifth Avenue, 1905.

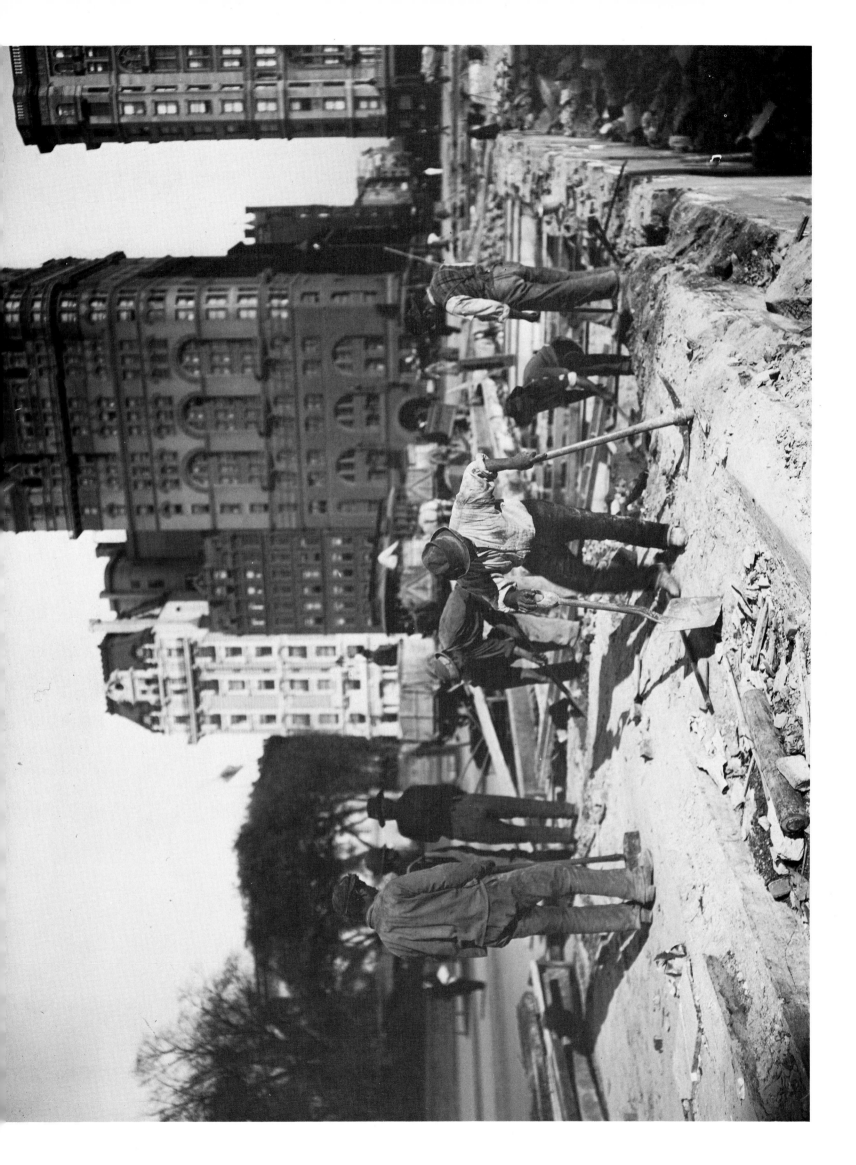

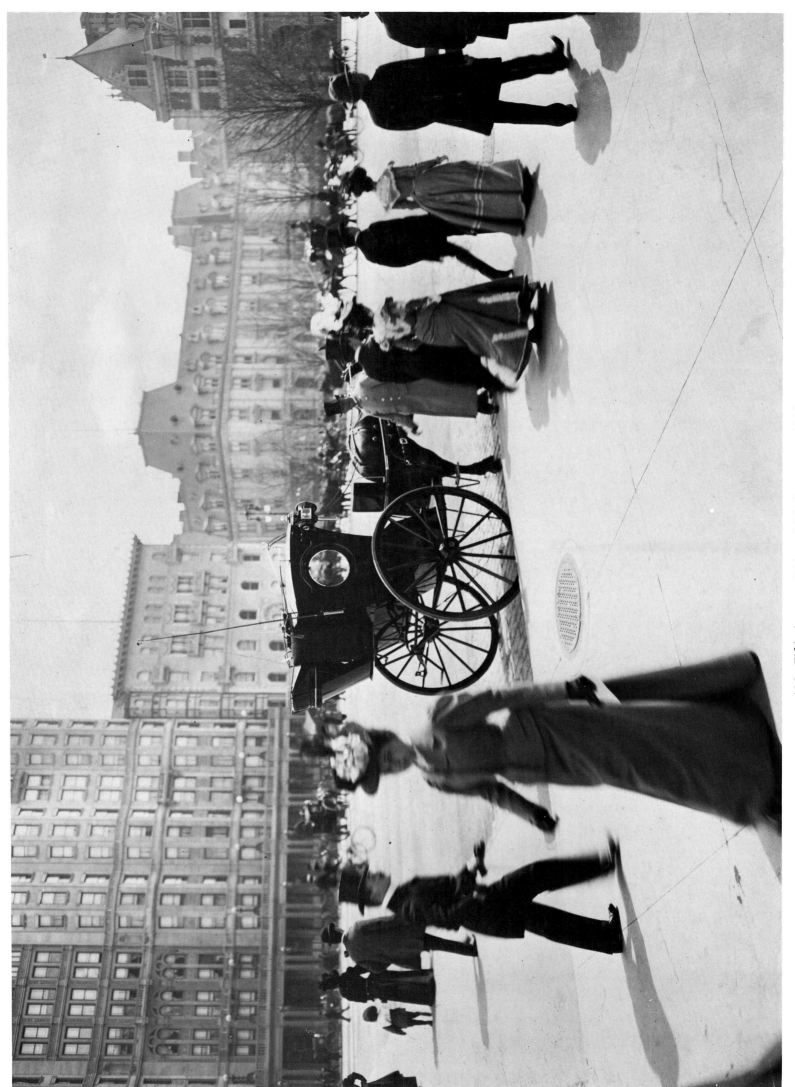

28. Fifth Avenue, 57th to 59th Streets, ca. 1898.

29. Brooklyn, 1899.

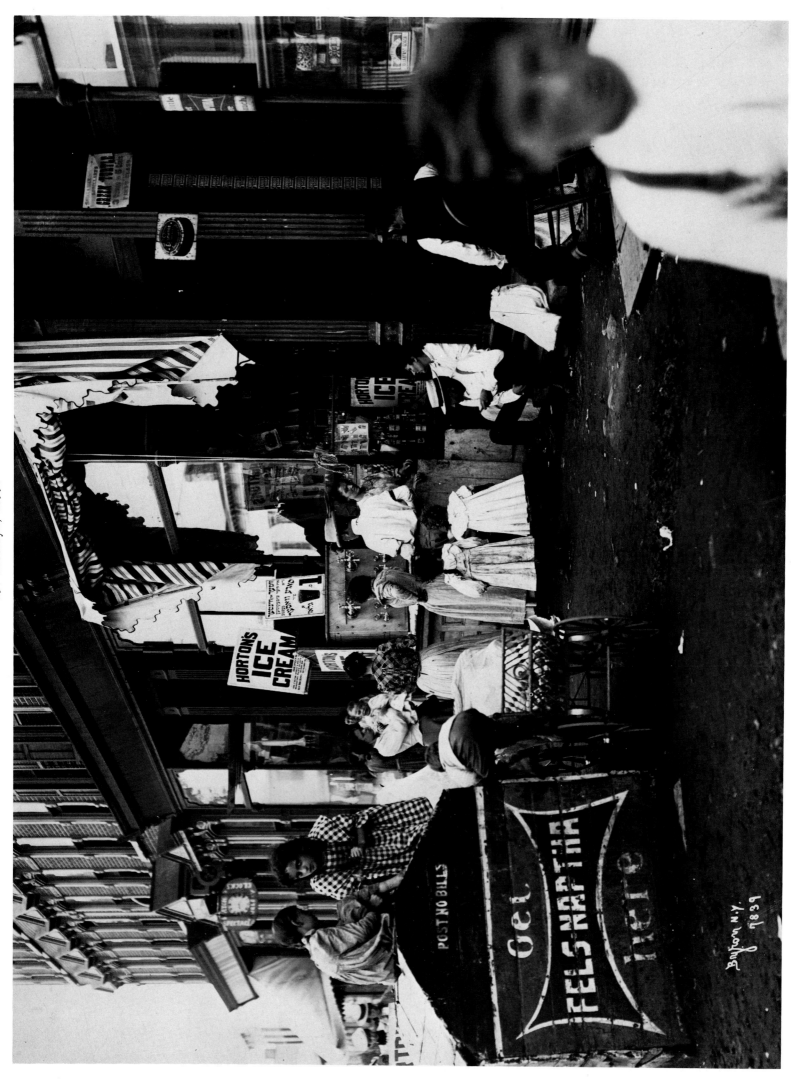

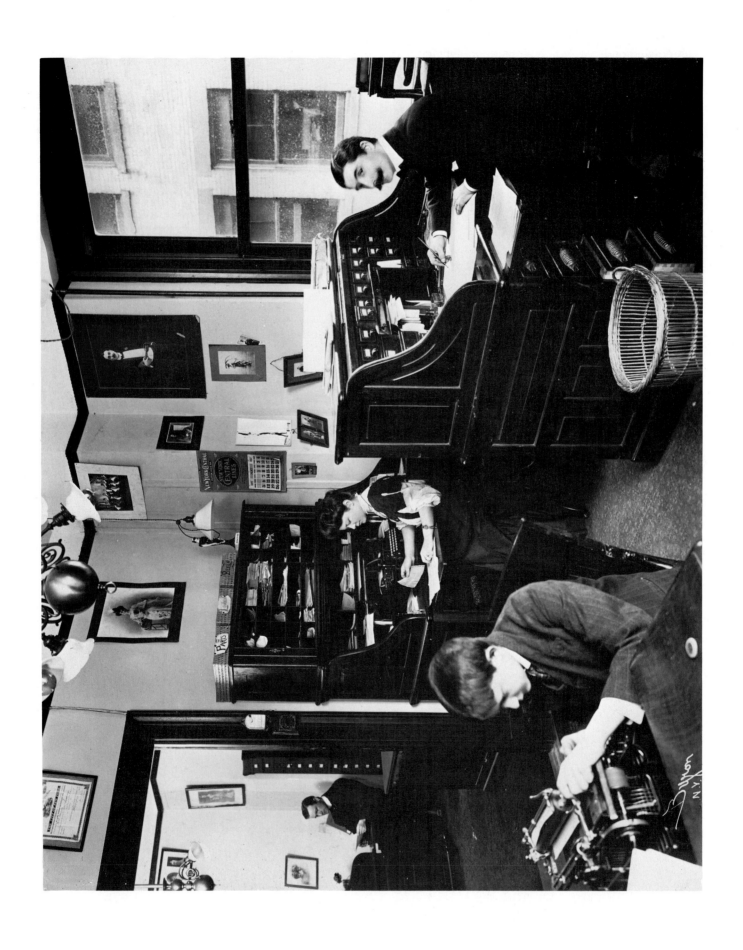

30. Herman B. Marinelli's Office, 1907.

31. BELOW: Siegel-Cooper's Bargain Counter, 1897.

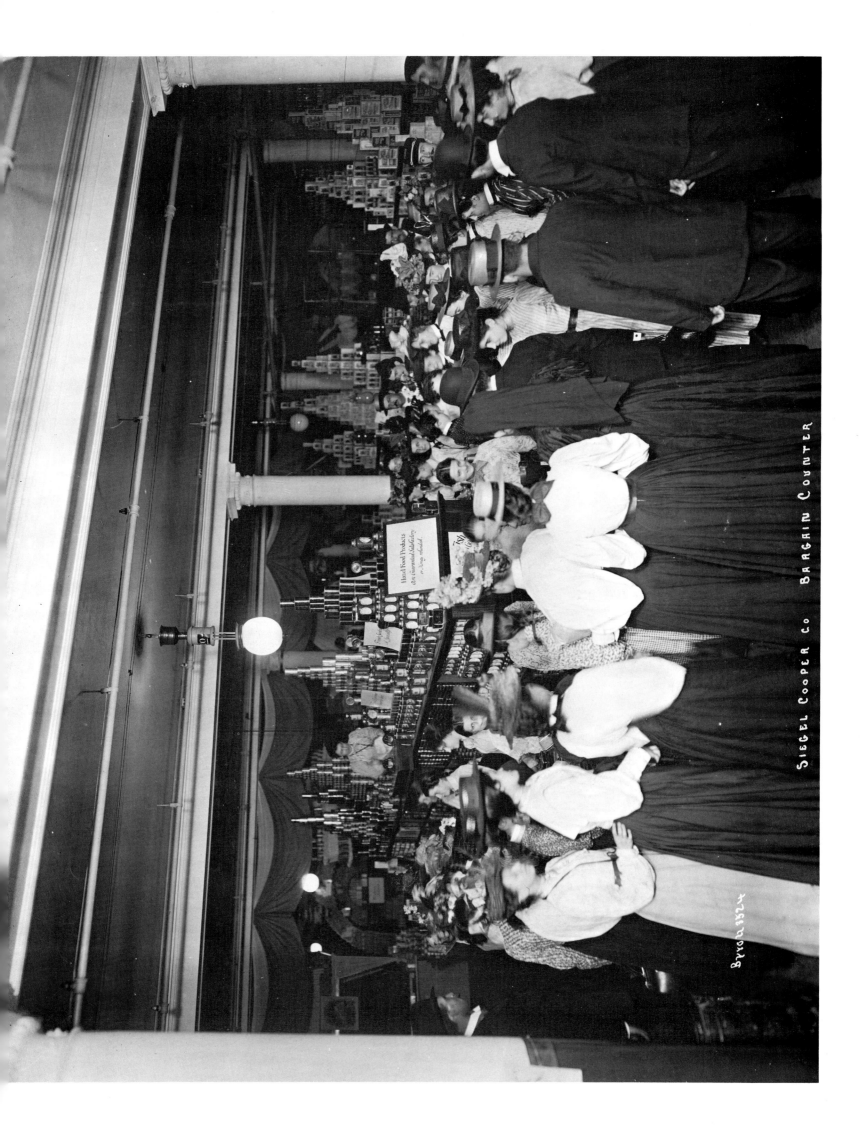

Hazel Food Products Are Guaranteed Satisfactory or Money Refunded

BYRON 1524

SIEGEL COOPER CO BARGAIN COUNTER

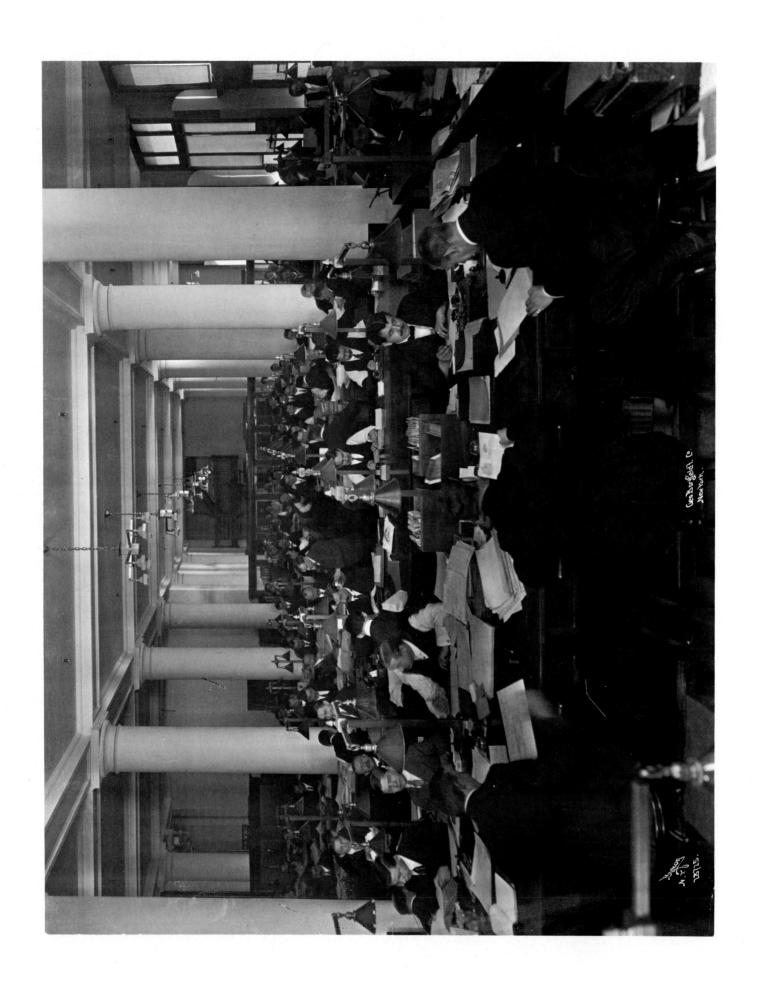

32. George Borgfeldt Company, 1910.
33. BELOW: *McCall's* Magazine, ca. 1912.

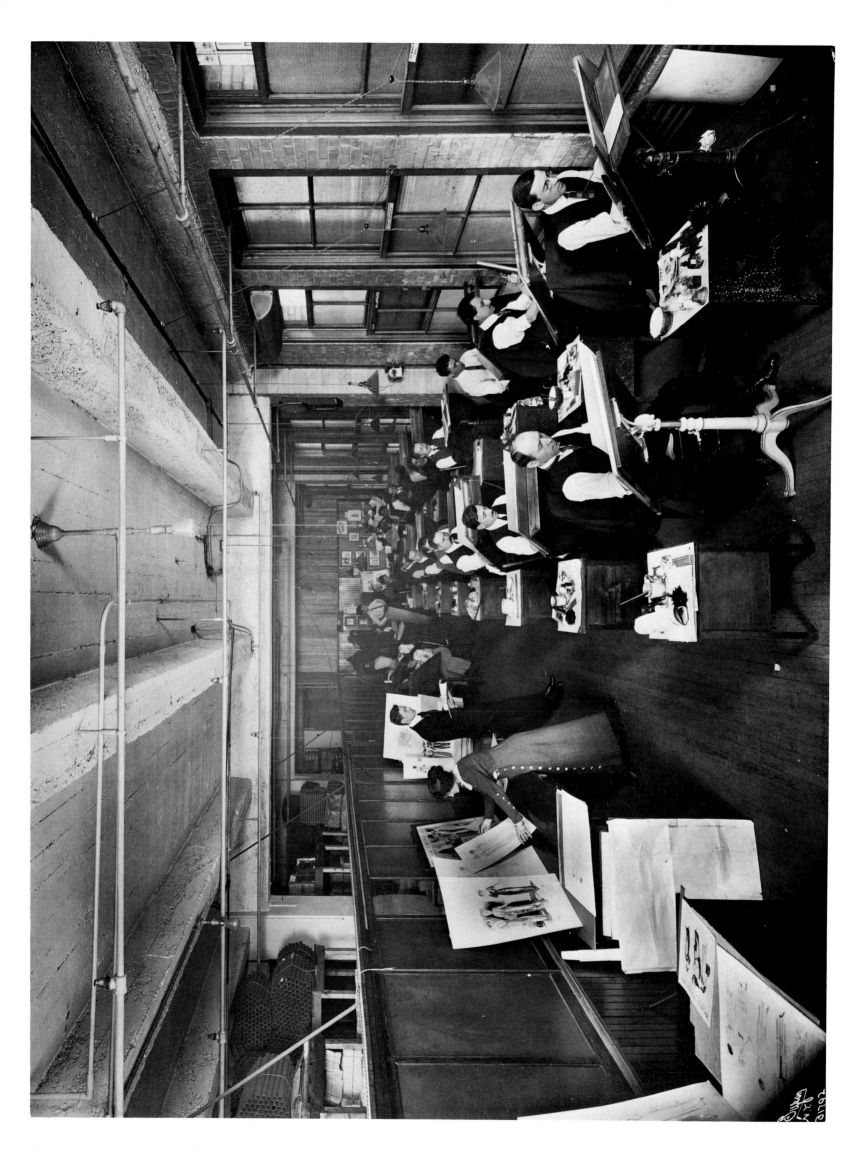

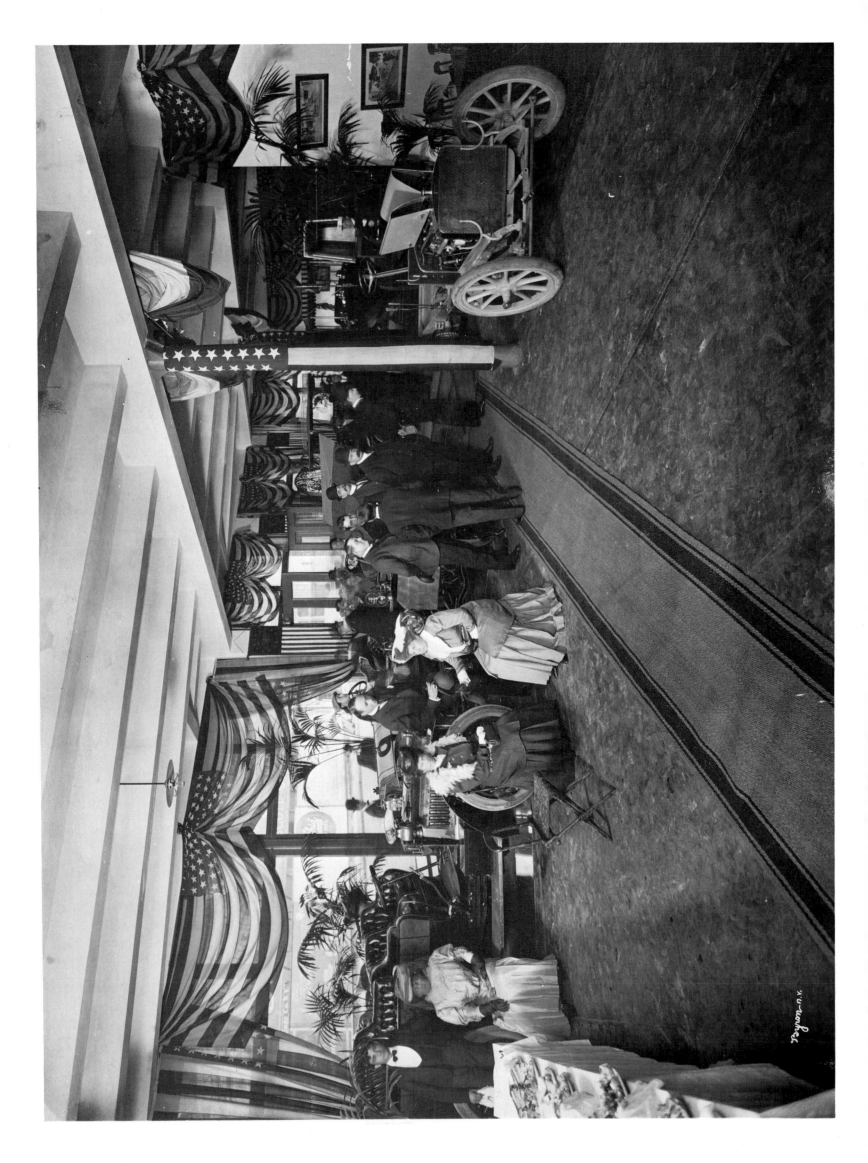

34. ABOVE: Smith & Mobley Company, 1905.
35. J. Ehrlich & Sons, Opticians, 1894.

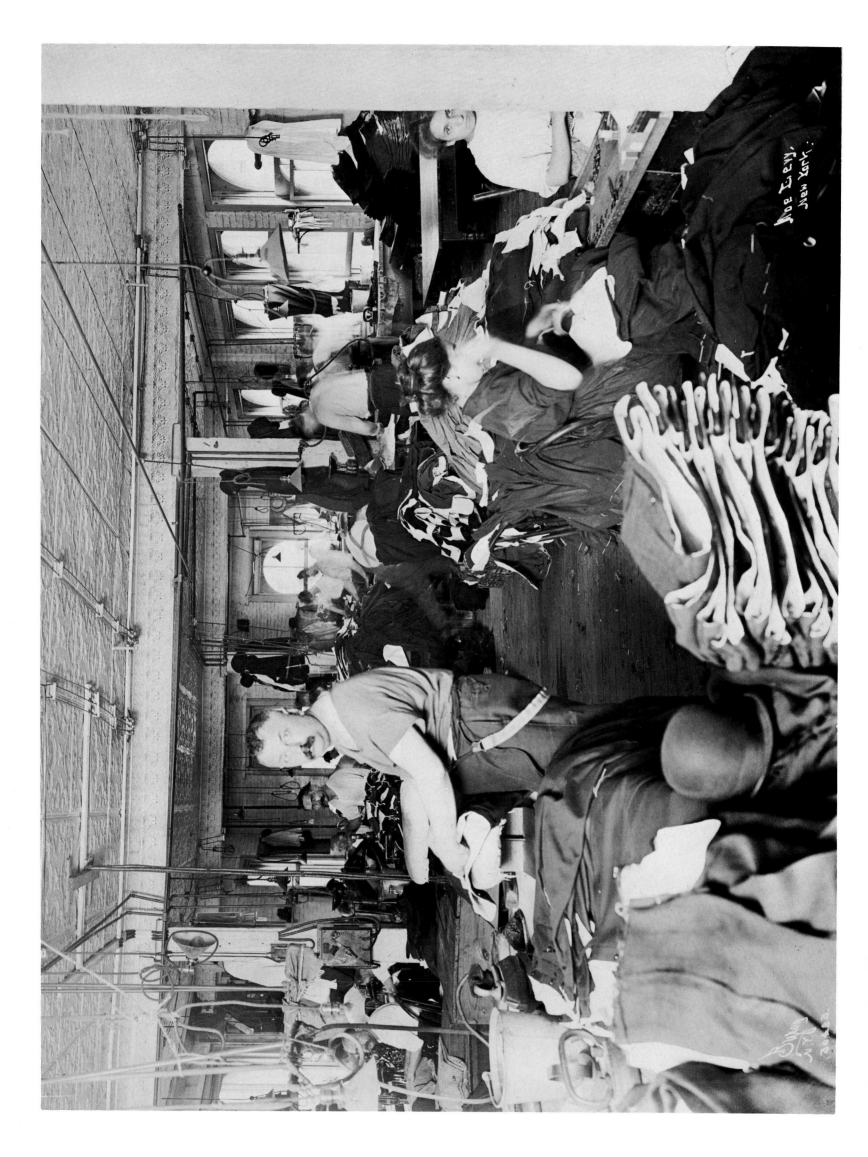

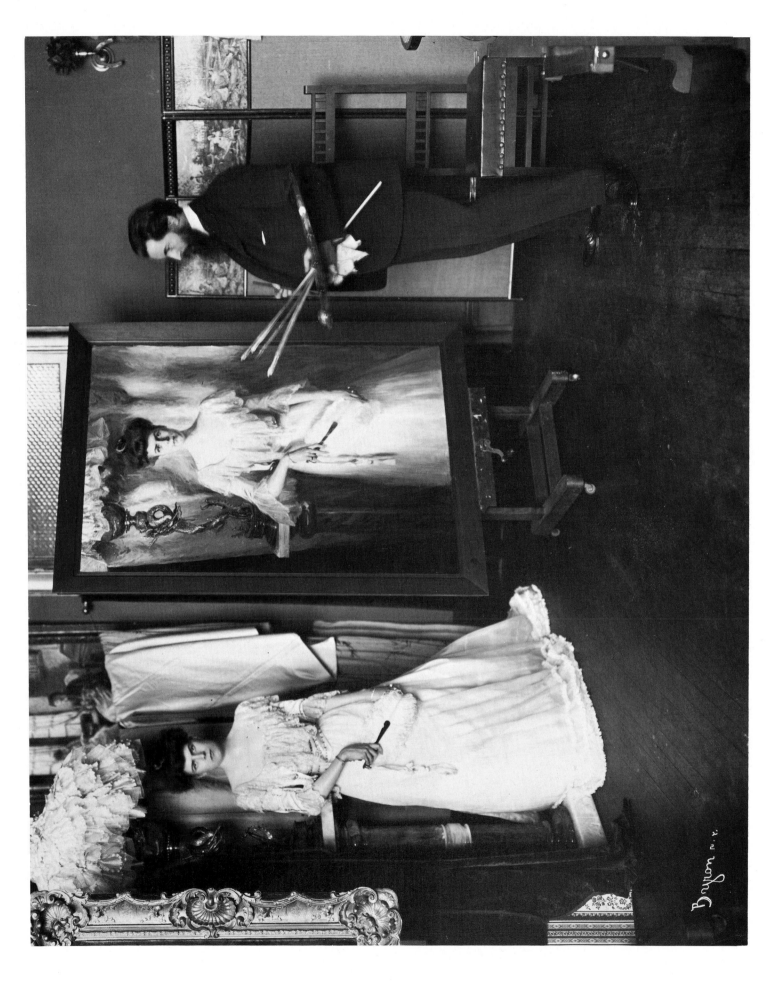

36. ABOVE: Moe Levy & Co., 1911.
37. The Studio of Richard Hall, 1903.

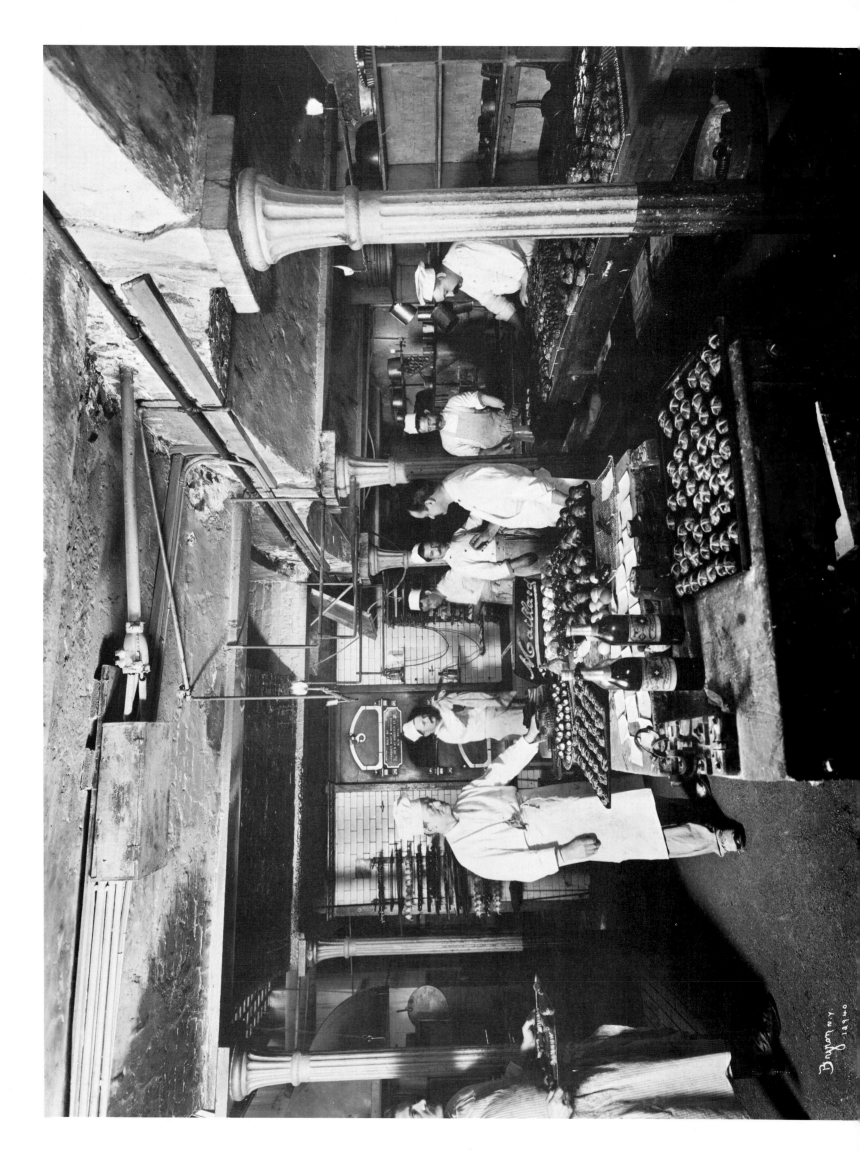

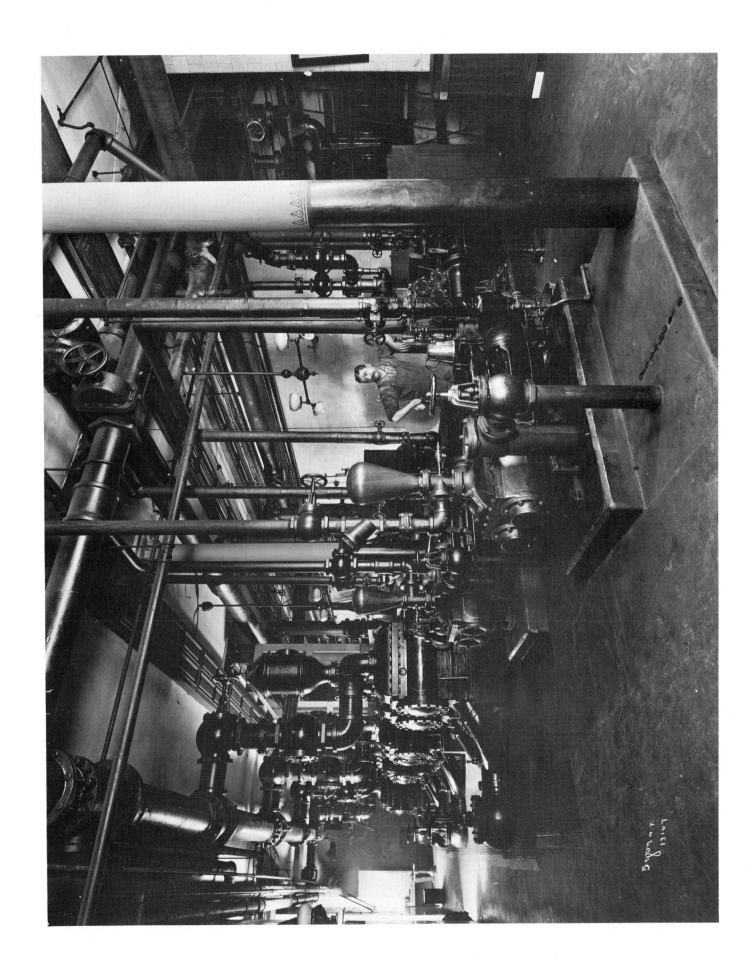

38. ABOVE: Maillard's Chocolate Factory, 1902.
39. The Pump Room of the Equitable Building, 1902.

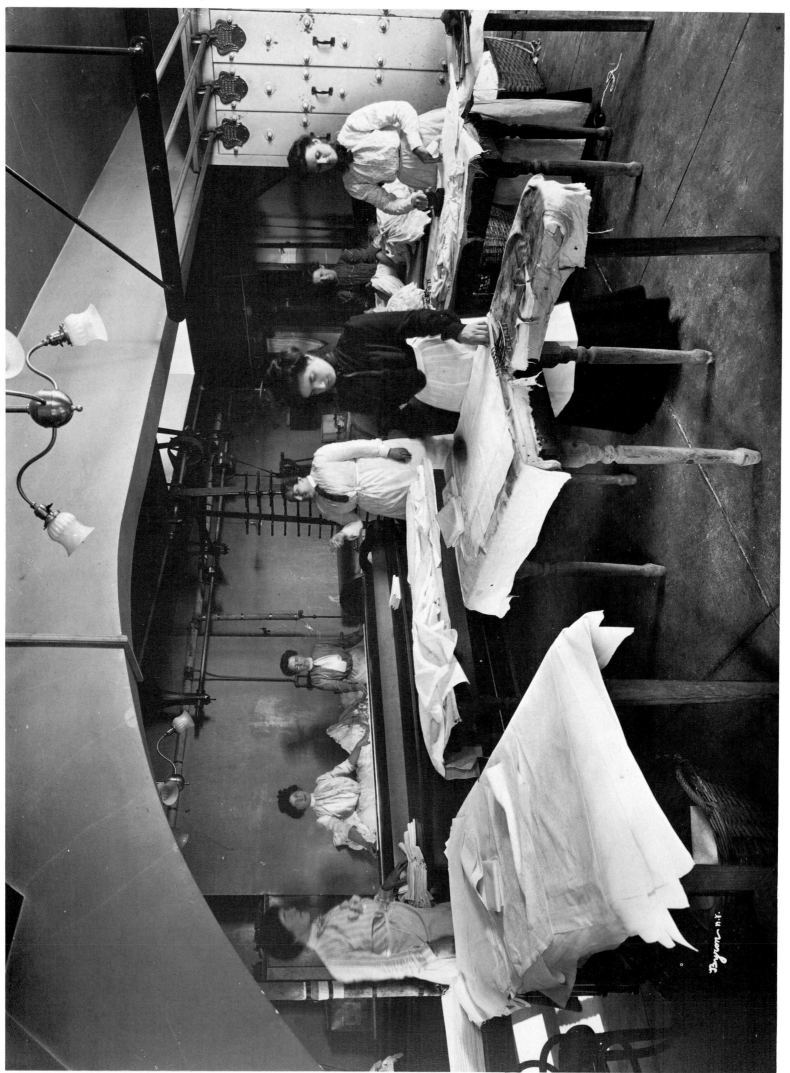

40. Laundry Room, Down Town Association, 1902.

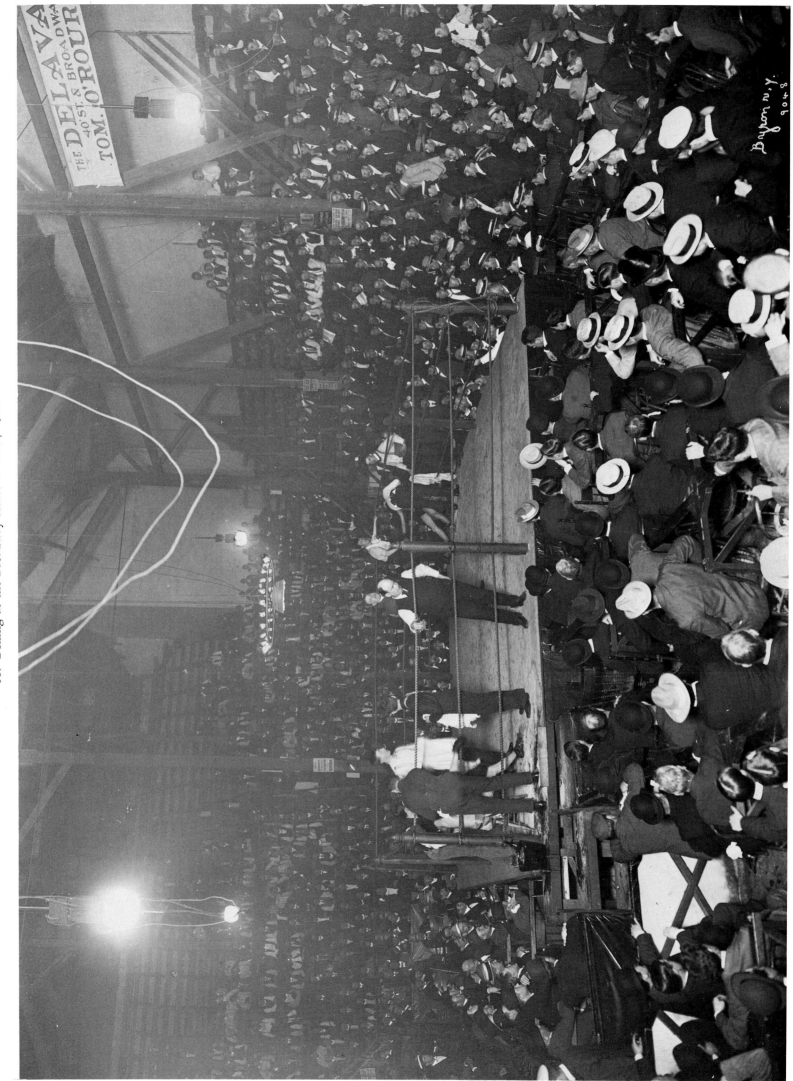

41. Boxing at the Broadway Athletic Club, 1900.

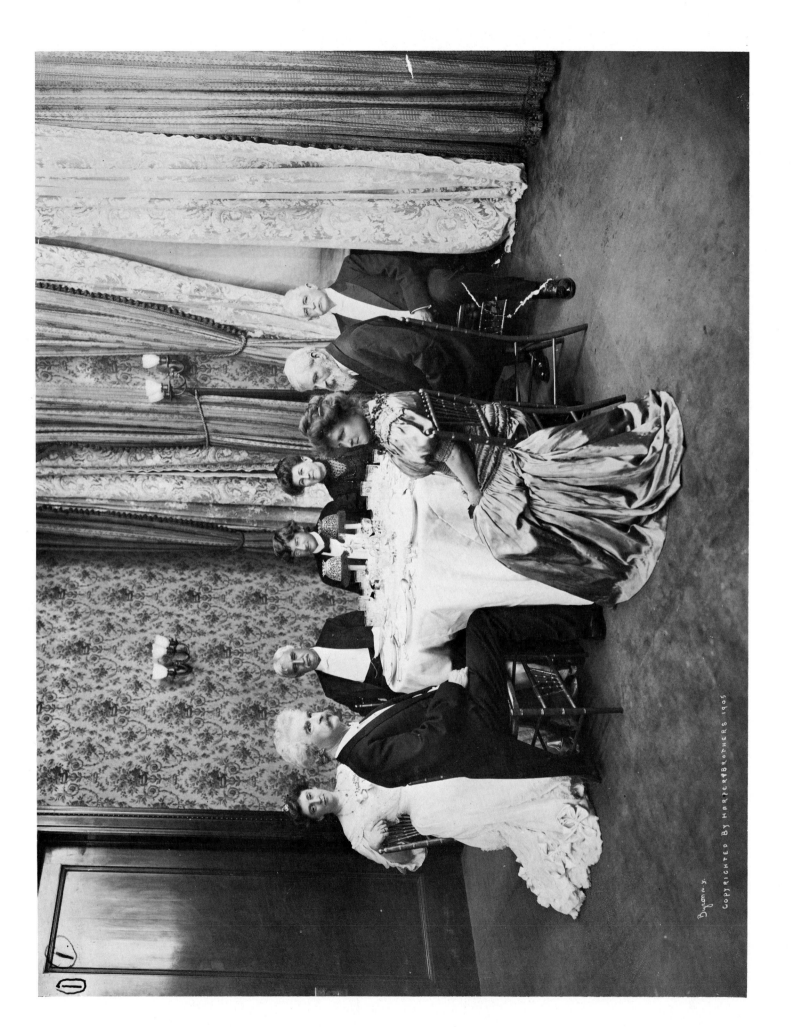

Byron.
COPYRIGHTED BY HARPER & BROTHERS 1905

42. The Mark Twain Dinner, Delmonico's Restaurant, 1905.
43. BELOW: The Kitchen, Delmonico's Restaurant, 1902.

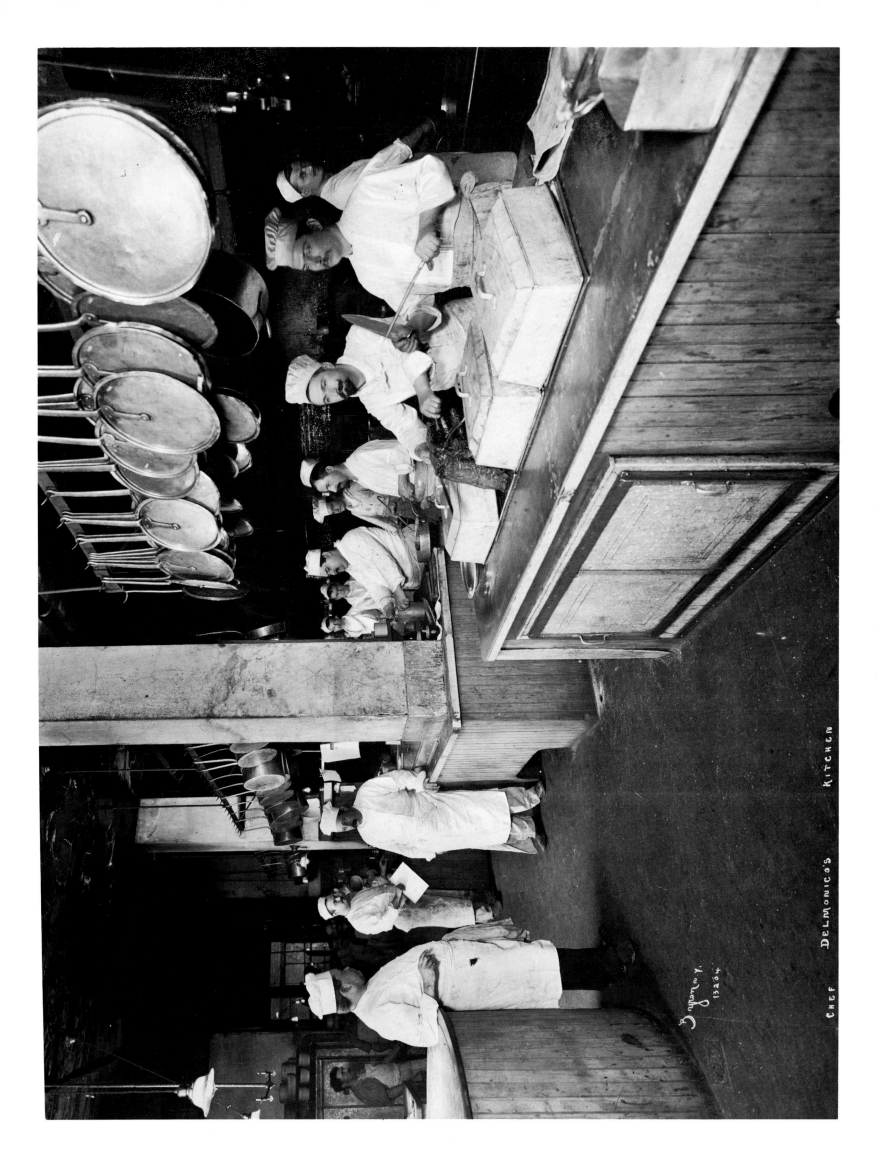

CHEF DELMONICO'S KITCHEN

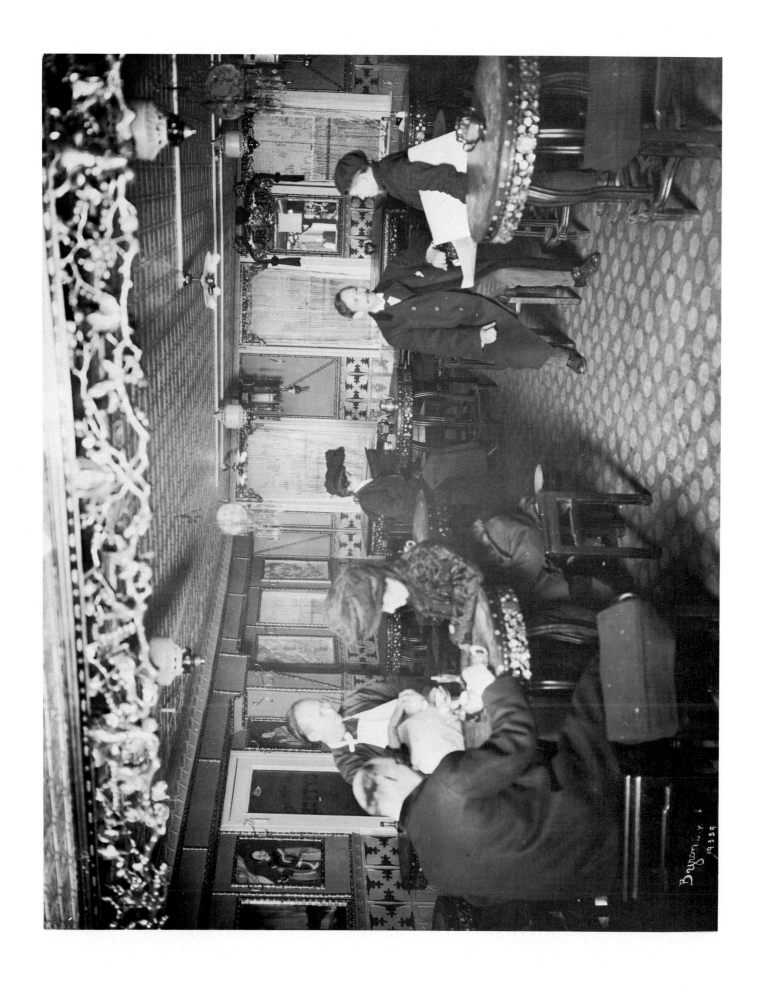

44. "The Chinese Delmonico's," 1905.

45. BELOW: American Theatre Roof Garden, 1898.

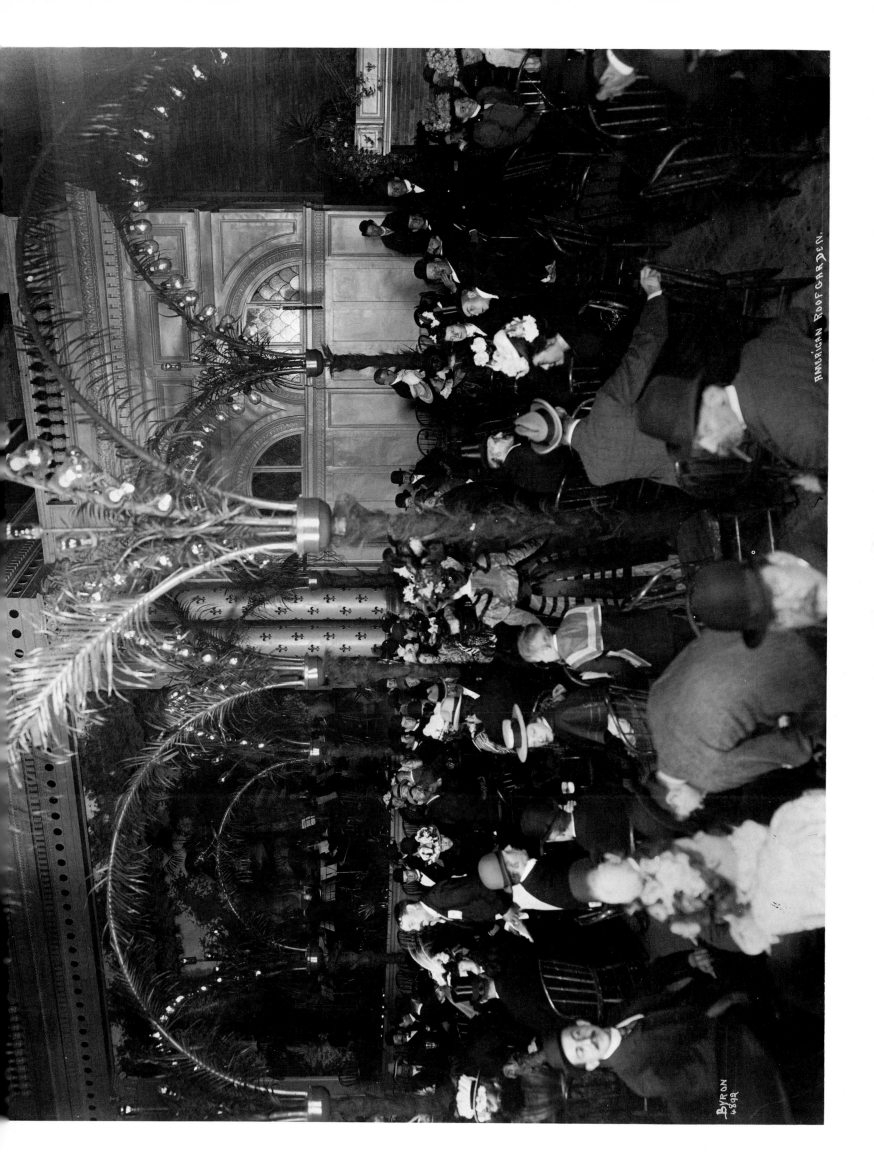

AMERICAN ROOF GARDEN.

BYRON
4892

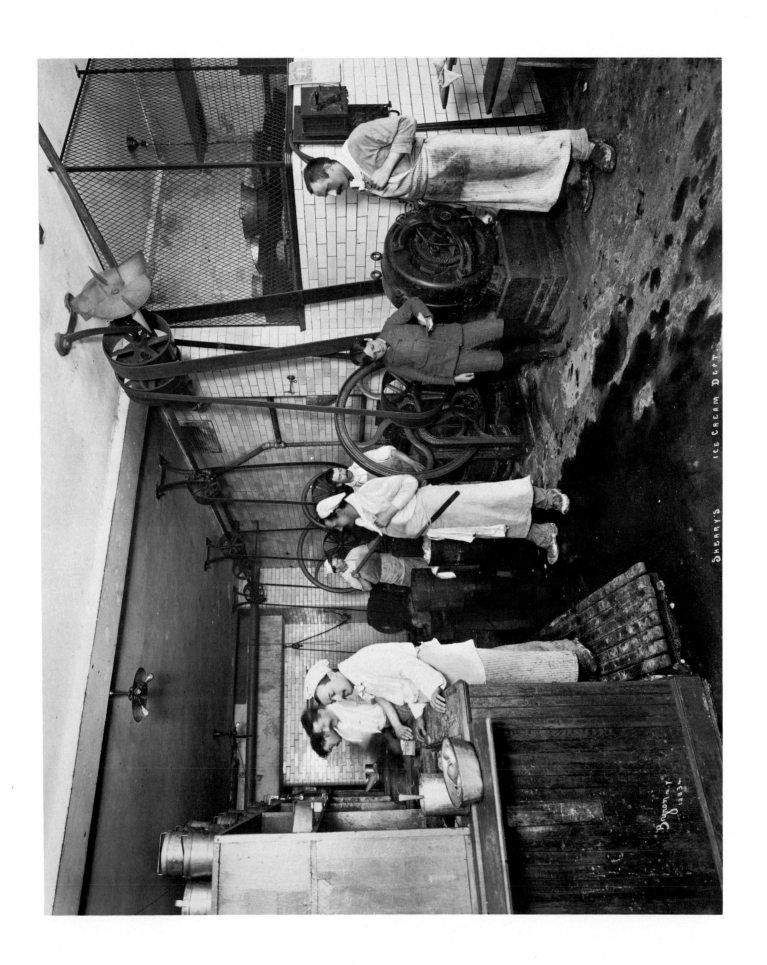

46. Sherry's Restaurant, 1902.
47. BELOW: Hotel Astor, 1904.

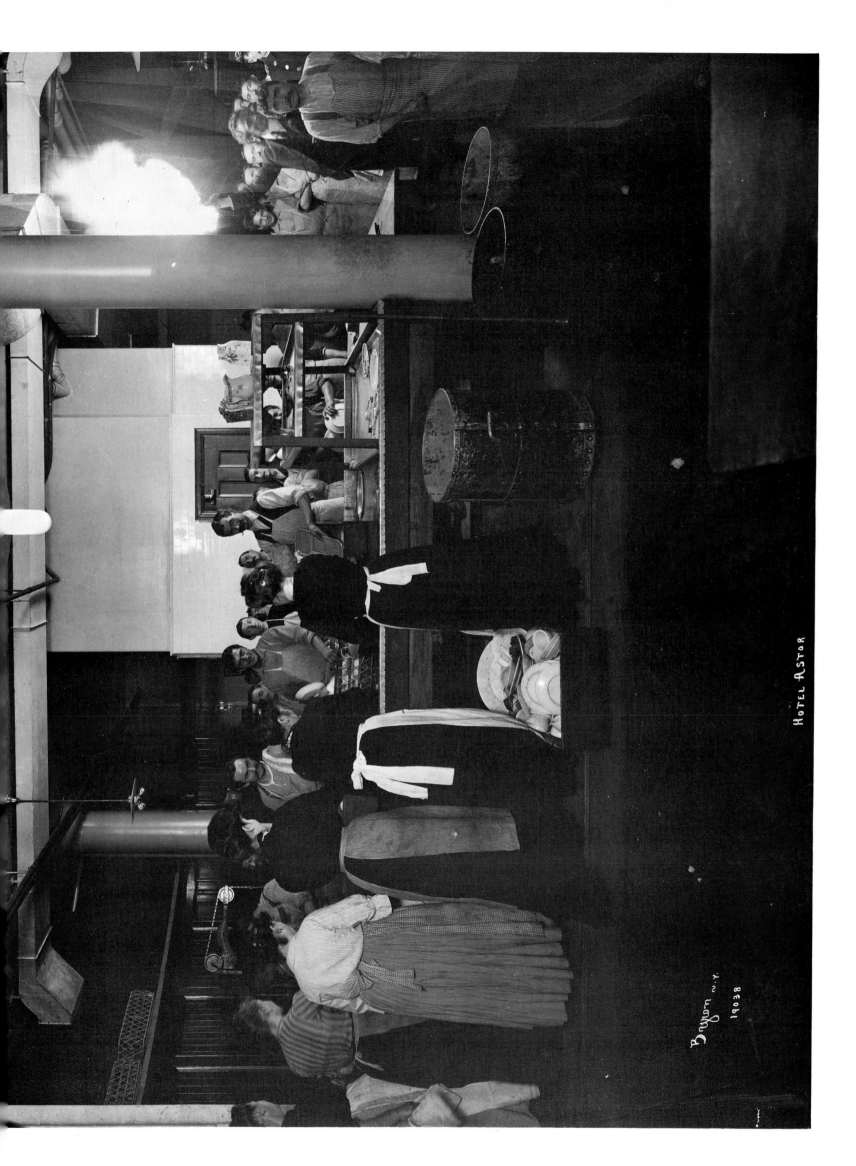

Bryson N.Y.
19038

HOTEL ASTOR

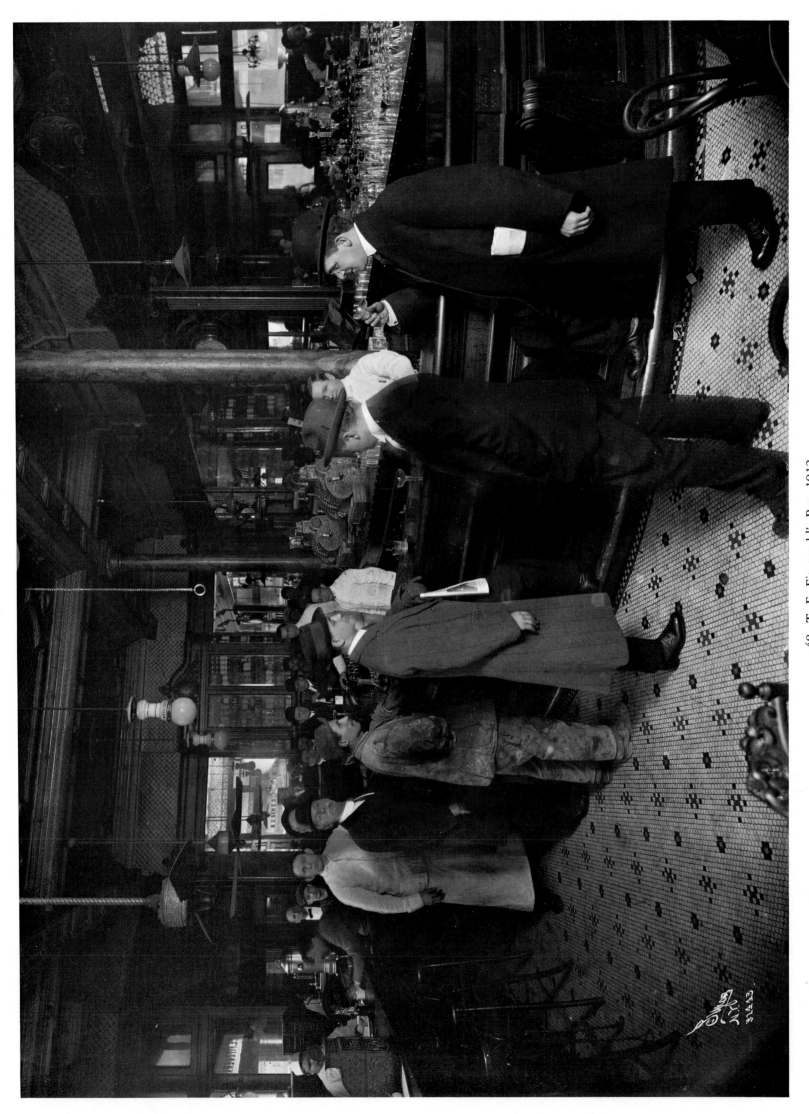

48. T. E. Fitzgerald's Bar, 1912.

49. Spanish Restaurant, 1904.

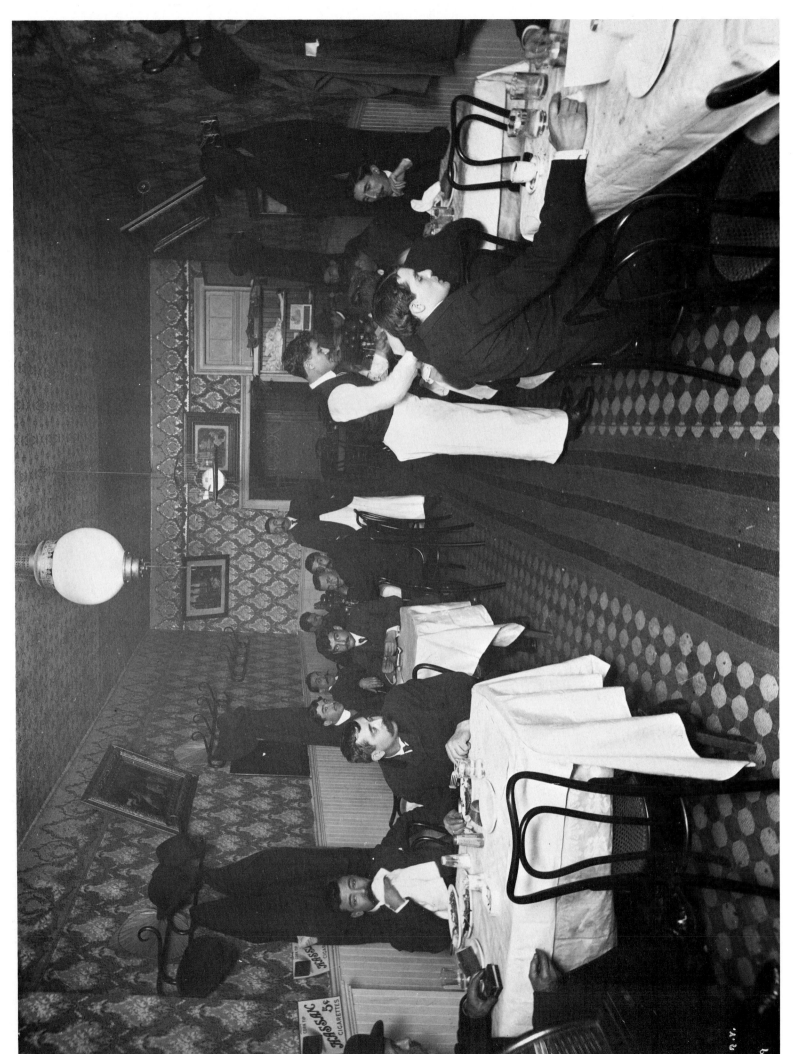

50. Greek Restaurant, The Bowery, 1904.

51. "Harrison Grey Fiske Dinner," Winter, 1900–01.

52. Bridge Party, 1901.

53. Children's Party, 1906.

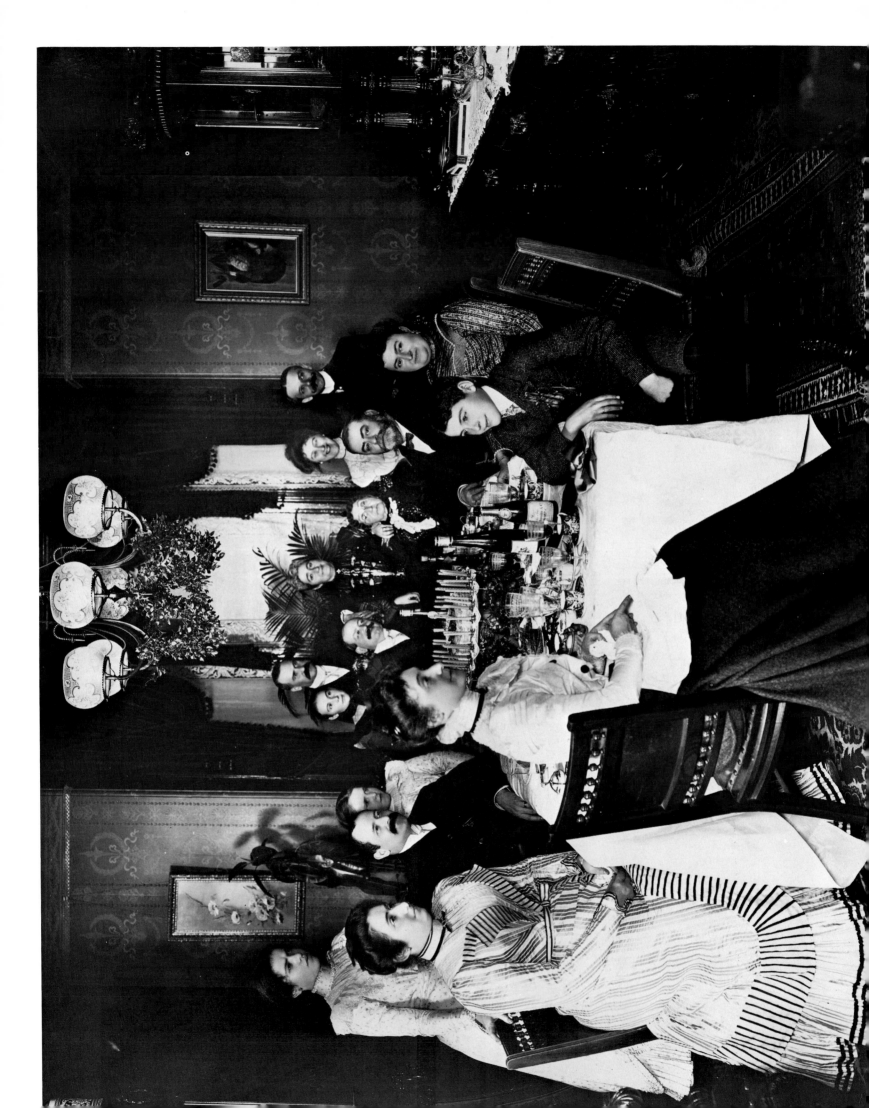

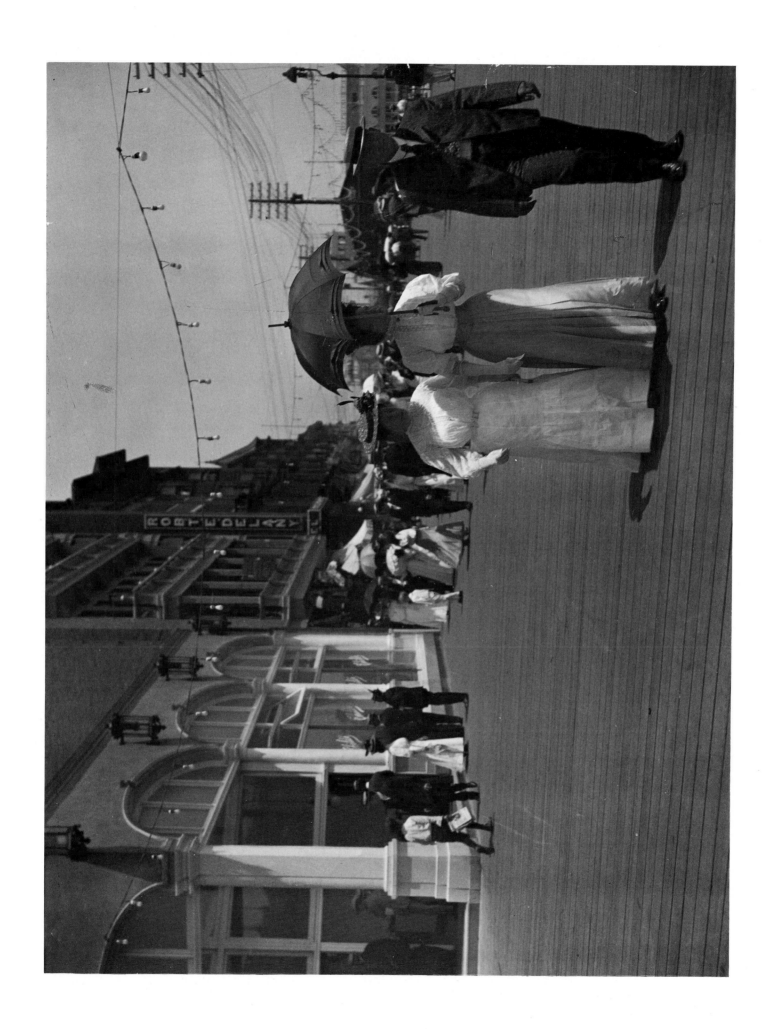

54. ABOVE: Birthday Party, 1897.

55. The Boardwalk, Coney Island, ca. 1897.

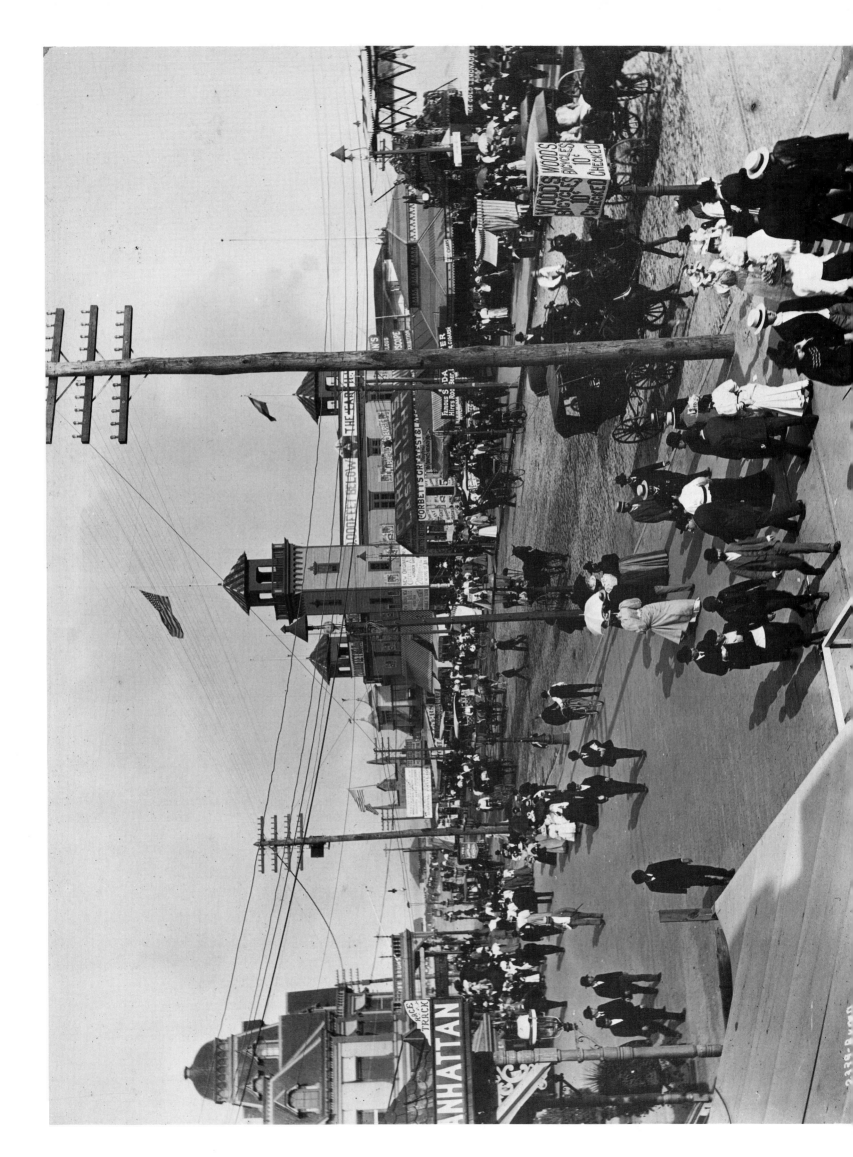

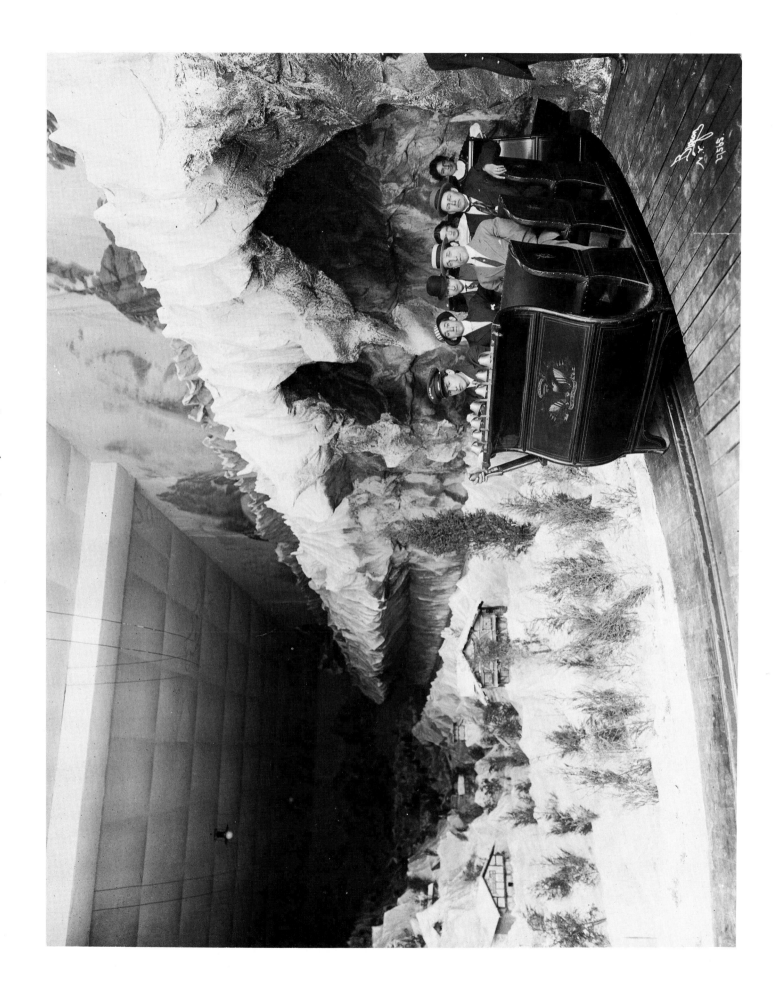

56. ABOVE: Surf Avenue, Coney Island, 1896.
57. Amusement Ride, Coney Island, 1909.

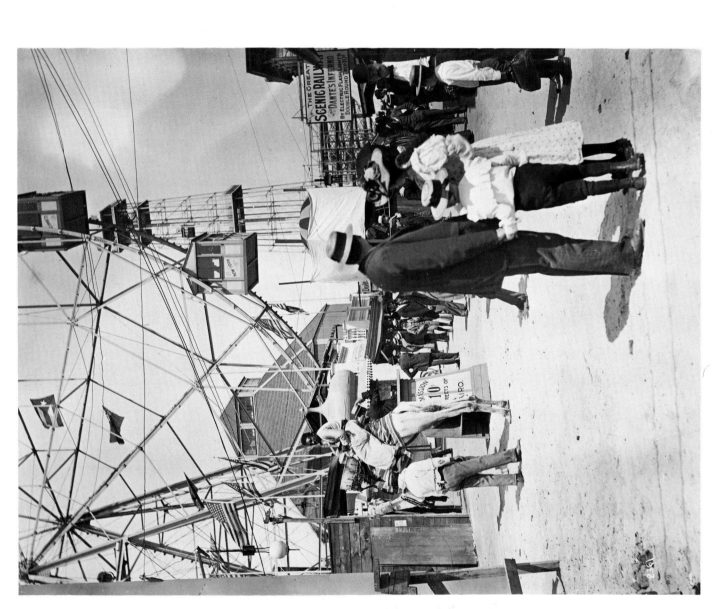

58. LEFT: Ferris Wheel, Coney Island, 1896.
59. BELOW: "Shoot the Chutes," Coney Island, 1896.

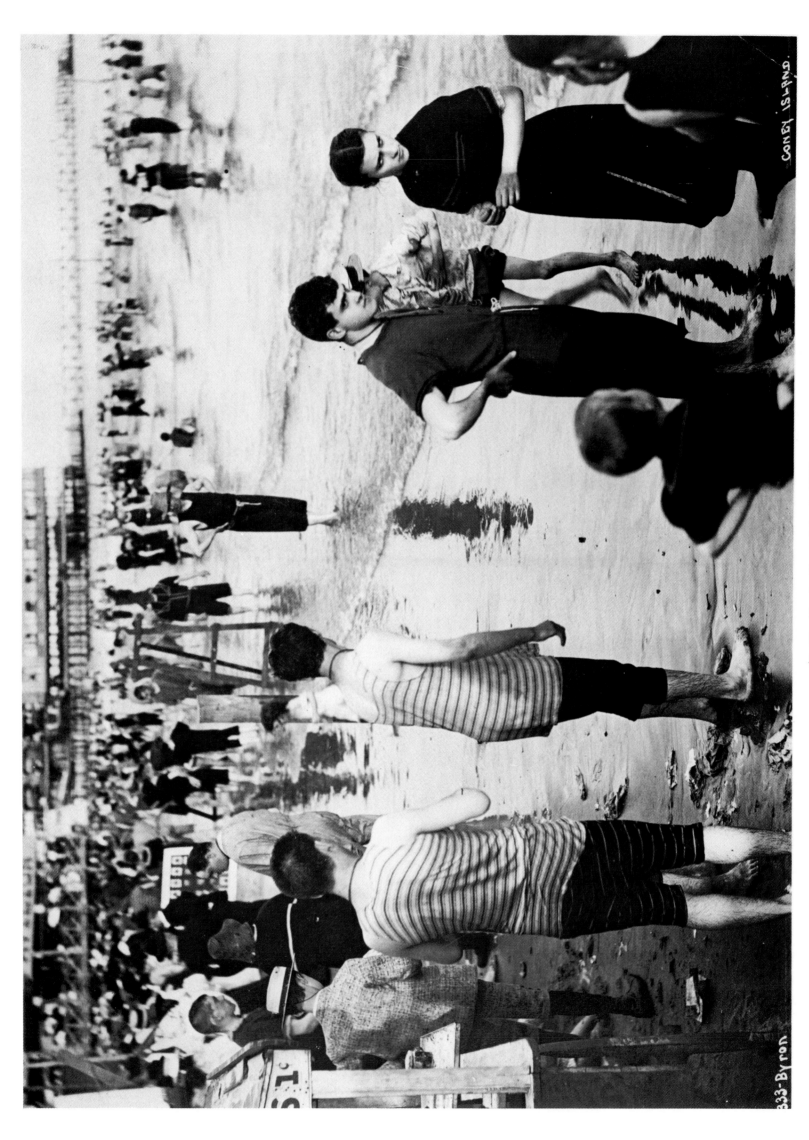

60. The Beach, Coney Island, 1896.

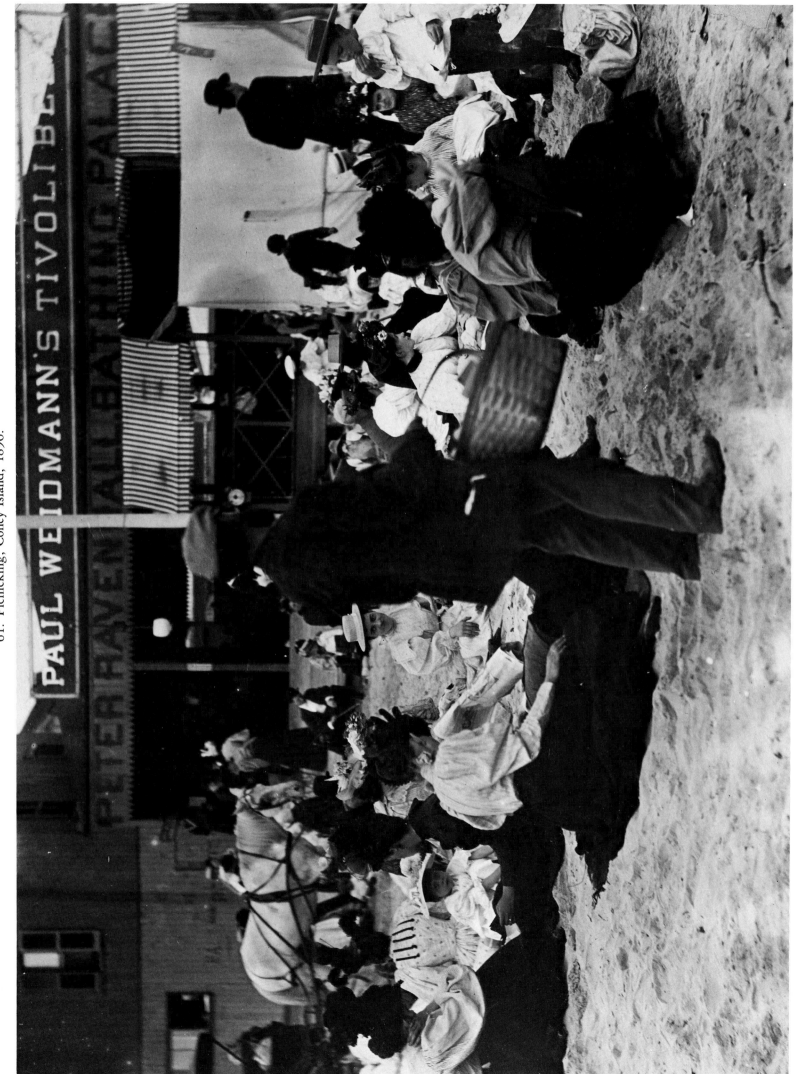

61. Picnicking, Coney Island, 1896.

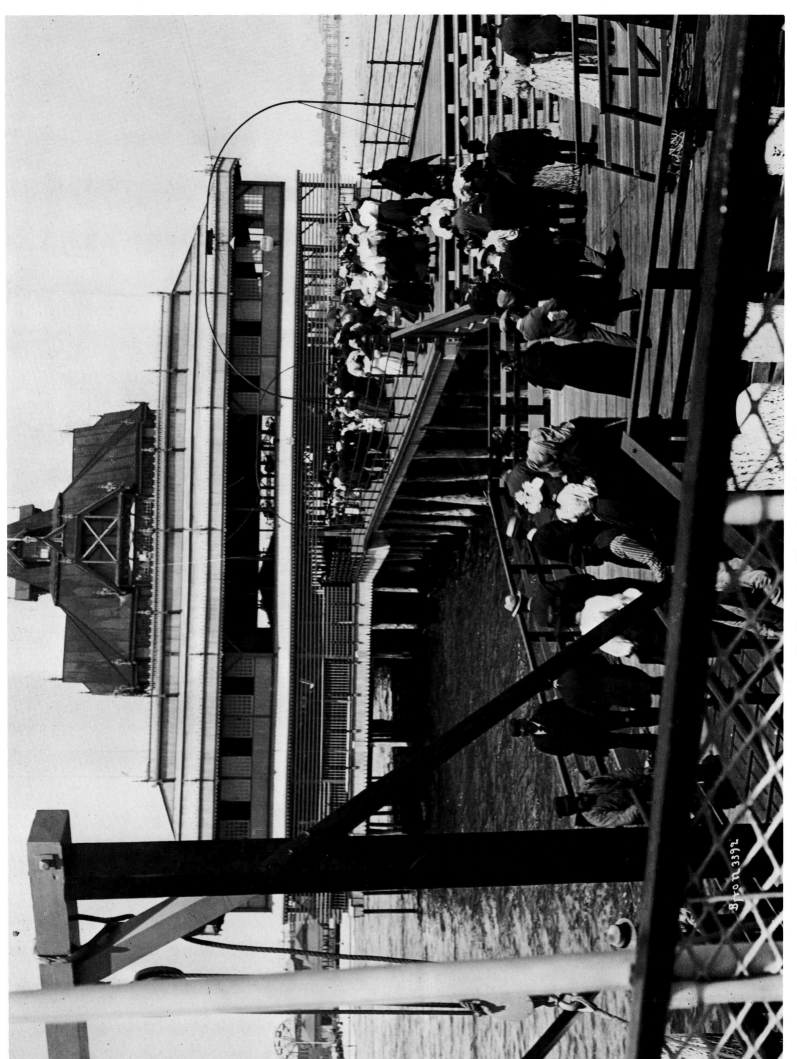

62. Upper Iron Pier, Coney Island, 1897.

63. Manhattan Beach, 1897.

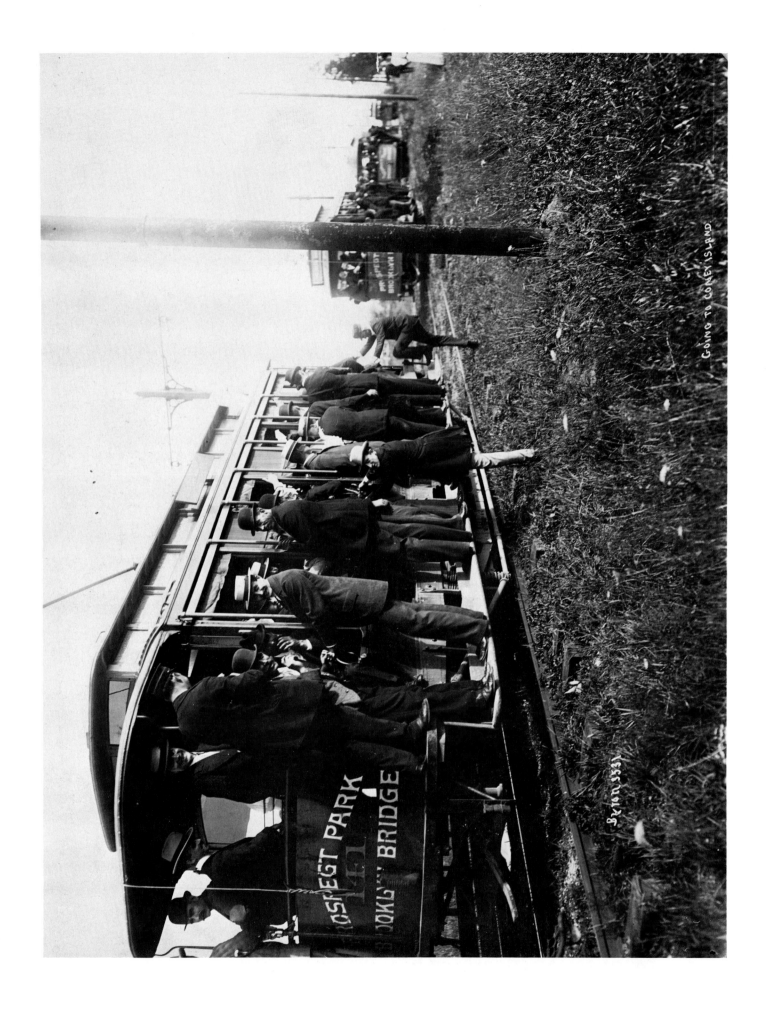

64. Going to the Brighton Beach Racetrack, 1897.

65. Rowing on the Harlem River, 1895.

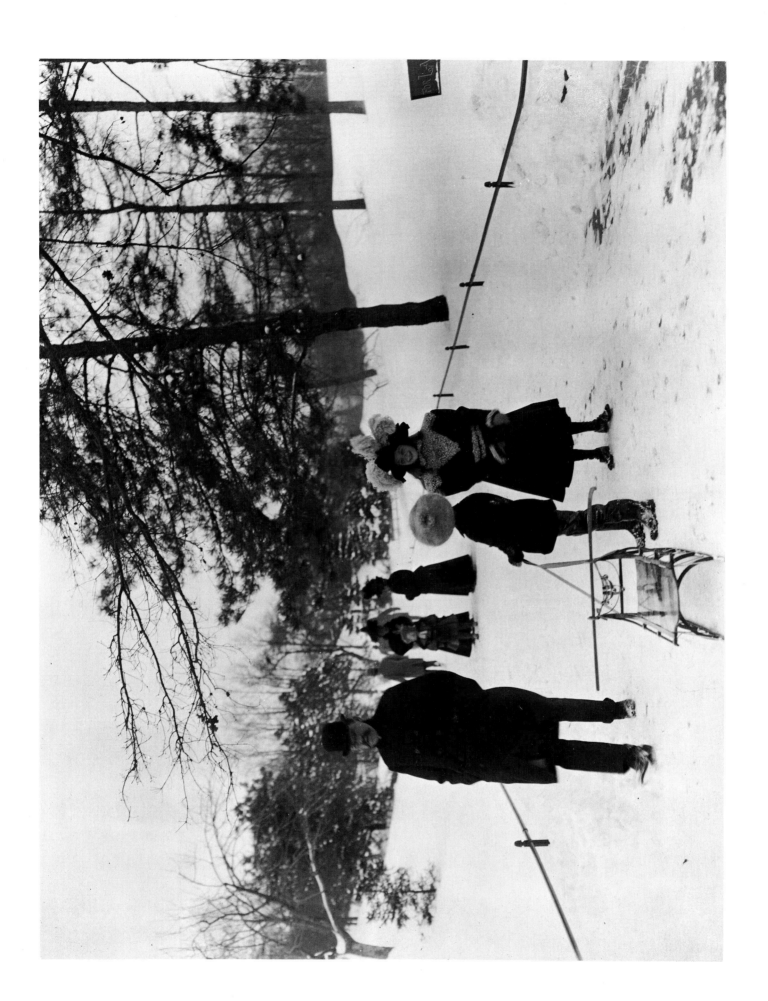

66. Sledding, Central Park, 1898.

67. BELOW: On the Ice, Central Park, 1898.

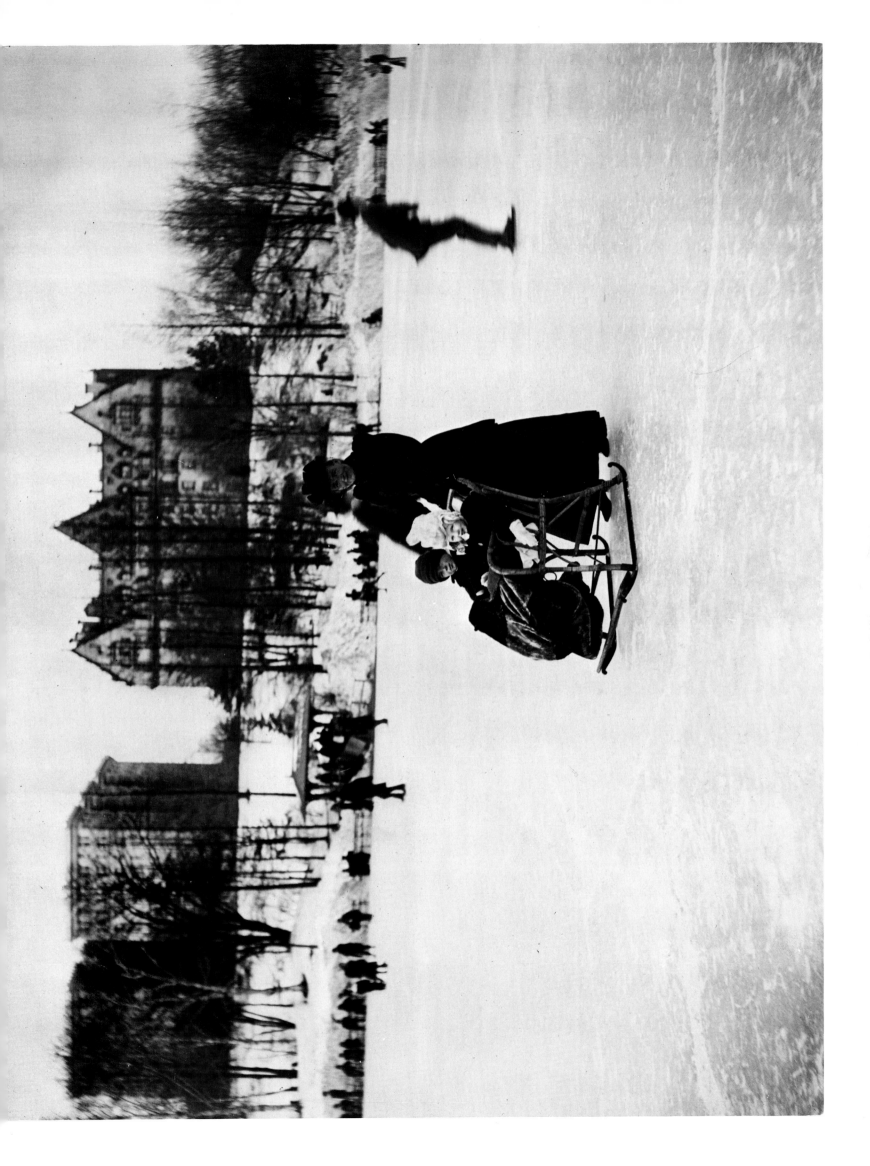

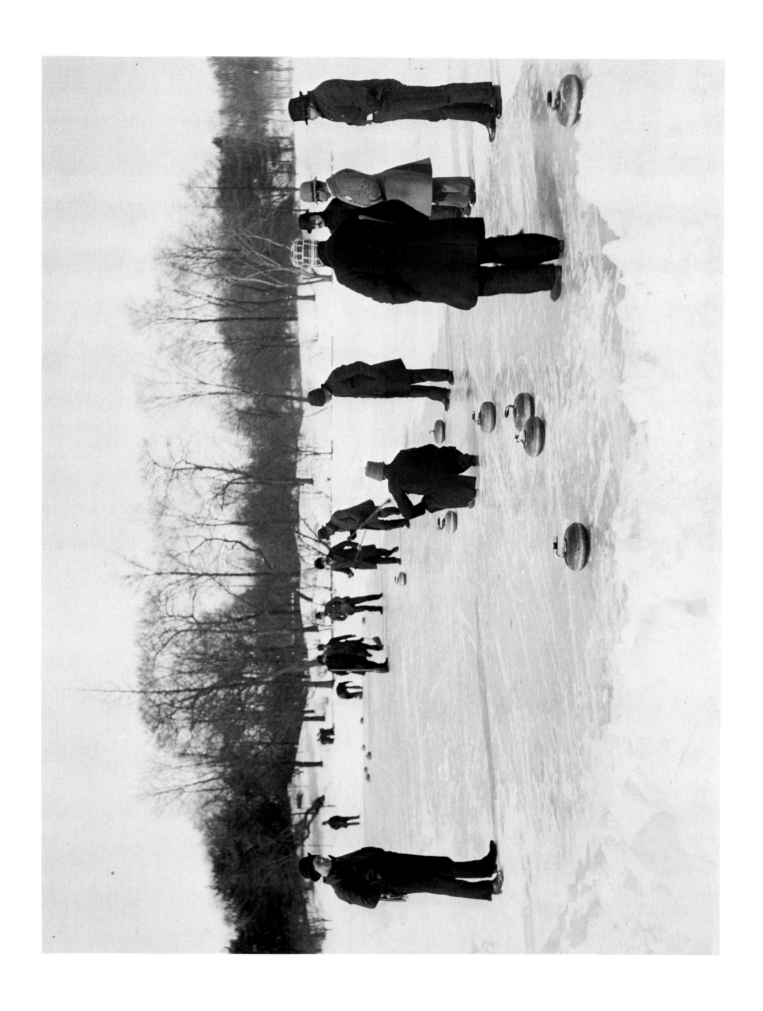

68. Curling, Central Park, 1894.

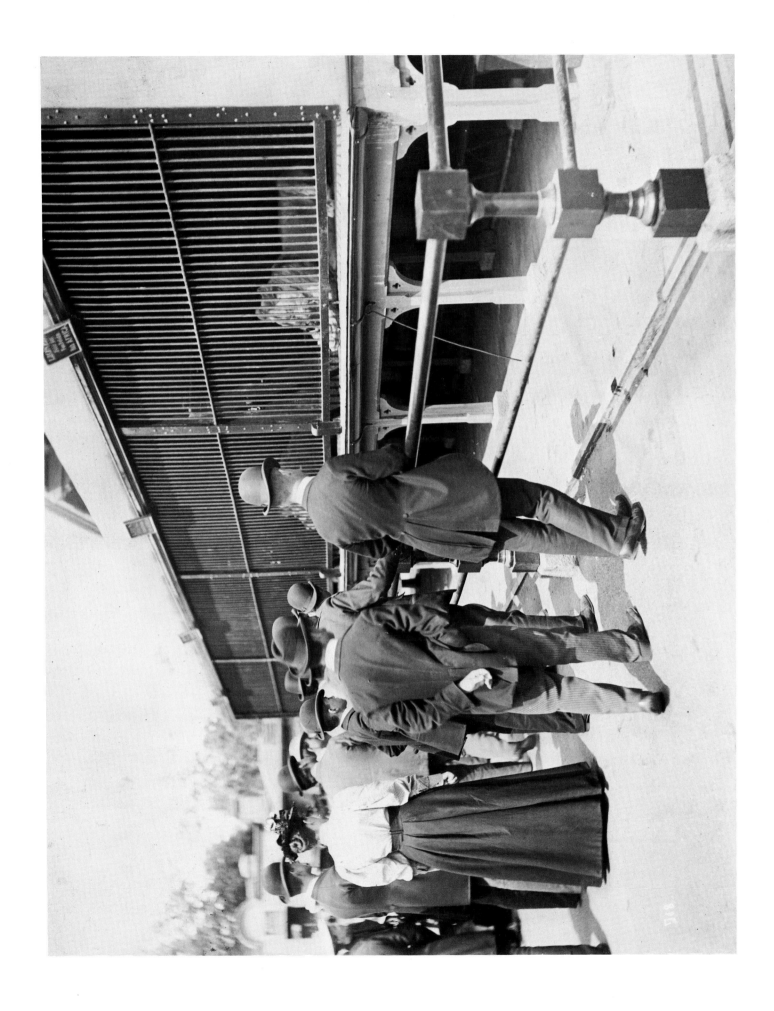

69. The Menagerie, Central Park, 1895.

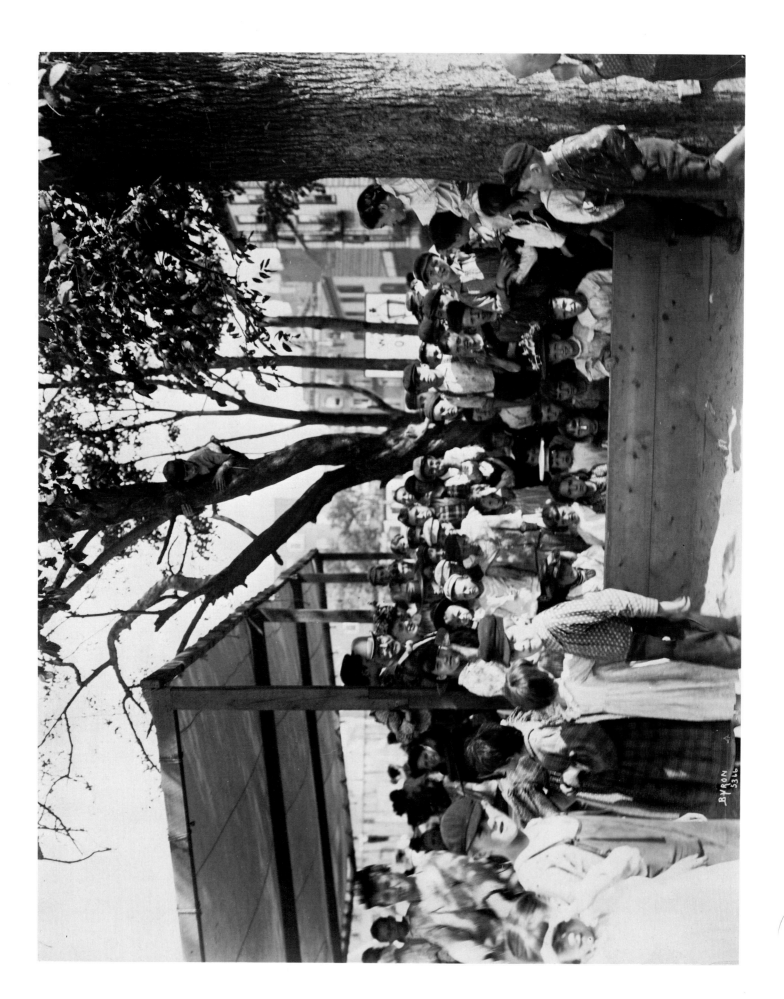

70. Hudsonbank Playground, 1898.

71. BELOW: Tompkins Square Park, May 6, 1904.

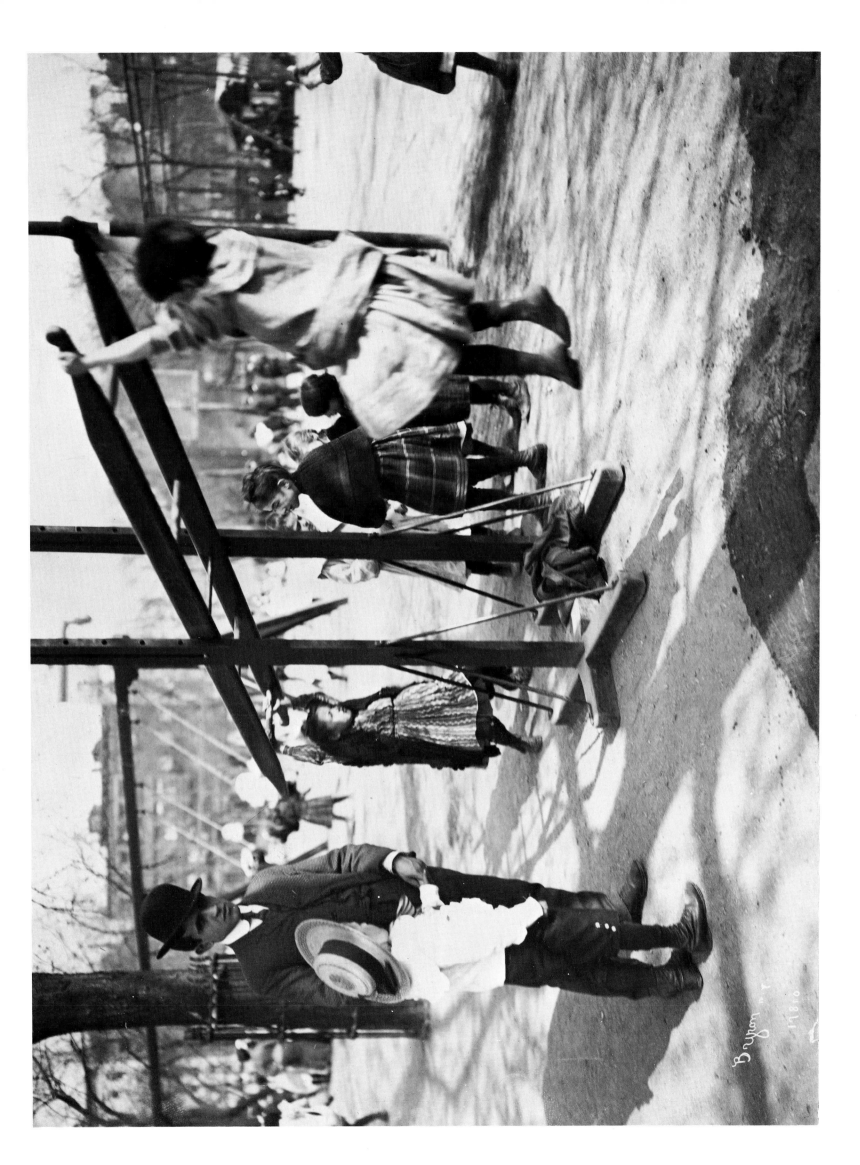

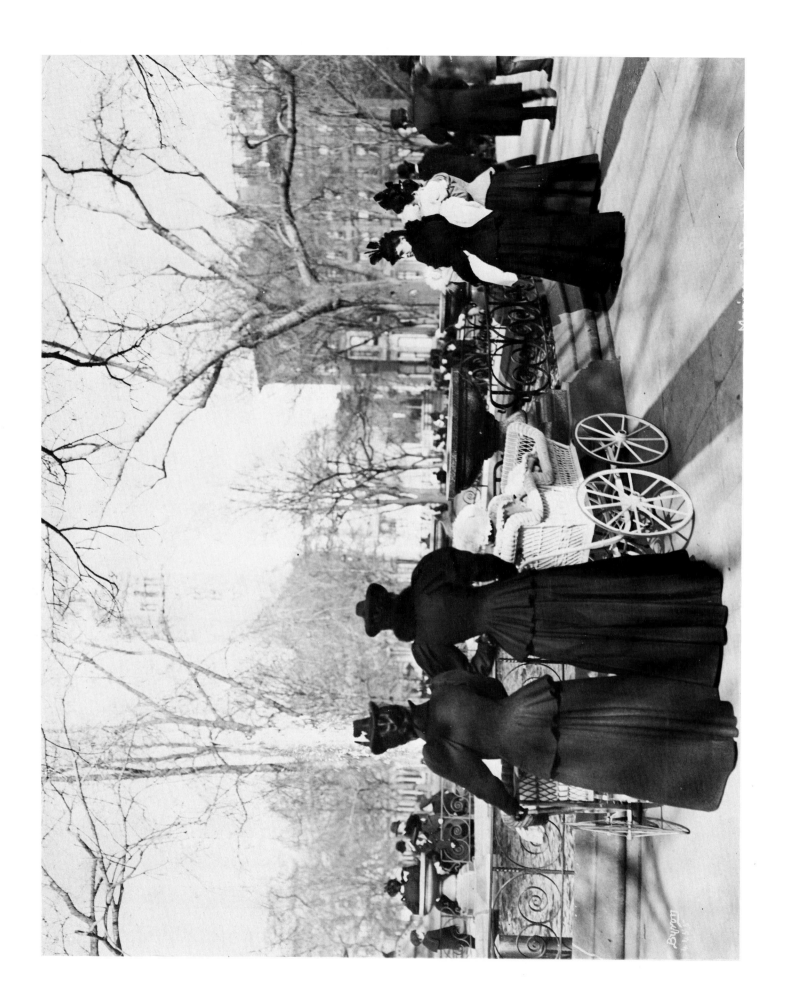

72. Madison Square Park, 1898.

73. BELOW: Madison Square Park, ca. 1901.

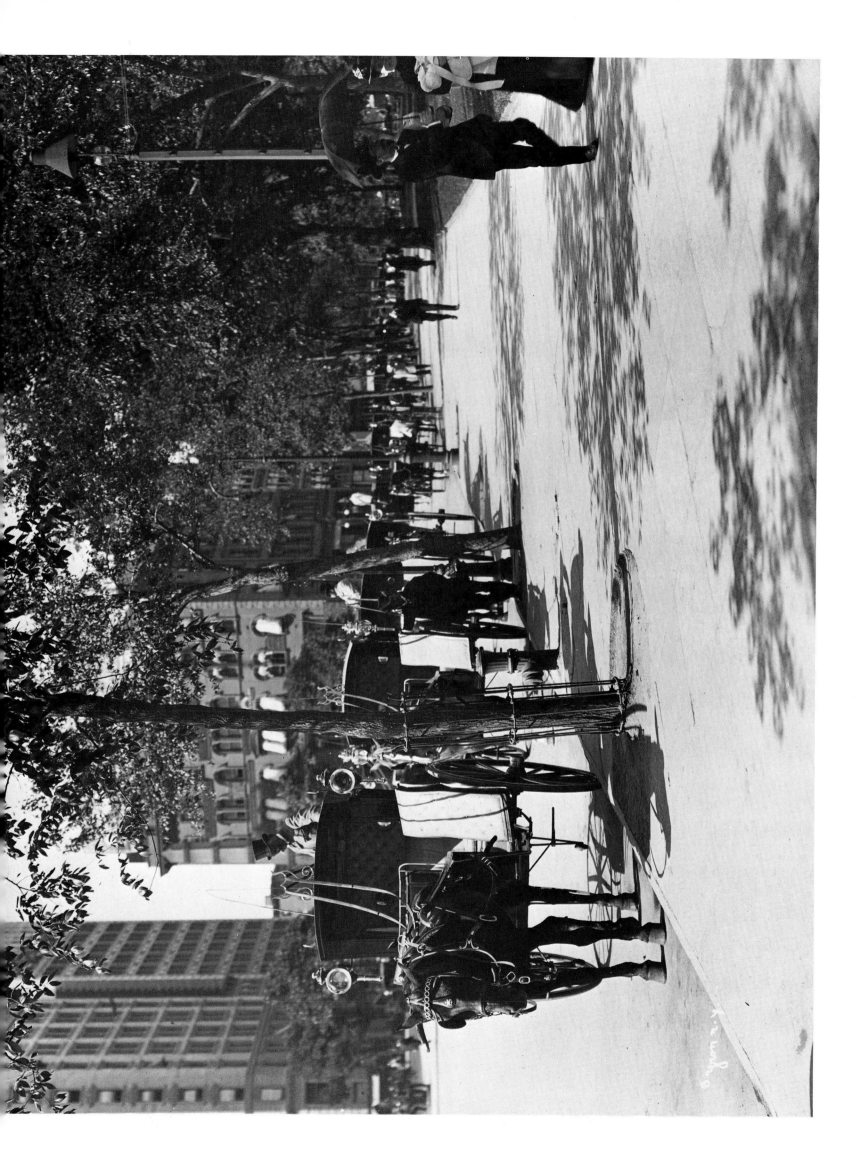

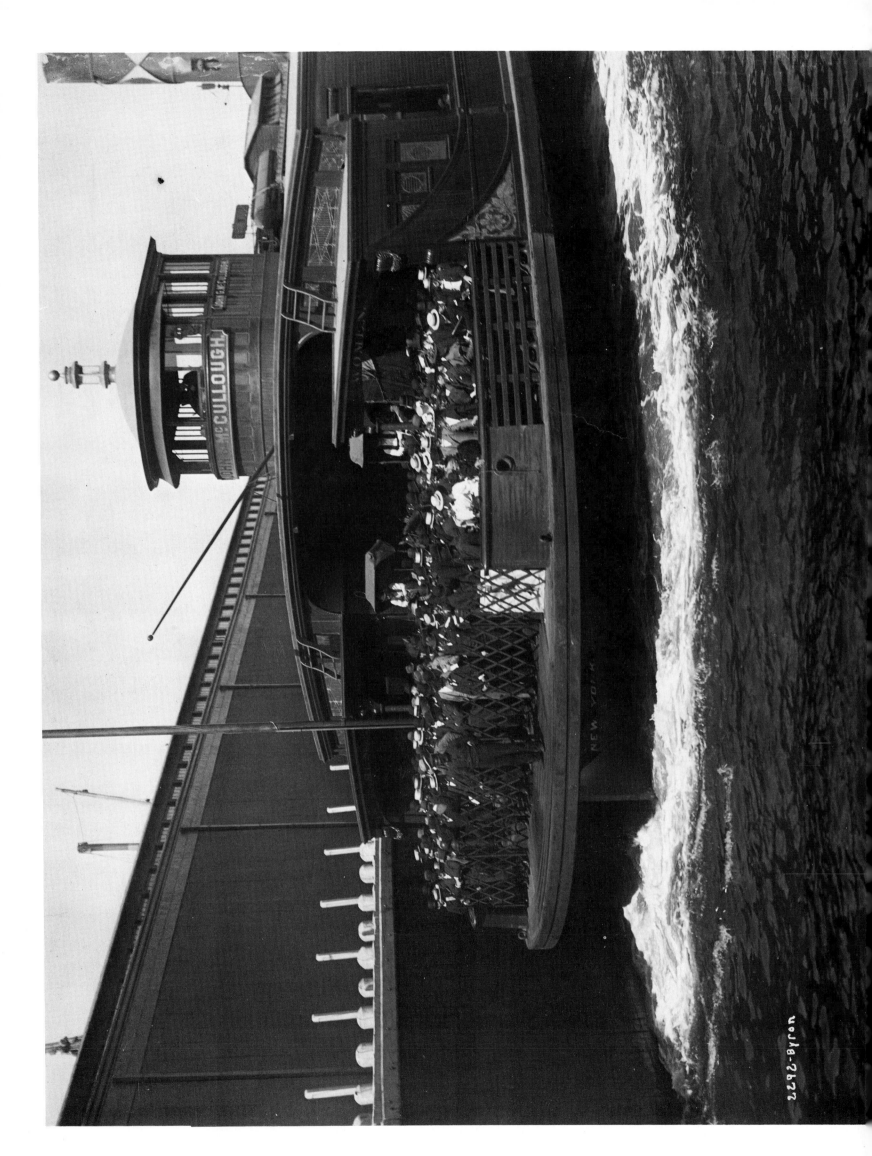

74. ABOVE: Ferryboat *John G. McCullough*, 1896.

75. Pavonia Ferry, 1896.

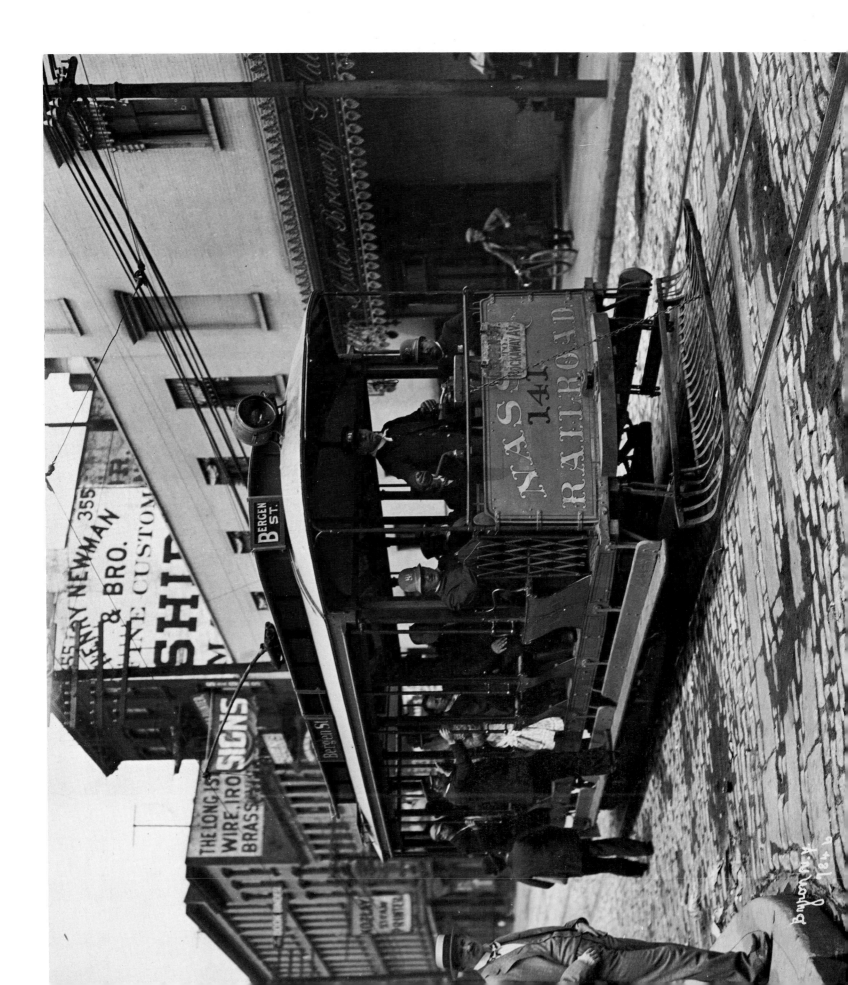

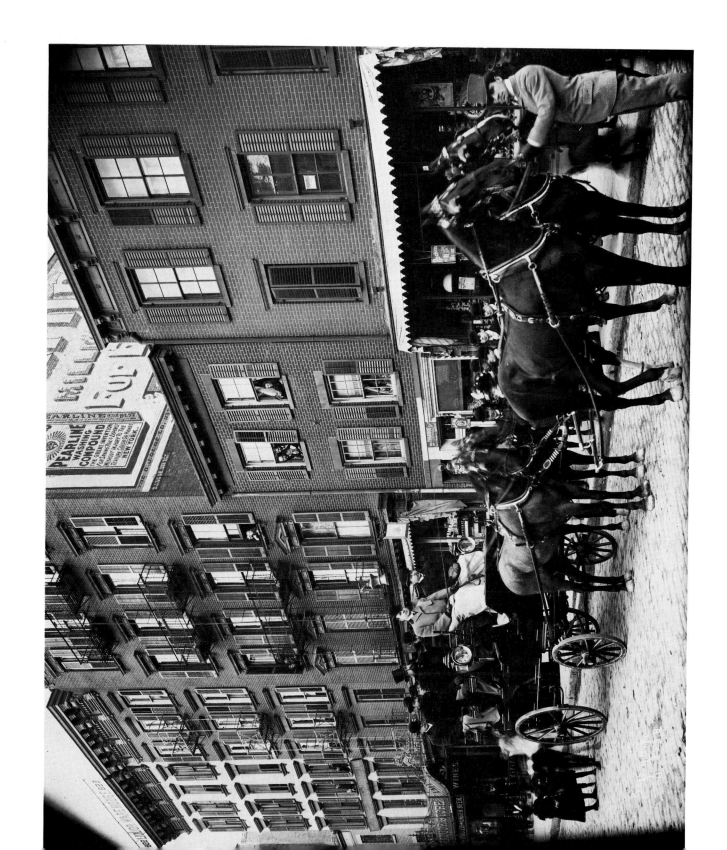

76. ABOVE: Brooklyn Trolley Strike, 1899.
77. Coach in the City Beautiful Campaign, 1900.

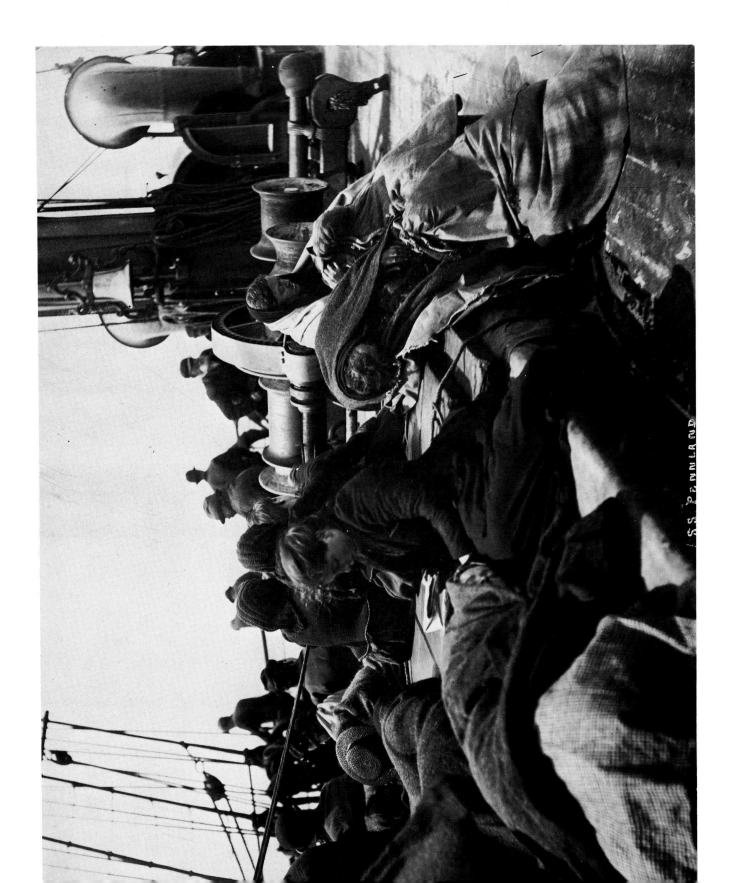

78. Steerage on the S.S. *Pennland*, 1893.

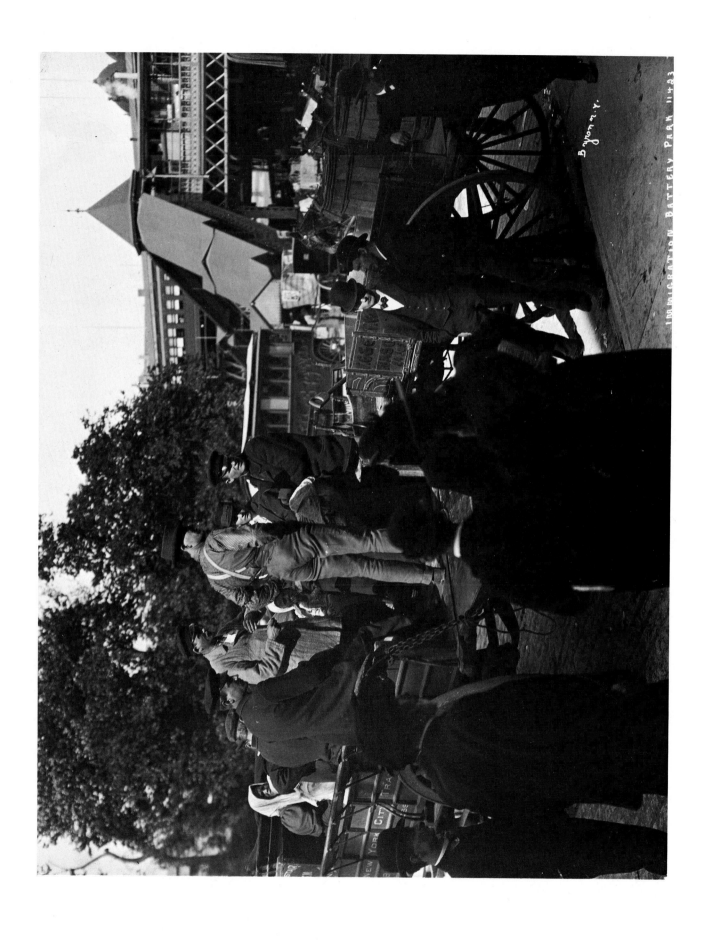

79. Immigrants at Battery Park, 1901.

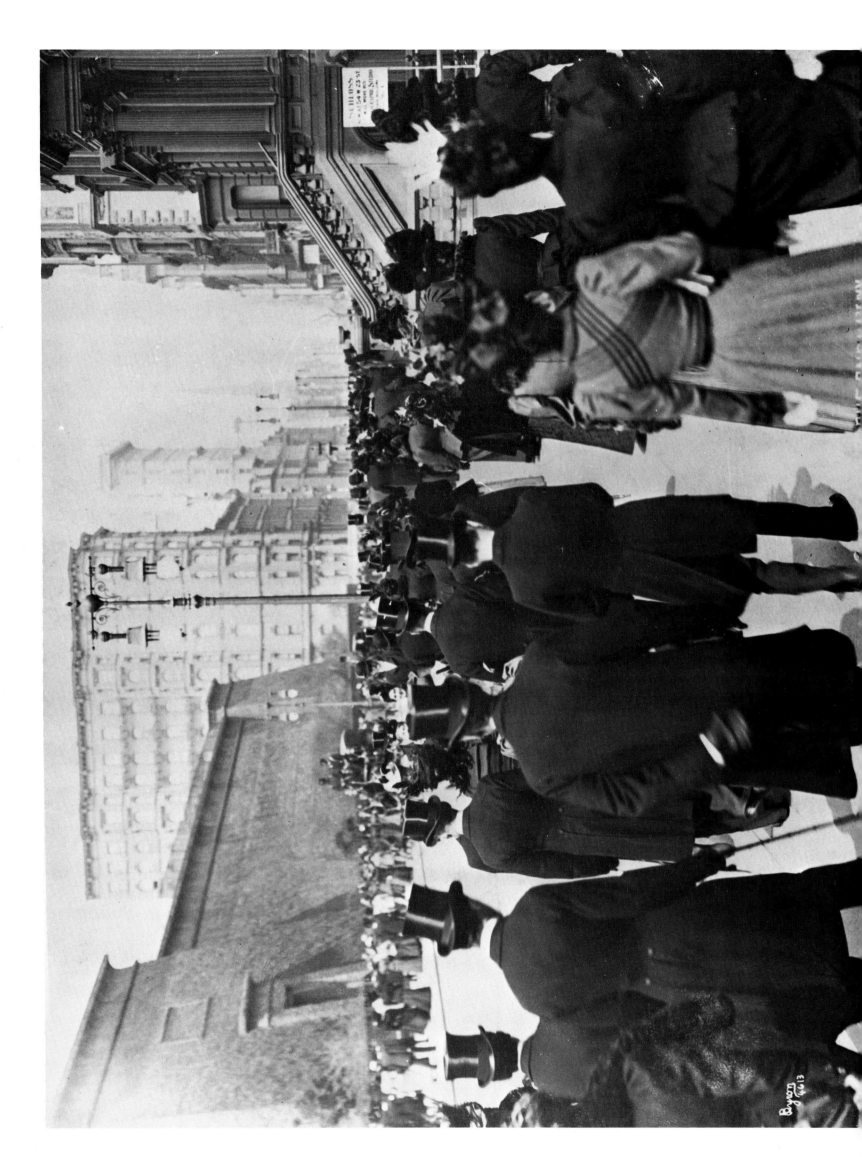

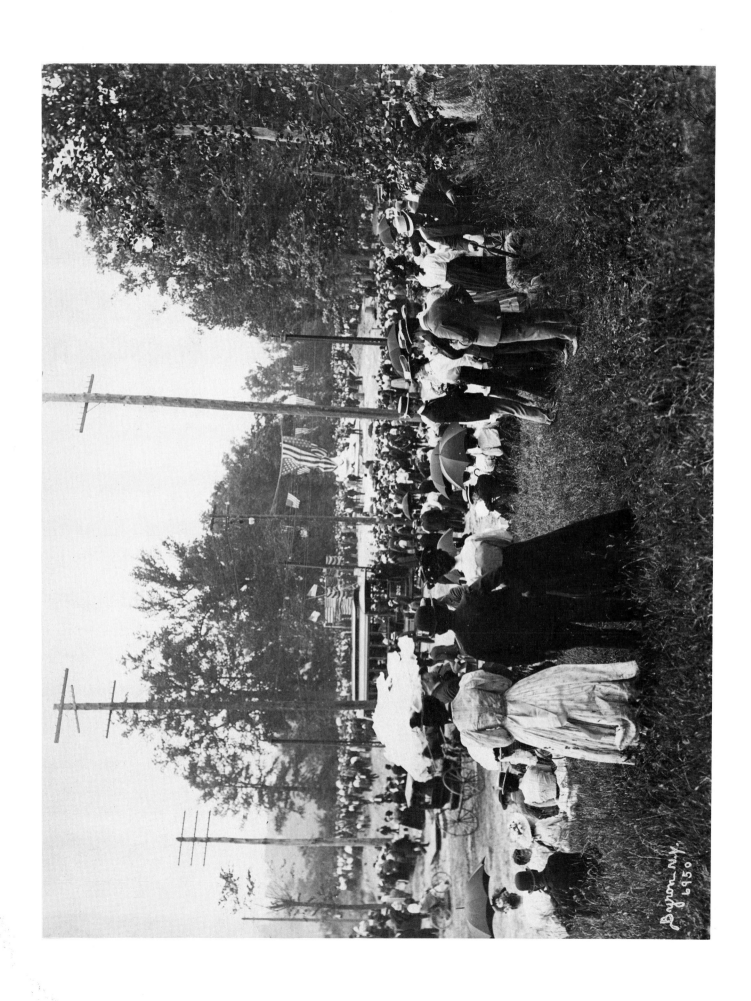

80. ABOVE: Easter Parade, Fifth Avenue, 1898.

81. Unveiling of the Lorelei Fountain, July 8, 1899.

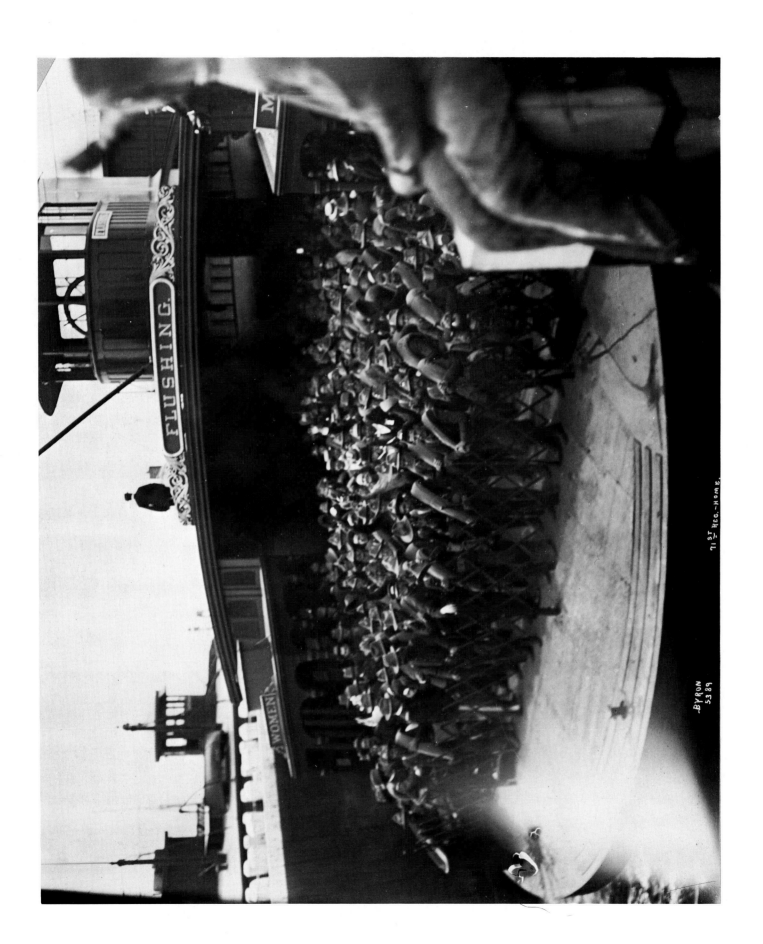

82. Return of the 71st Regiment, August 29, 1898.
83. BELOW: The Dewey Parade, 1899.

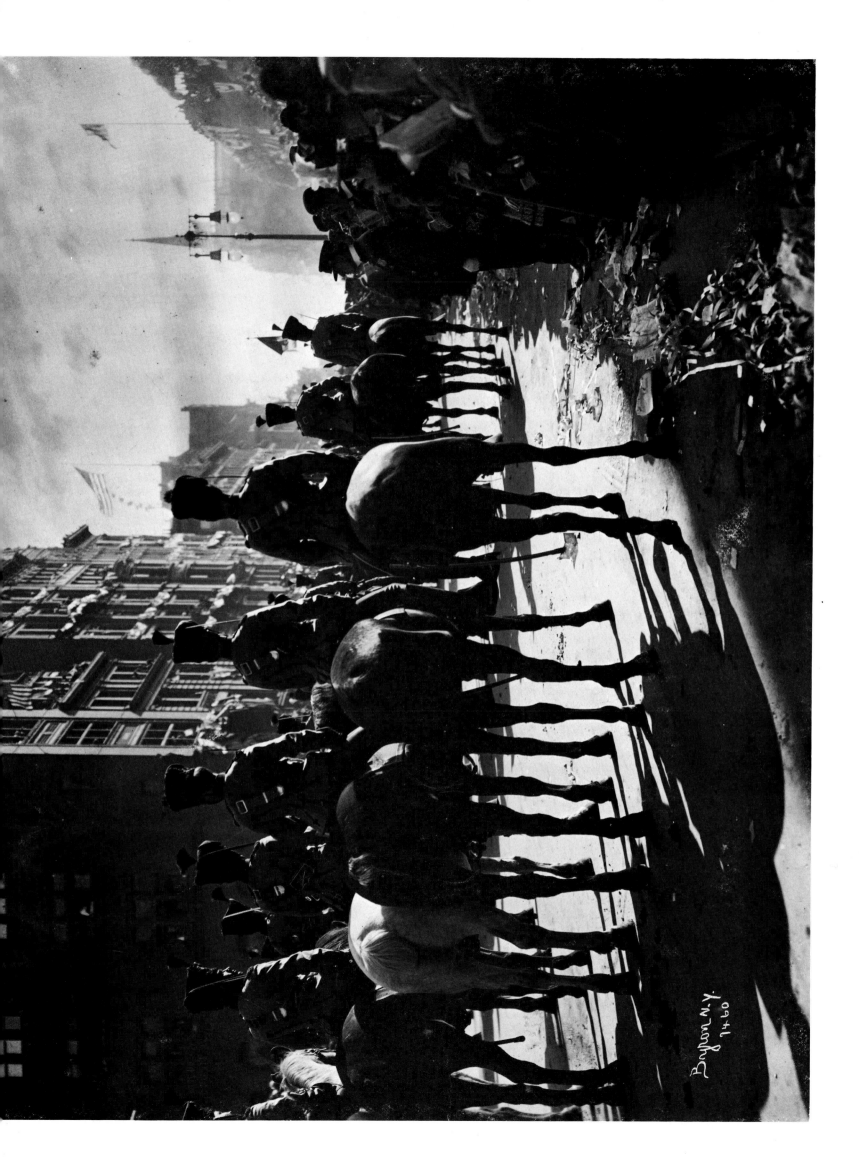

Byron N.Y.
1460

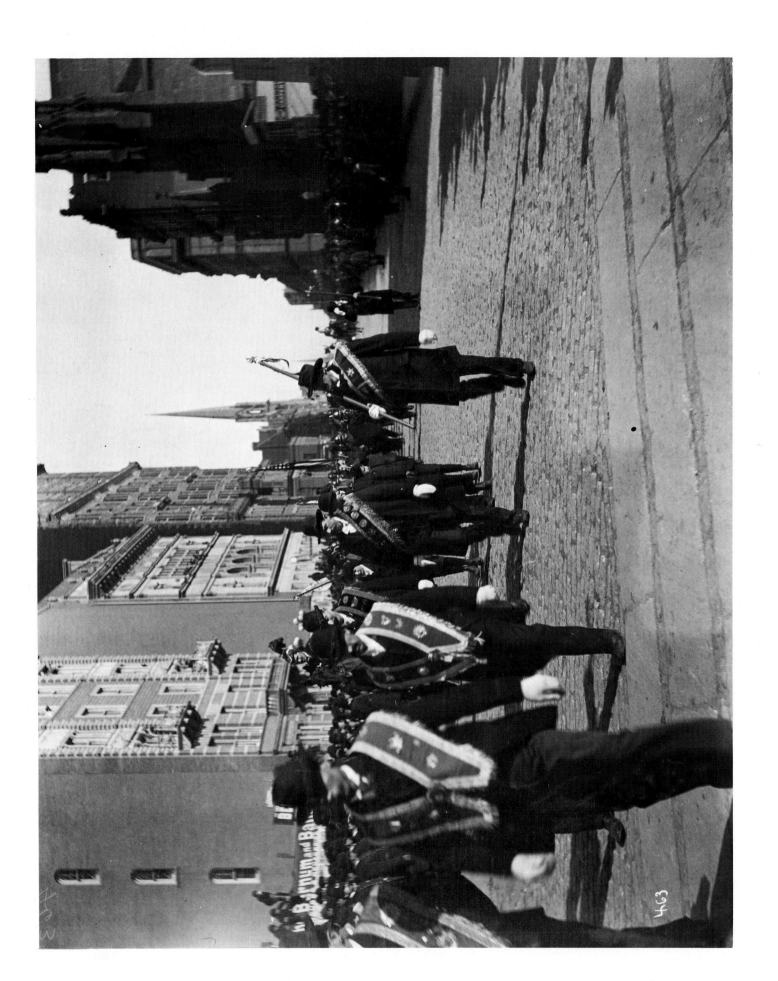

84. St. Patrick's Day Parade, March 18, 1895.
85. BELOW: Police Parade, 1898.

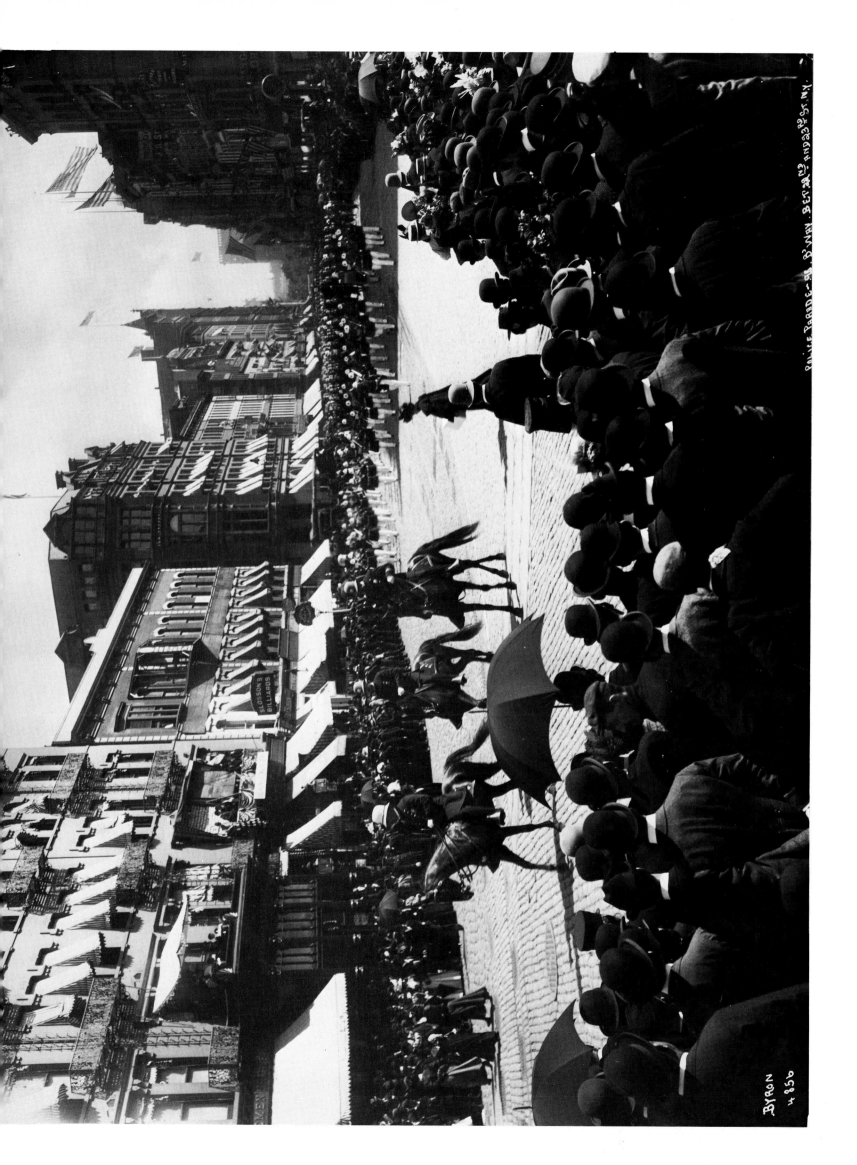

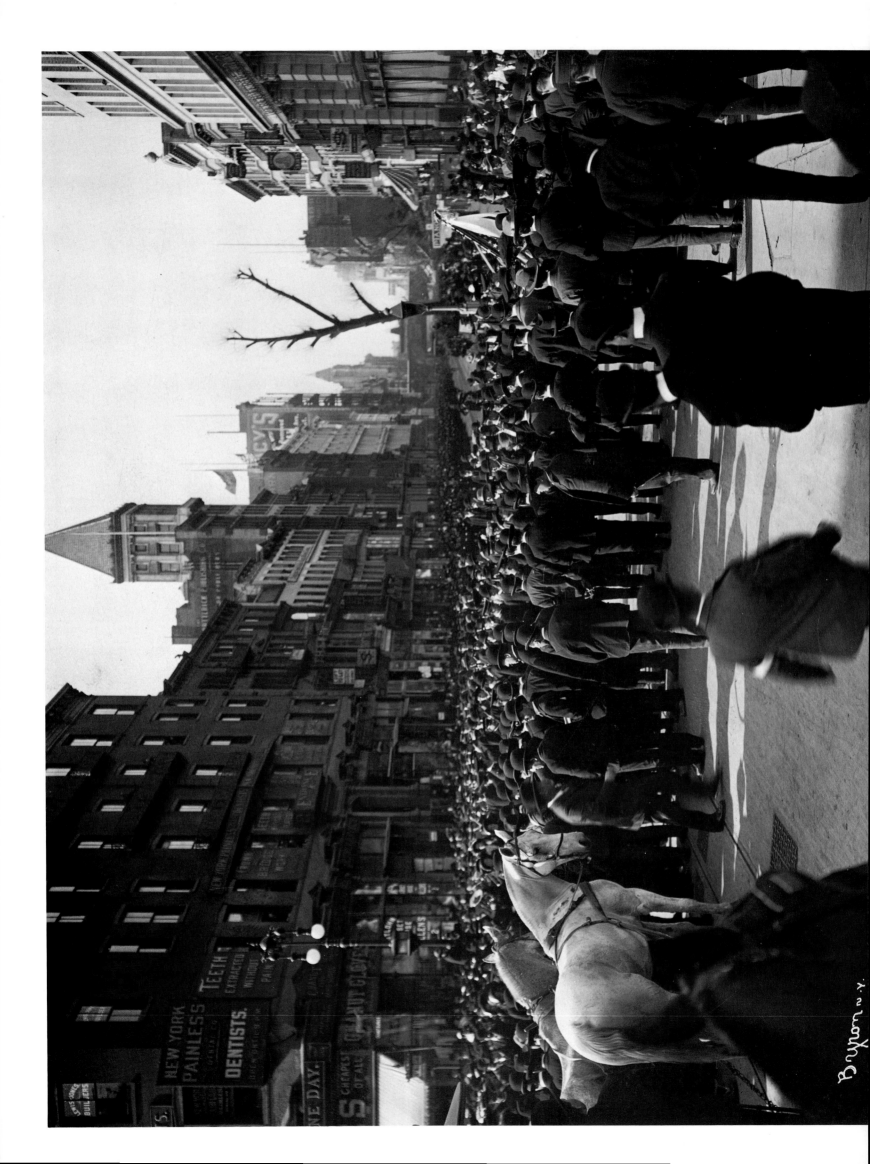

Byron n.y.

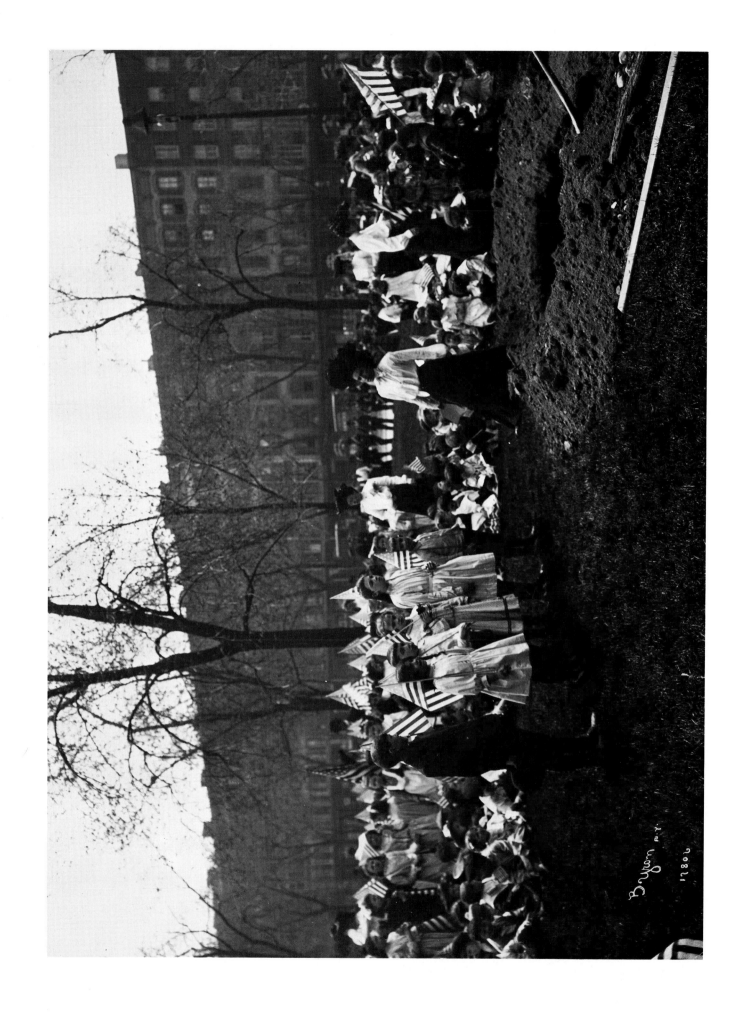

86. ABOVE: Funeral Procession, Fifth Avenue and 14th Street, 1903.

87. Arbor Day, May 6, 1904.

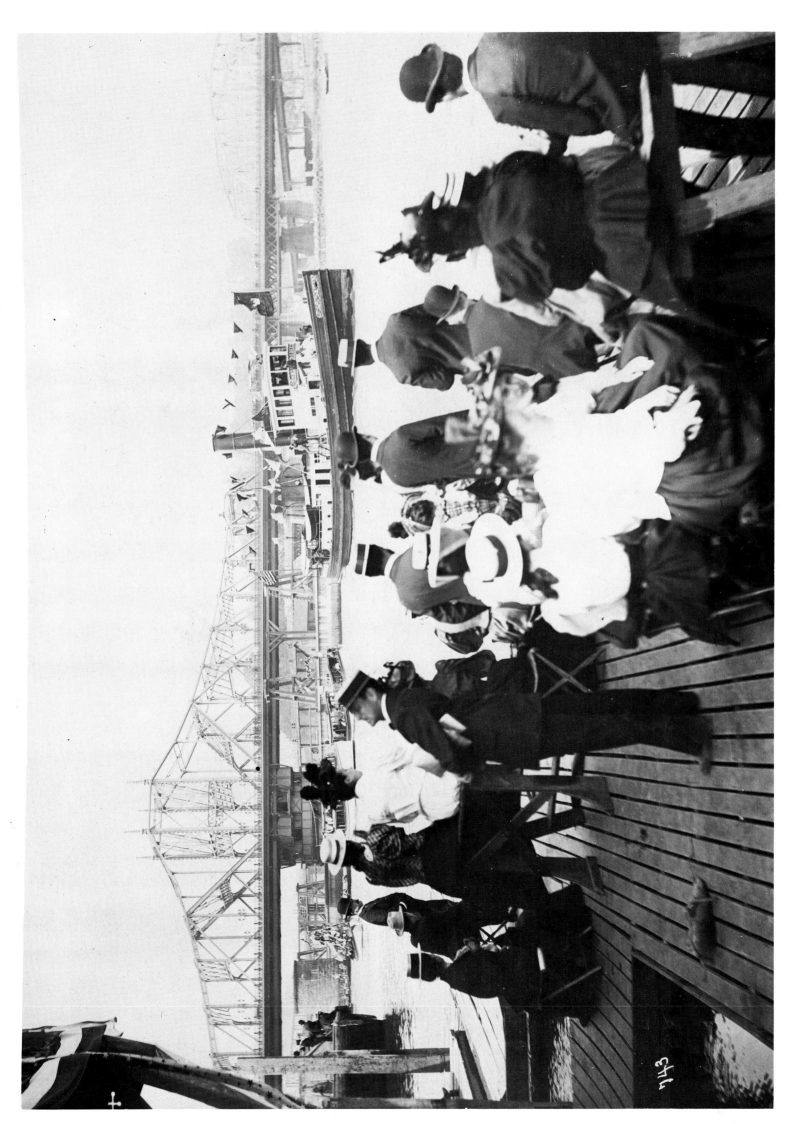

88. Opening of the Harlem Ship Canal, June 17, 1895.
89. BELOW: New York–Paris Auto Race, February 12, 1908.

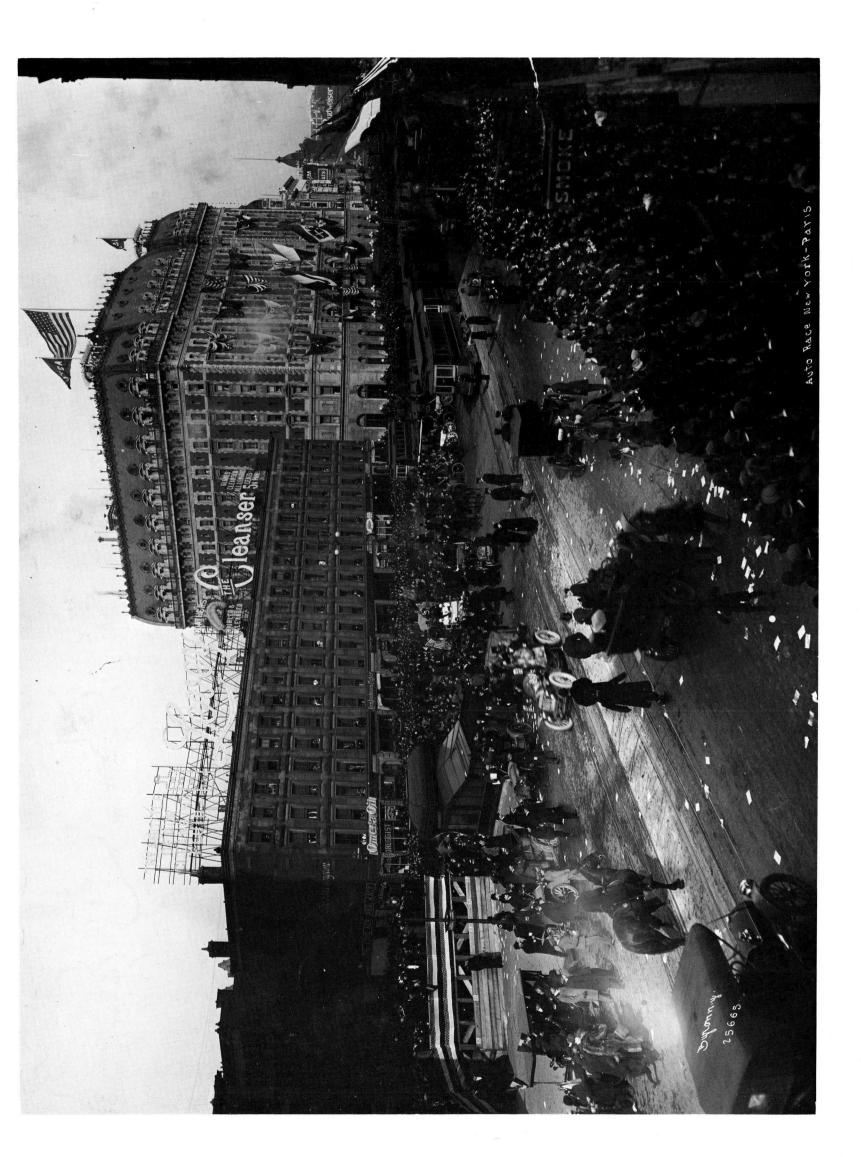

Auto Race New York–Paris.

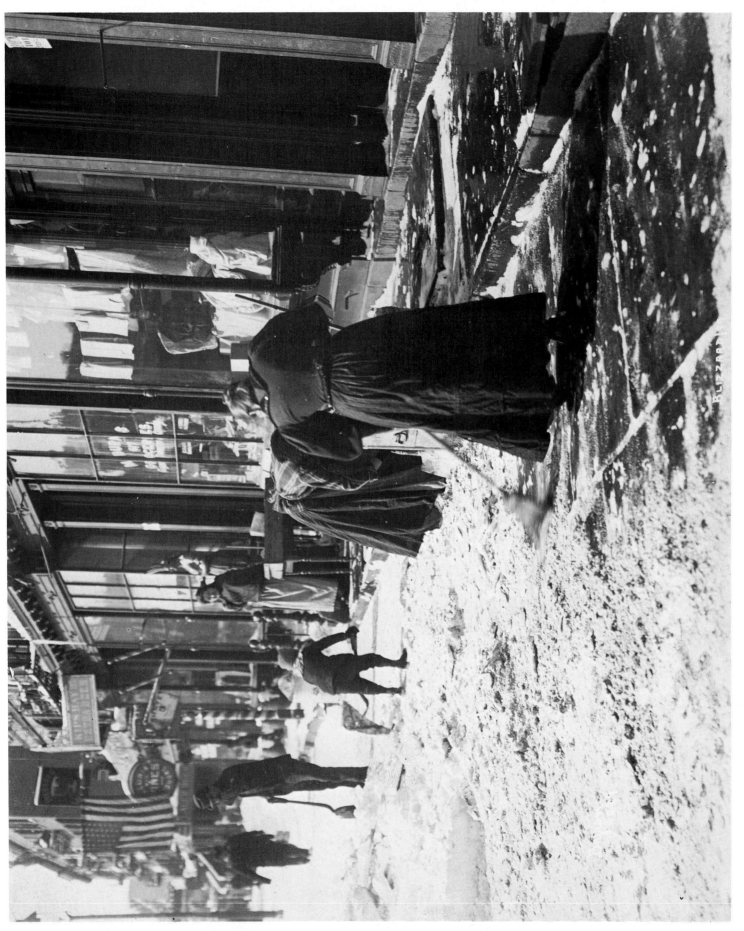

90. The Blizzard of 1899.

91. The Green-Wood Cemetery, Memorial Day, May 30, 1899.

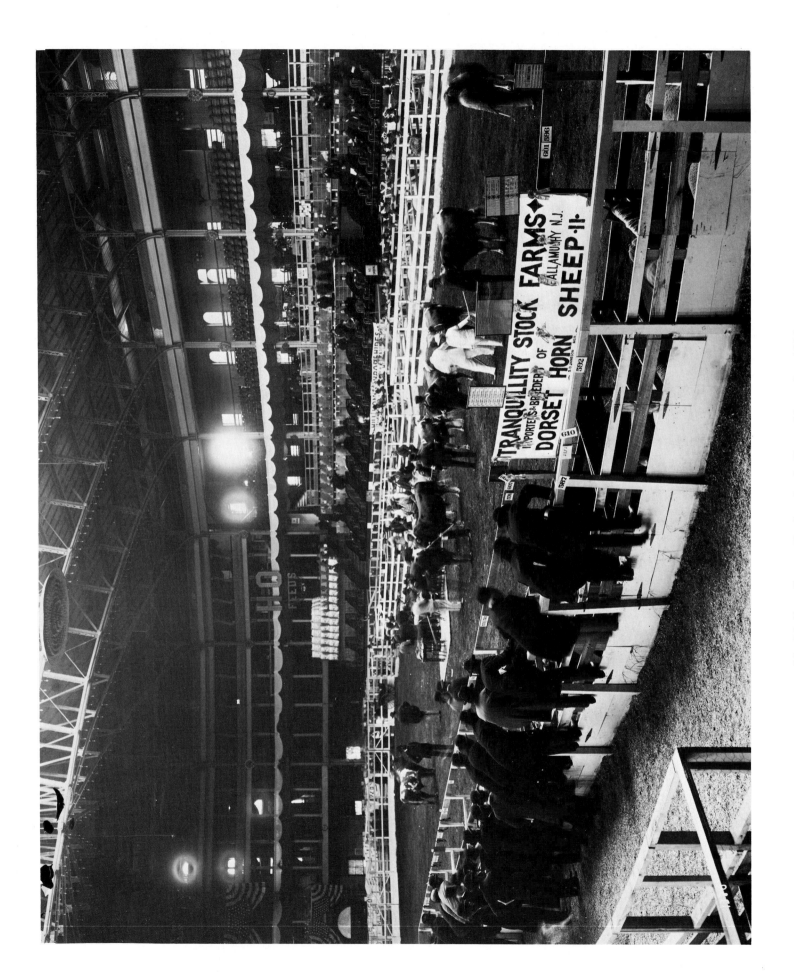

92. Madison Square Garden Cattle Show, November 1895.

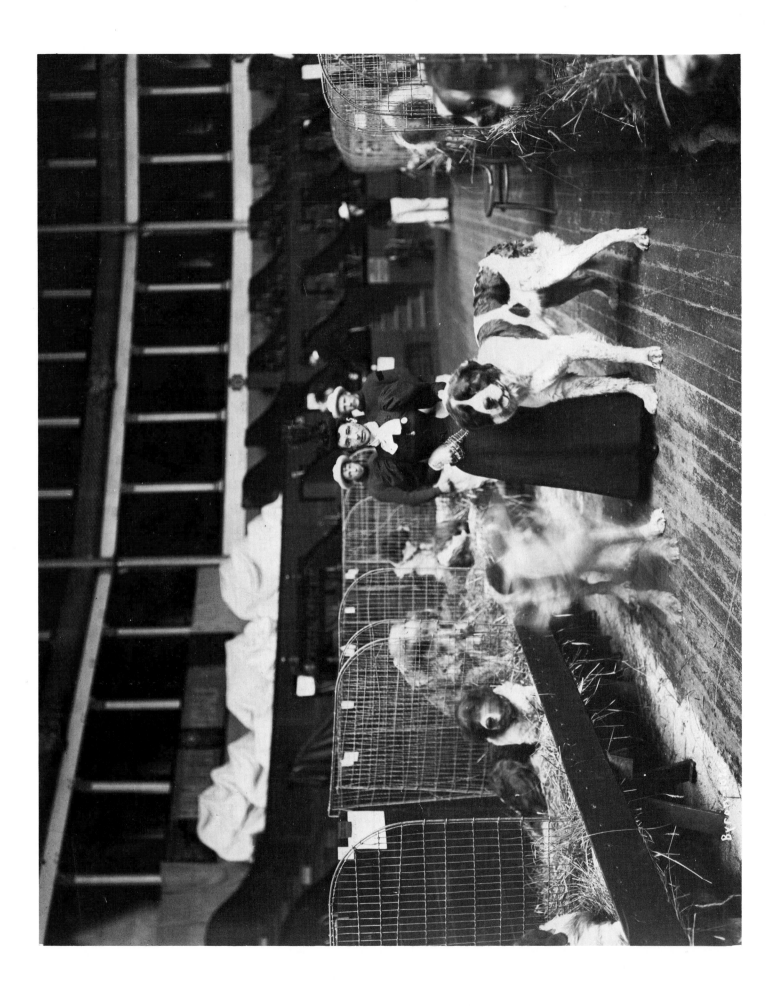

93. Dog Show, 1897.

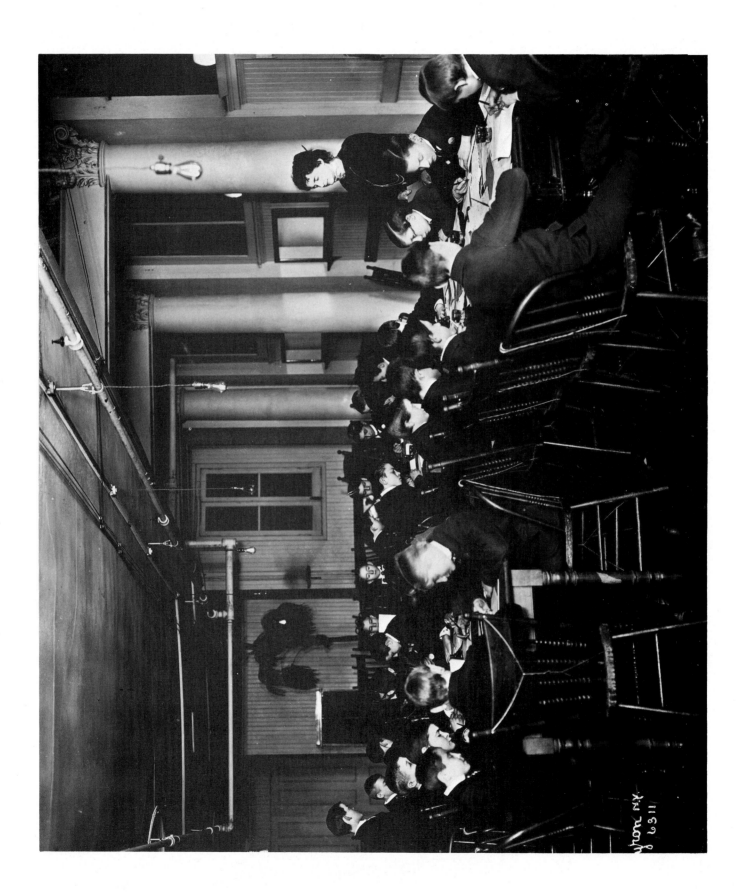

94. Wanamaker's School for Cash Boys, 1899.
95. BELOW: Columbia University Commencement, June 12, 1901.

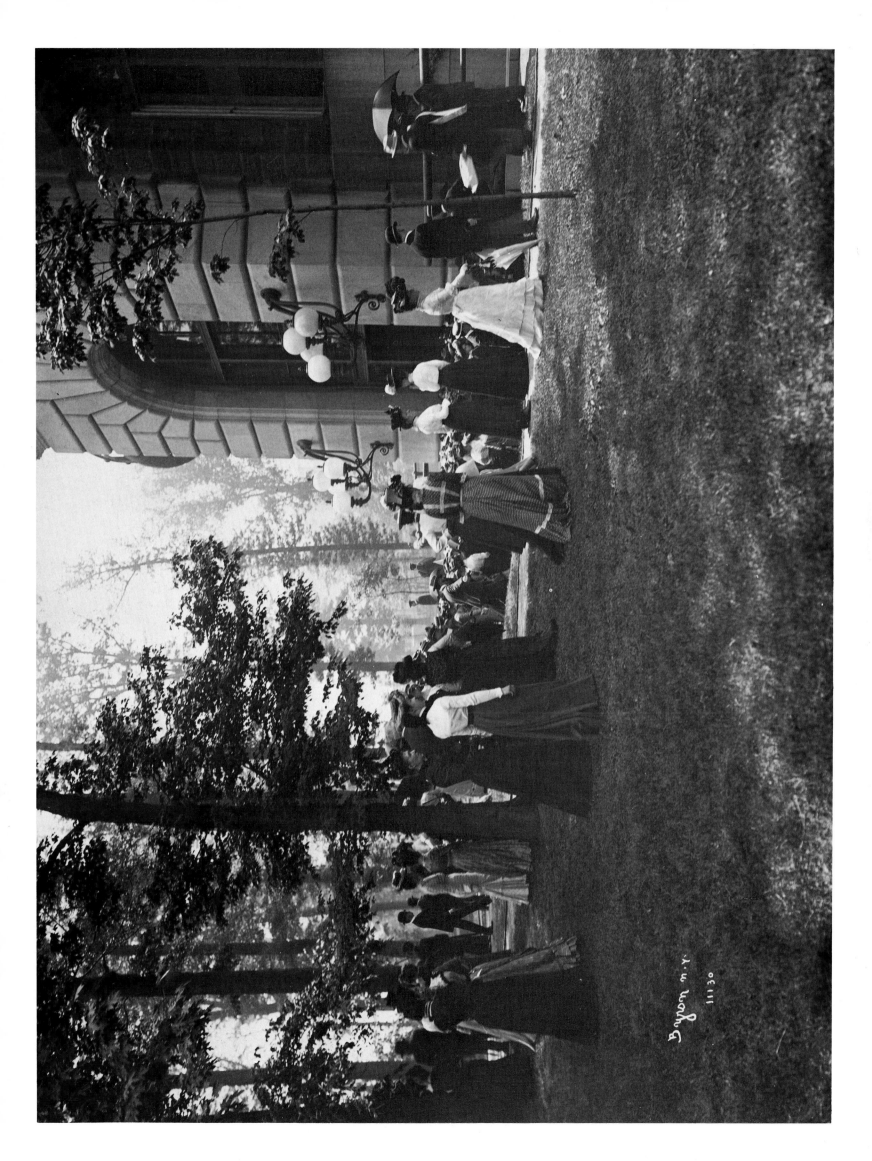

Bayon N.Y.
11130

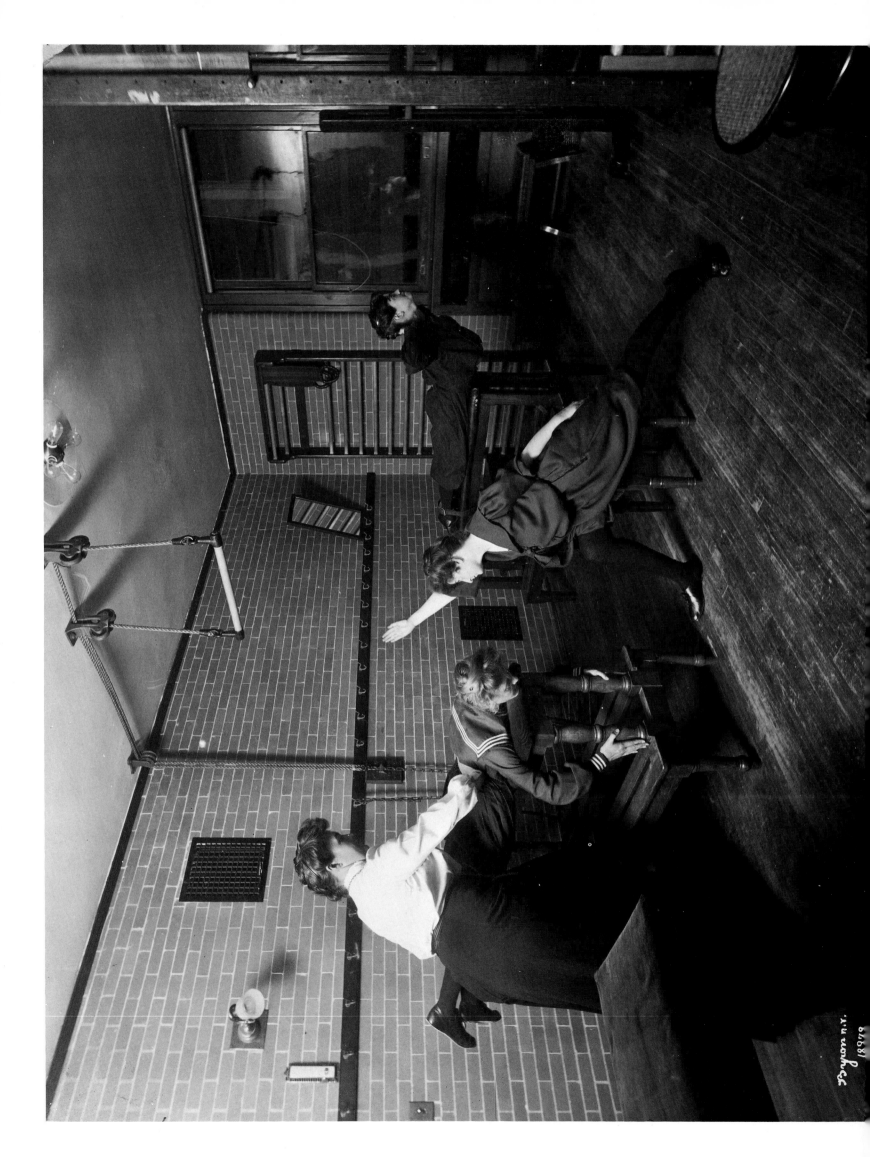

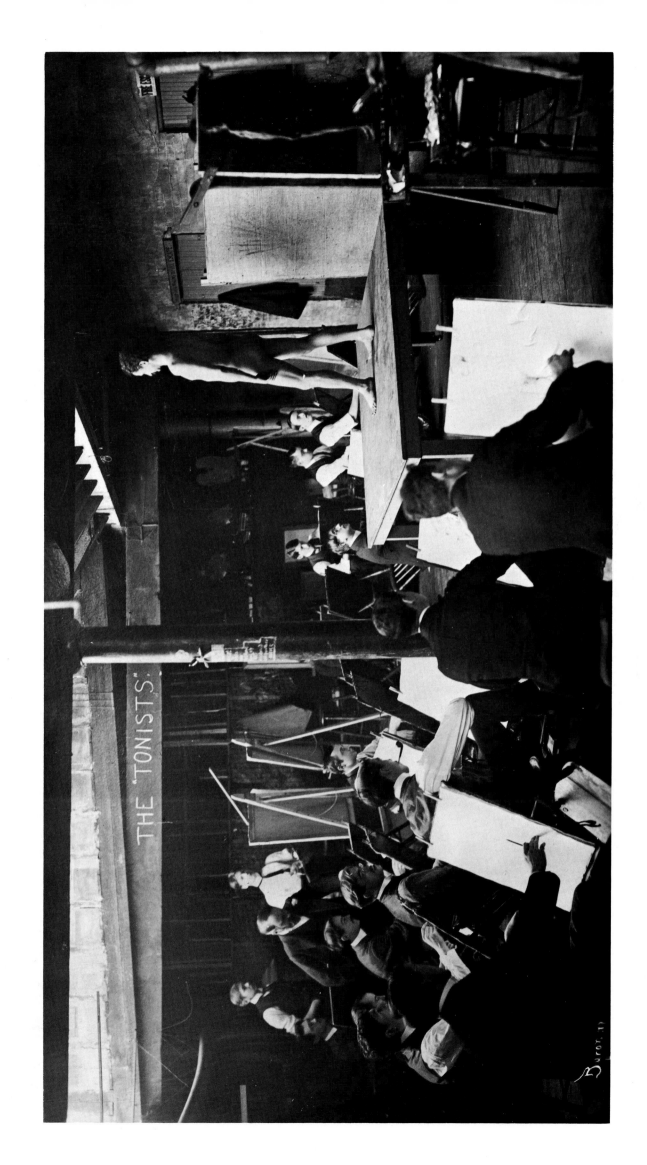

96. ABOVE: Teachers College, 1904.

97. Life Class at the Chase School of Art, 1896.

THE "TONISTS".

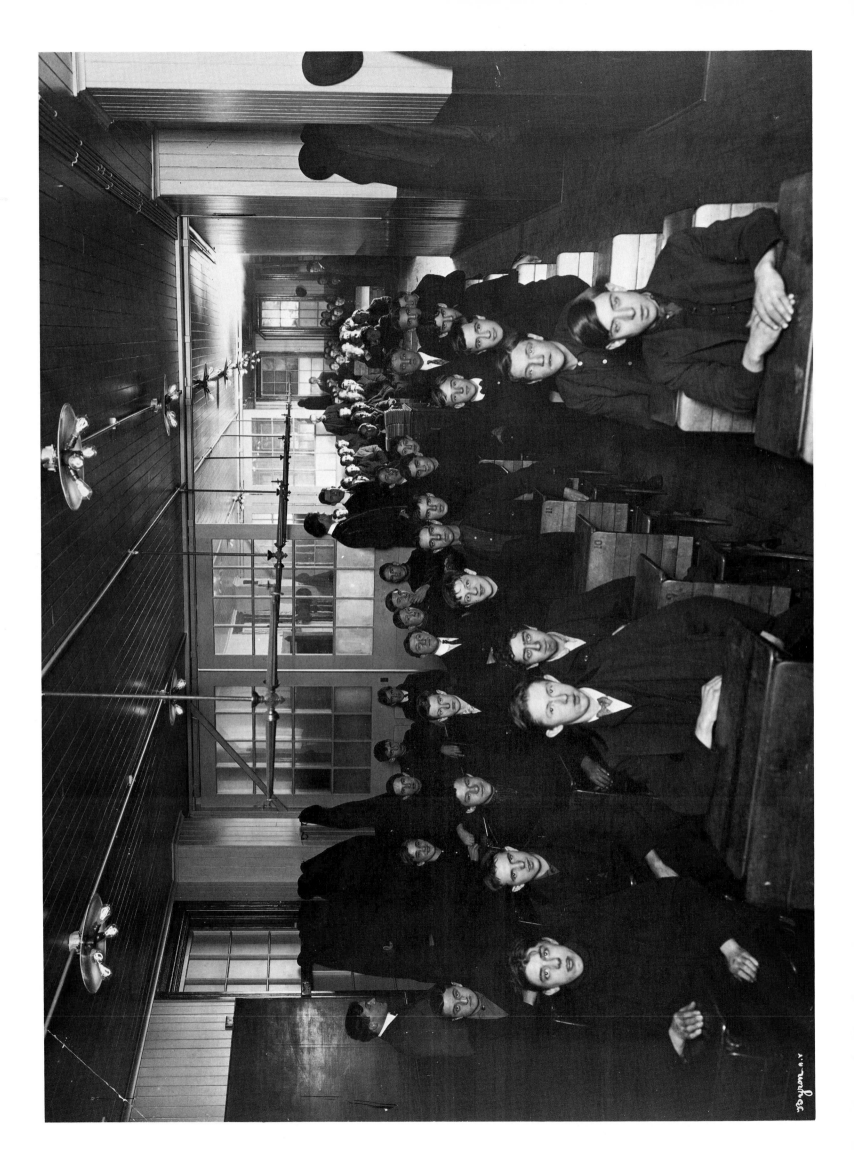

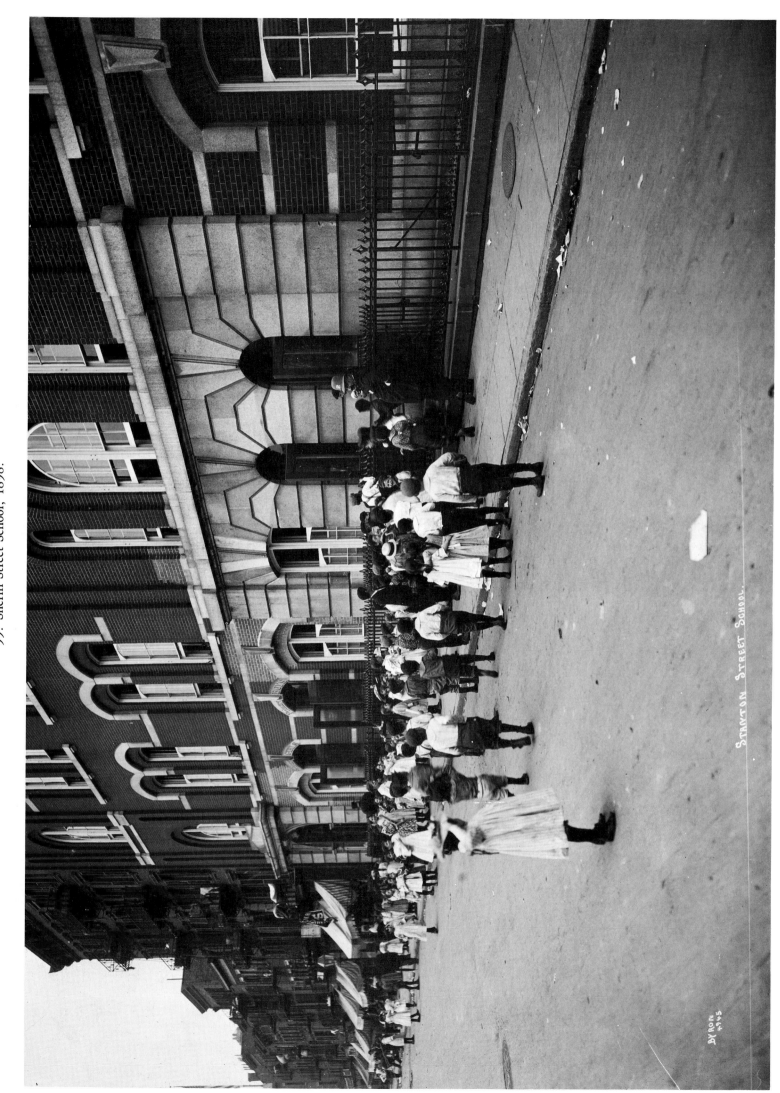

98. ABOVE: The R. Hoe & Co. Apprentice School, 1904.
99. Sheriff Street School, 1898.

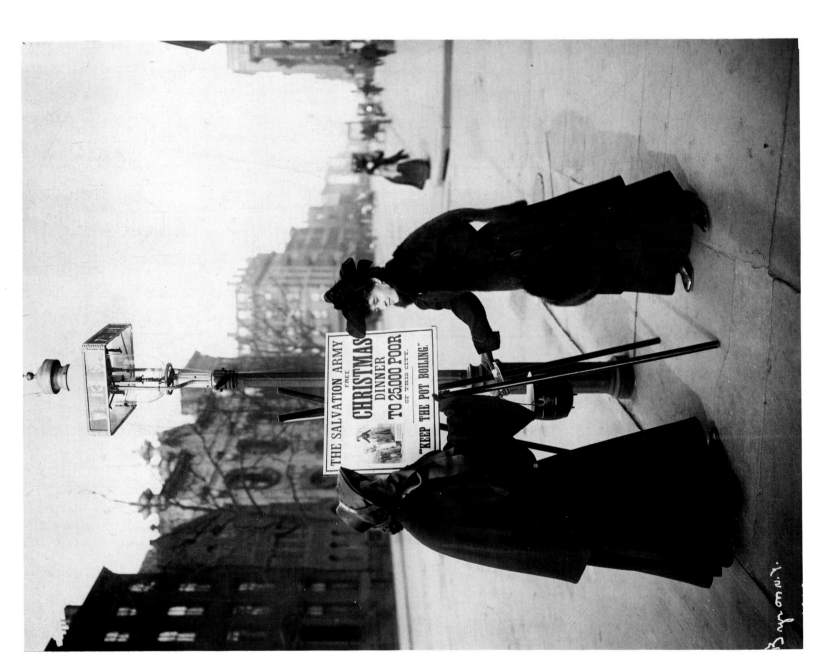

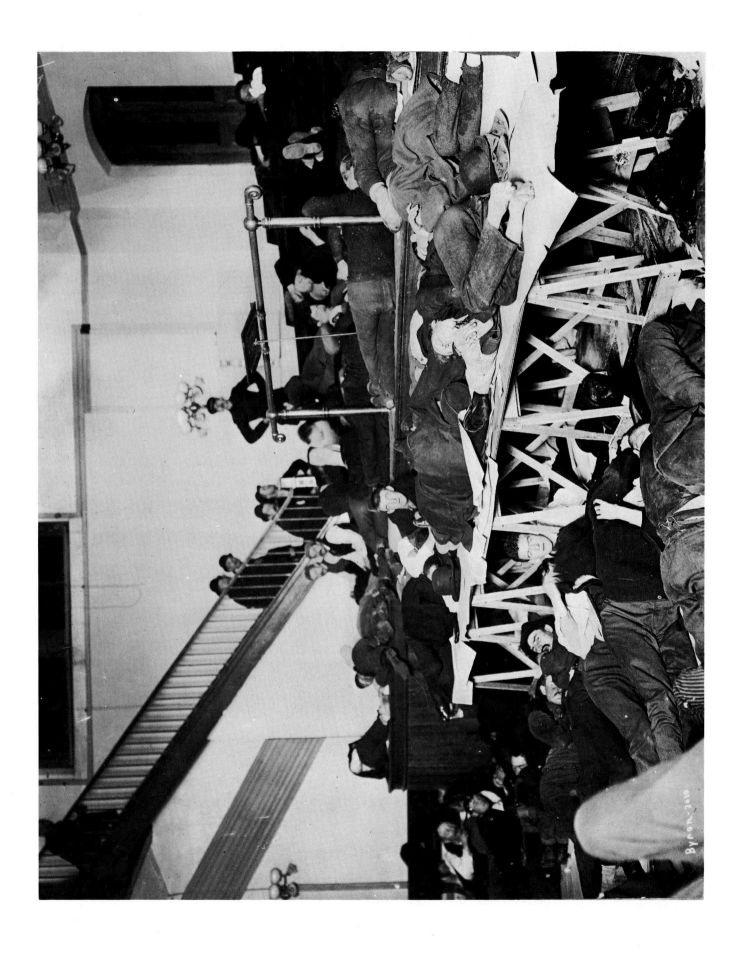

101. Salvation Army Headquarters, 1897.

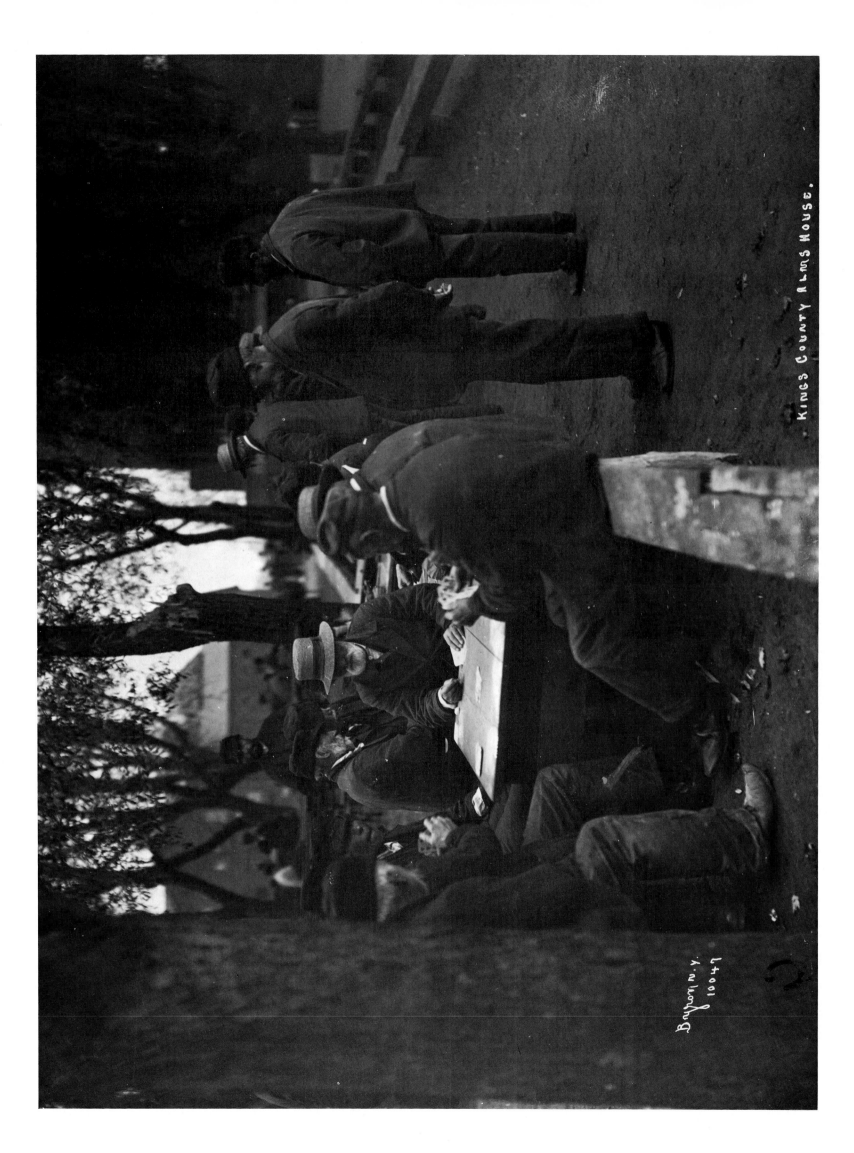

Kings County Alms House.

Brooklyn, N.Y.
10047

102. ABOVE: Kings County Almshouse, 1900.

103. LEFT: Bide-A-Wee Home for Animals, 1906.

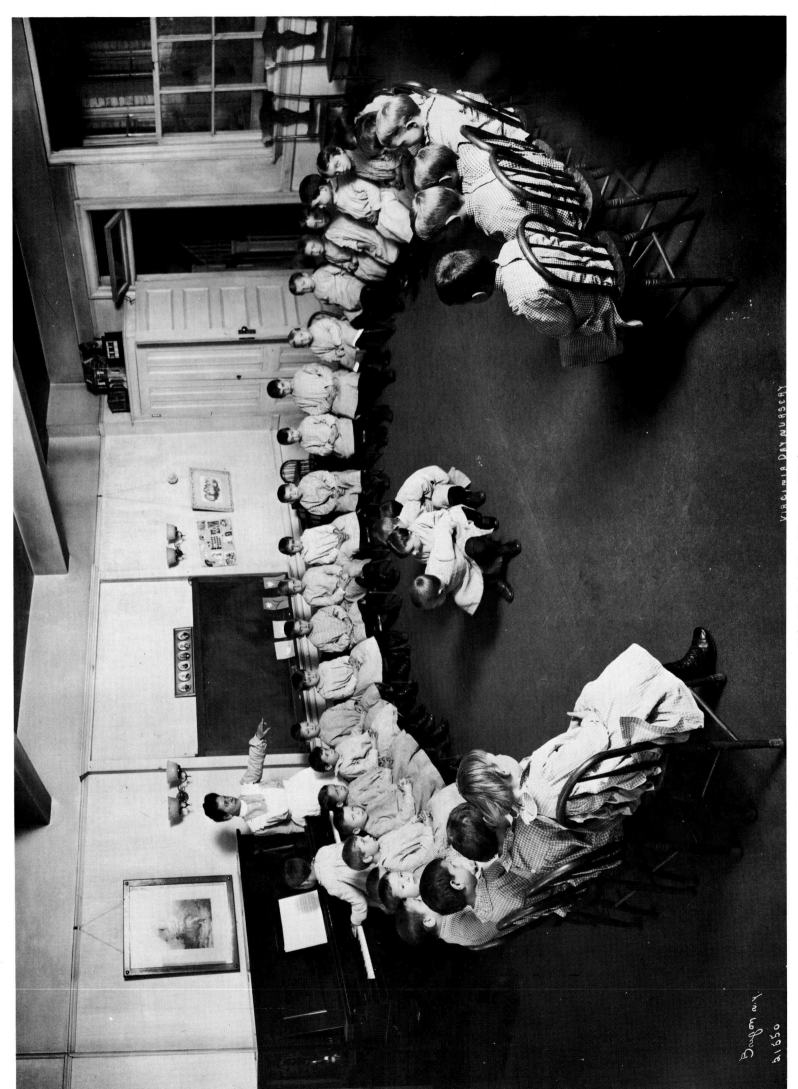

104. Virginia Day Nursery, 1906.

105. Bellevue Hospital Ambulance, 1895.

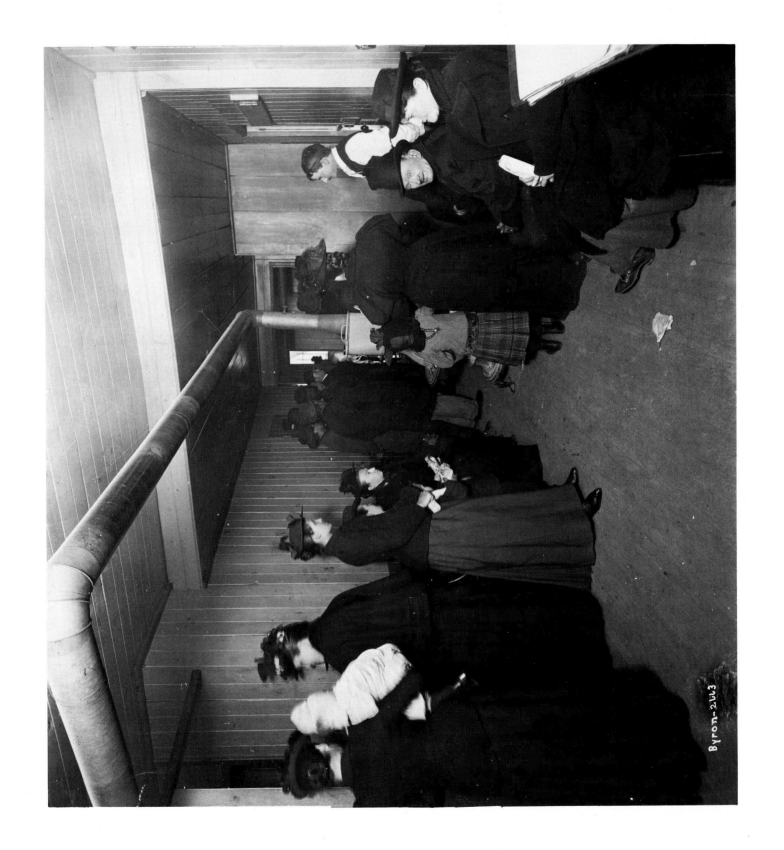

106. Harlem Hospital, 1896.

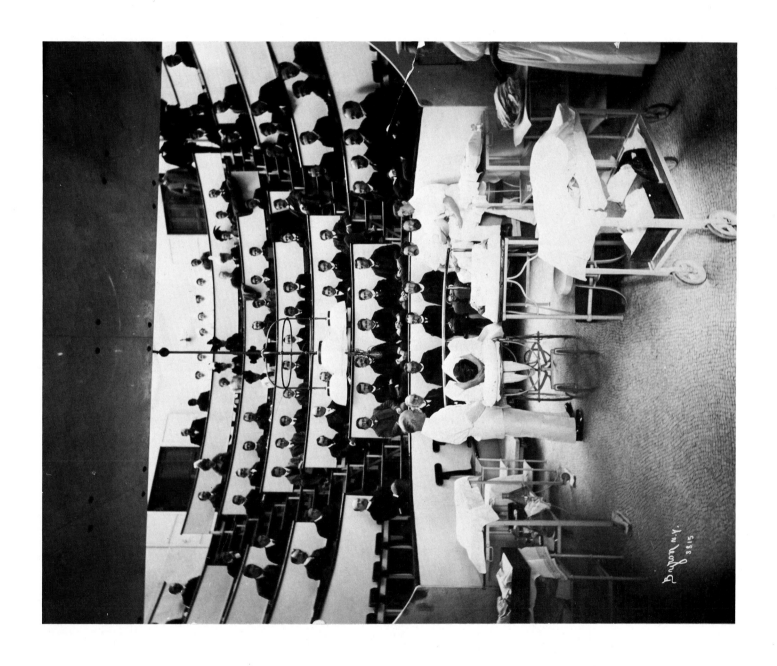

107. Roosevelt Hospital Amphitheater, 1900.

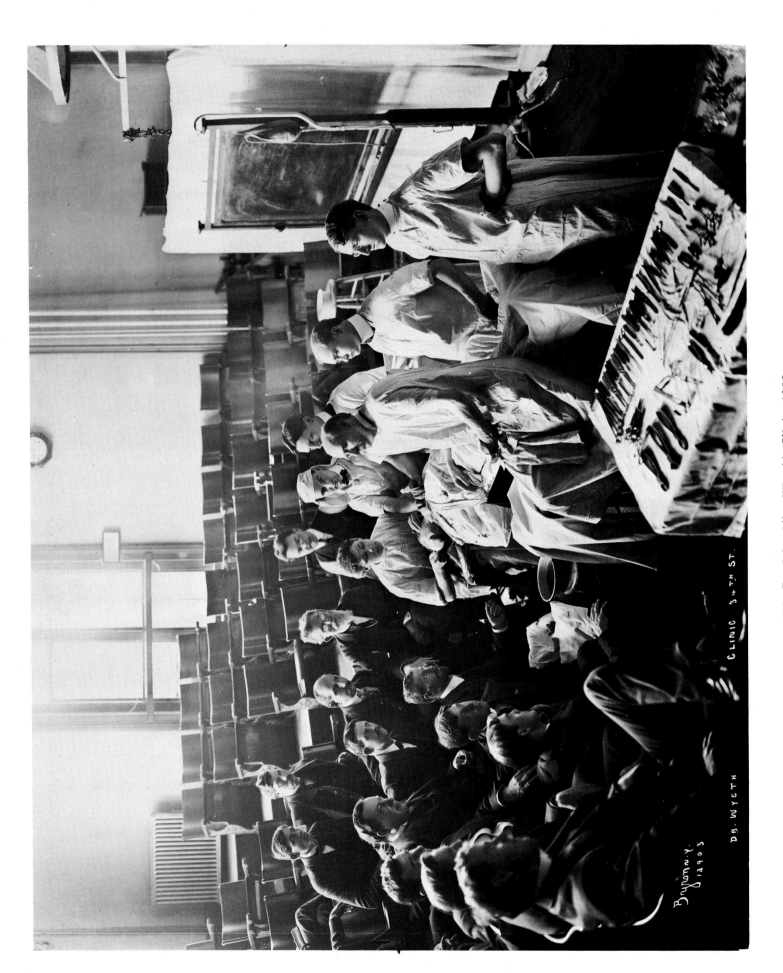

108. Dr. John Allan Wyeth's Clinic, 1902.
109. BELOW: Hahnemann Hospital, 1905.

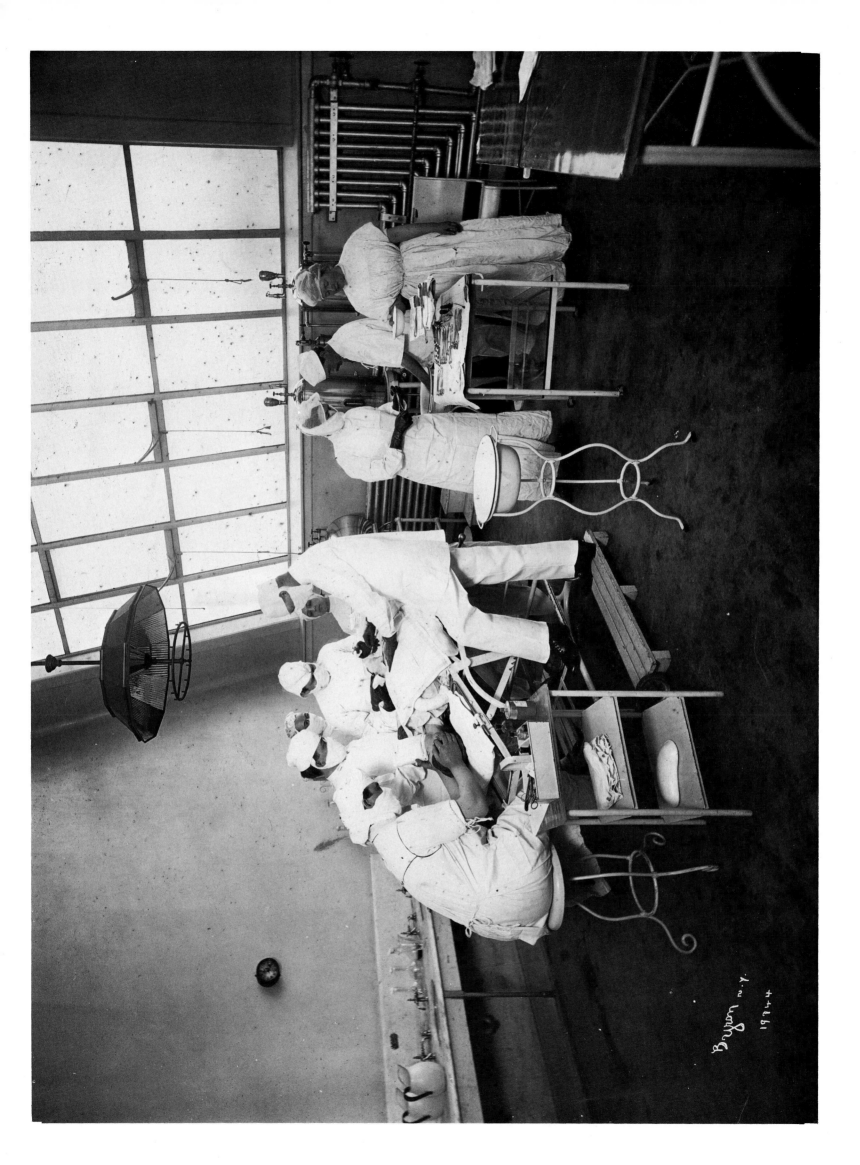

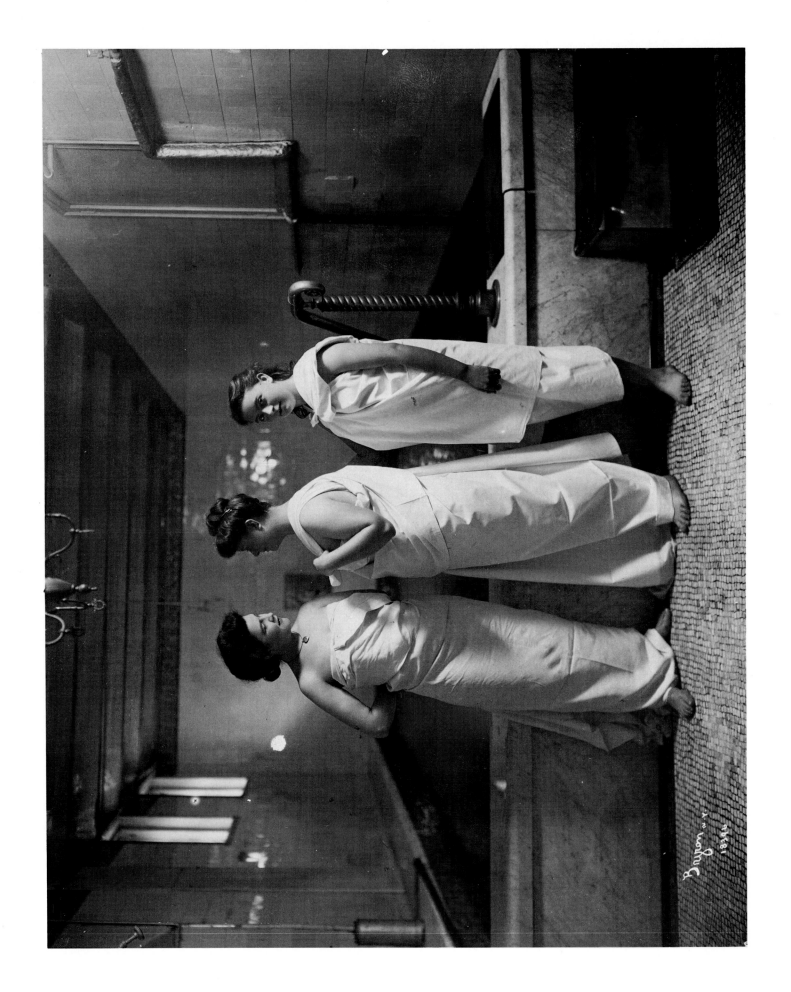

110. Turkish Bath Club, 1904.

111. Turkish Bath Club, 1904.

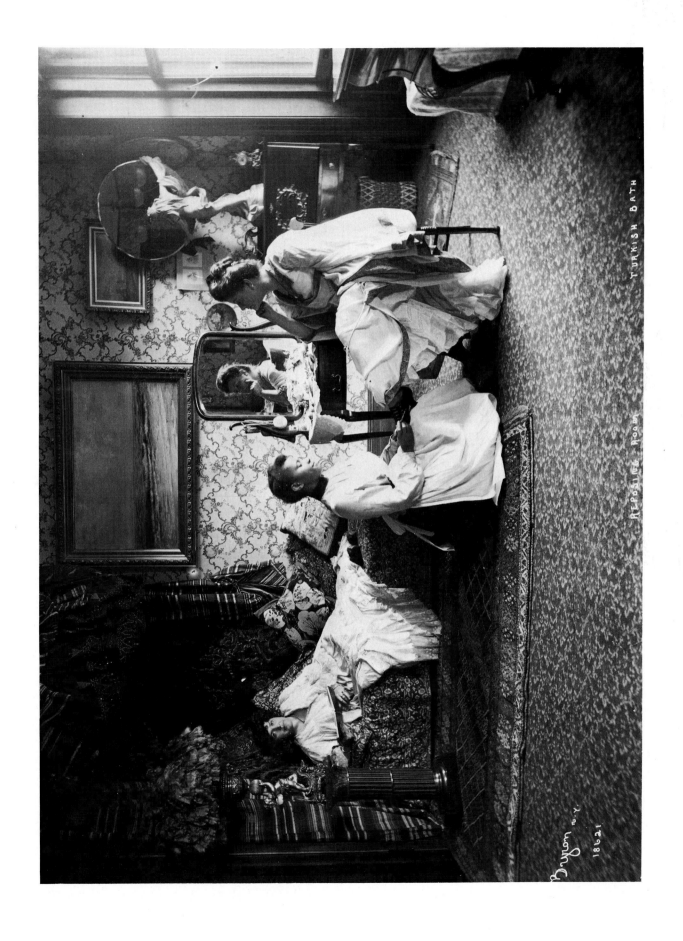

112. Barnard College, ca. 1900.

113. Telephone Exchange, 1896.

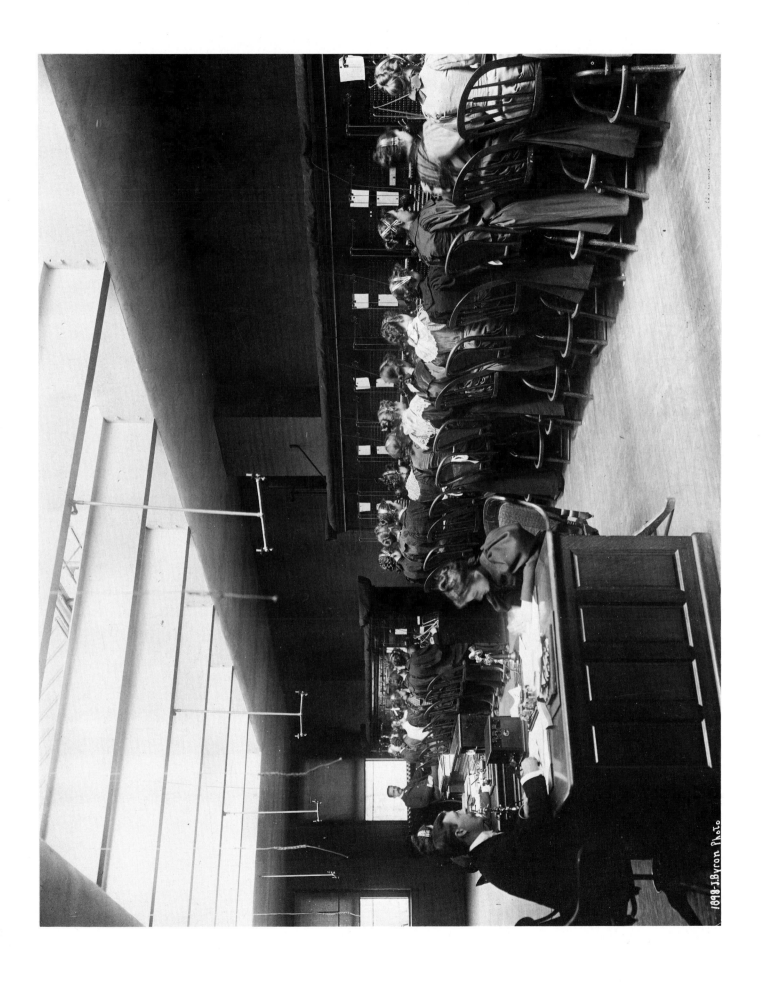

1898-J.Byron Photo

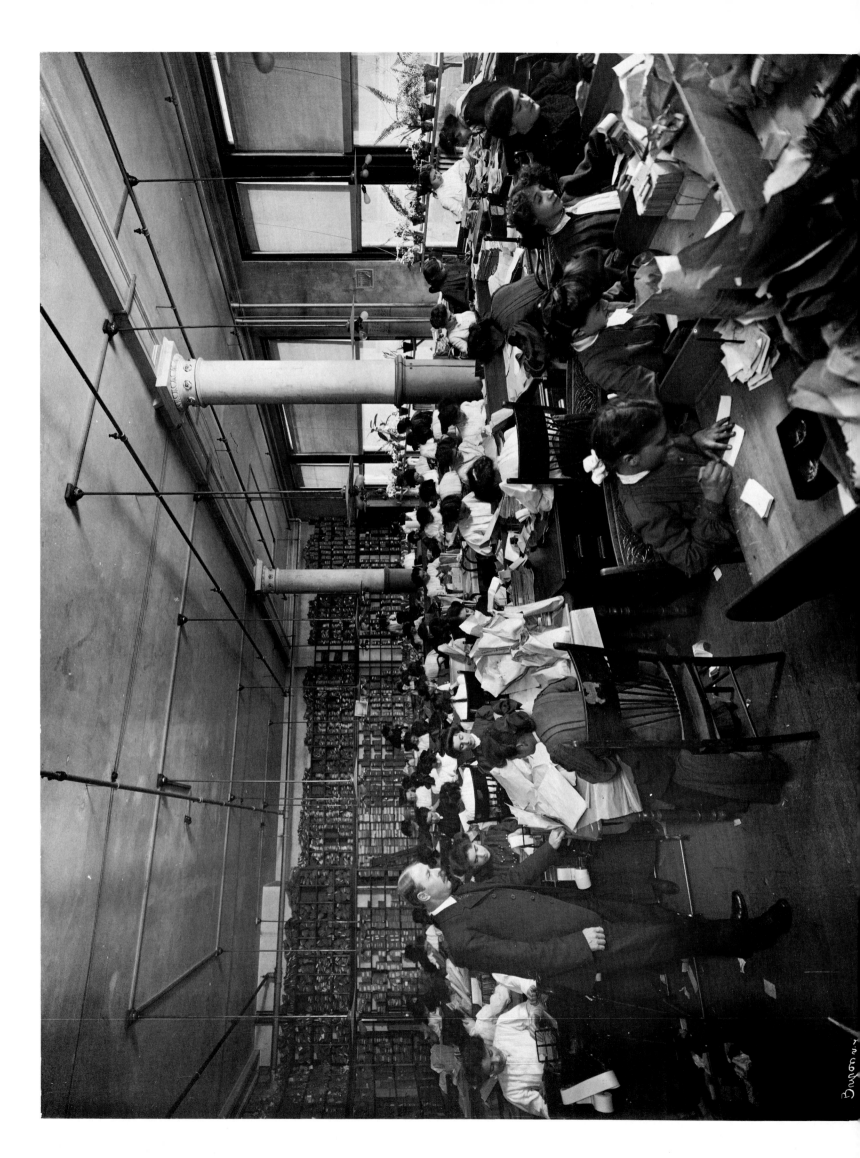

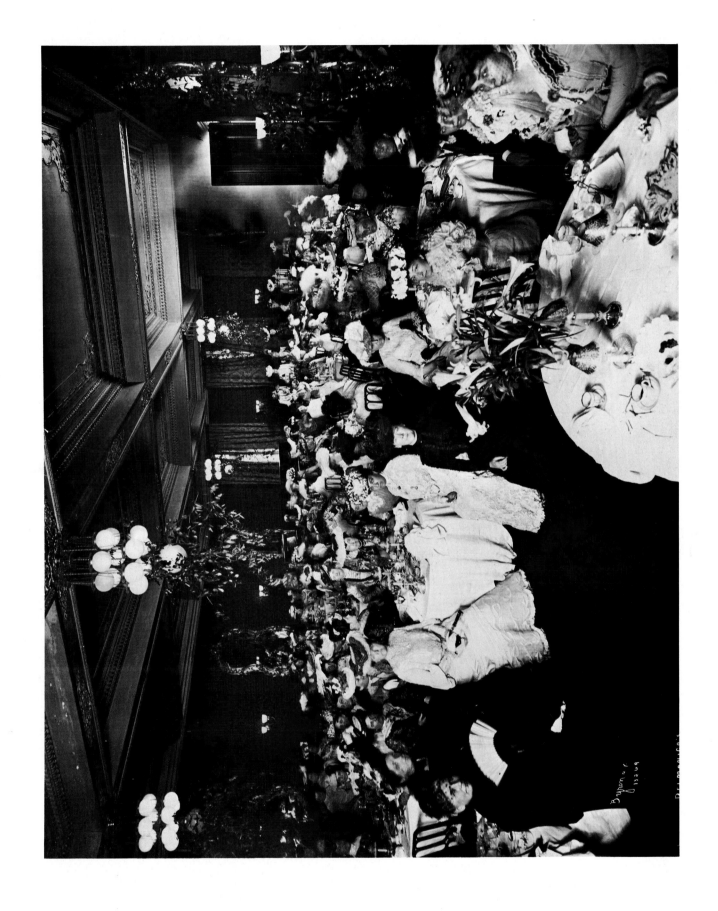

114. ABOVE: Siegel-Cooper's Sales-Checking Department, 1906.
115. Ladies' Luncheon at Delmonico's Restaurant, 1902.

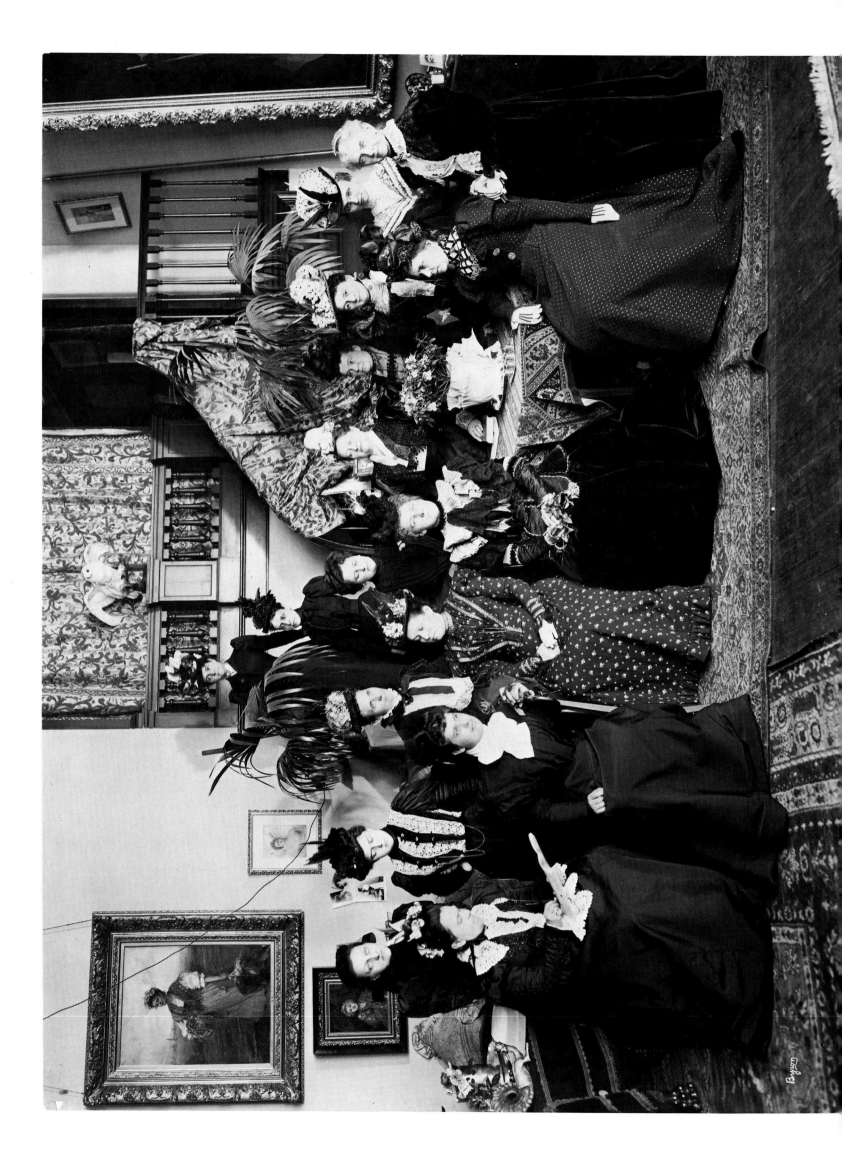

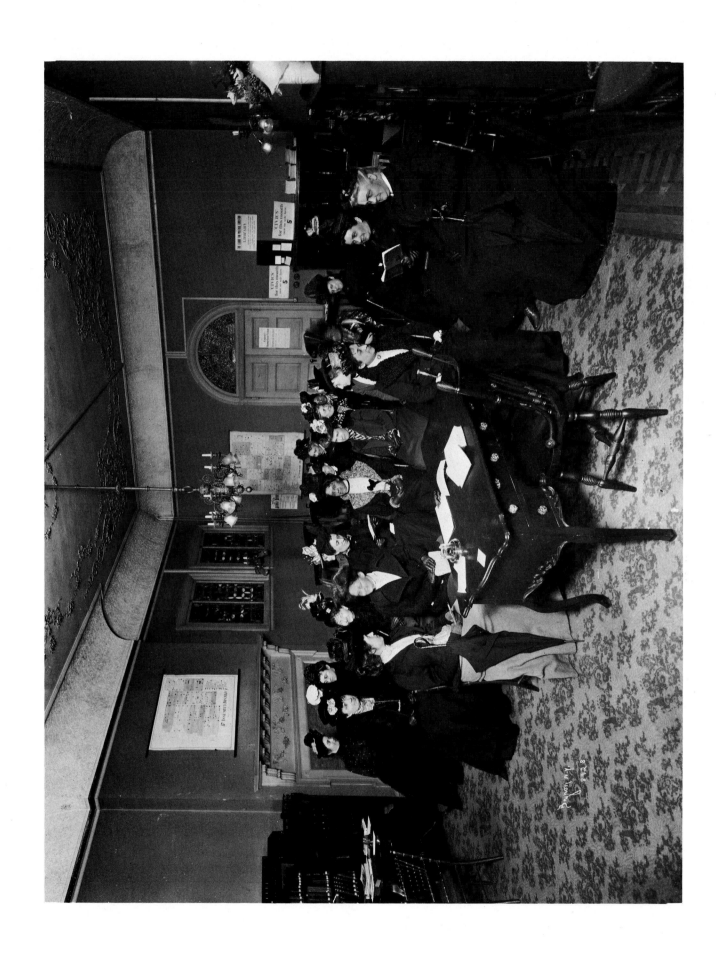

116. ABOVE: *Daughters of the American Revolution*, 1898.
117. *The League for Political Education*, 1899.

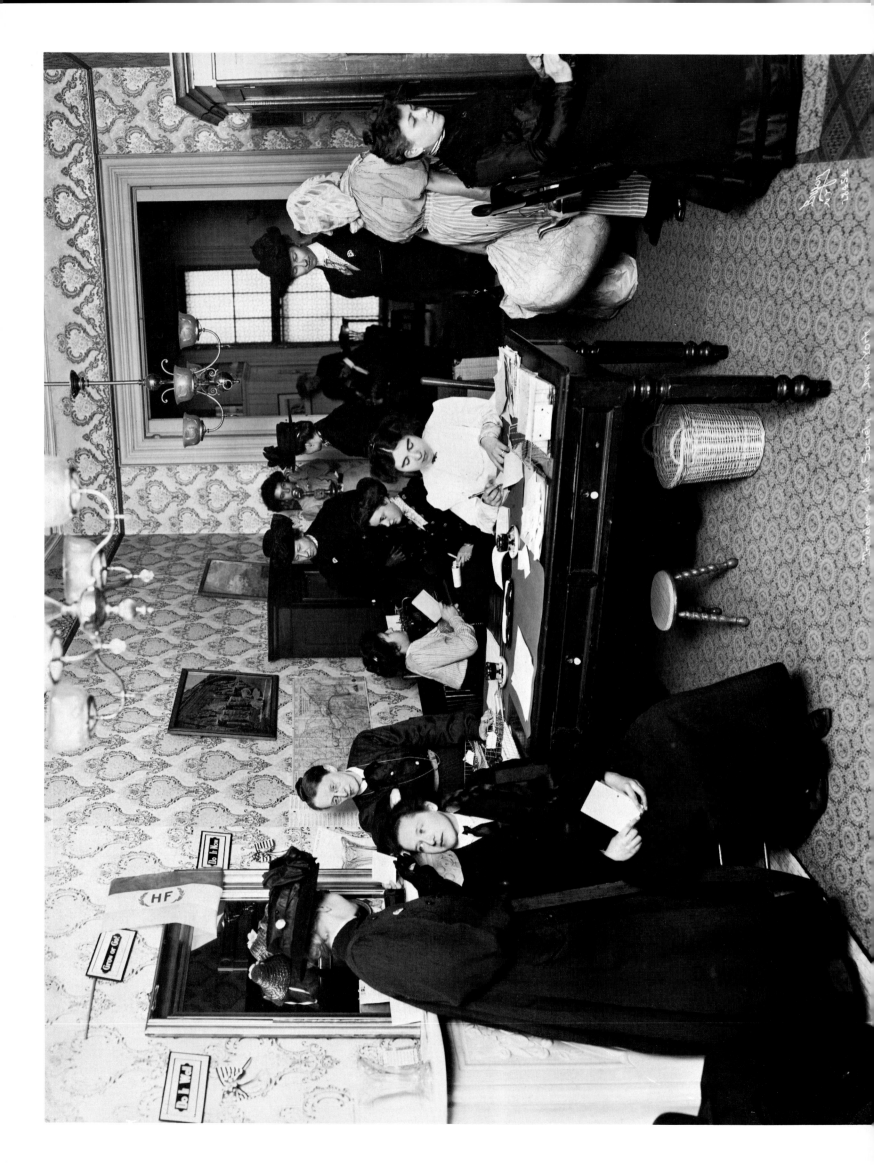

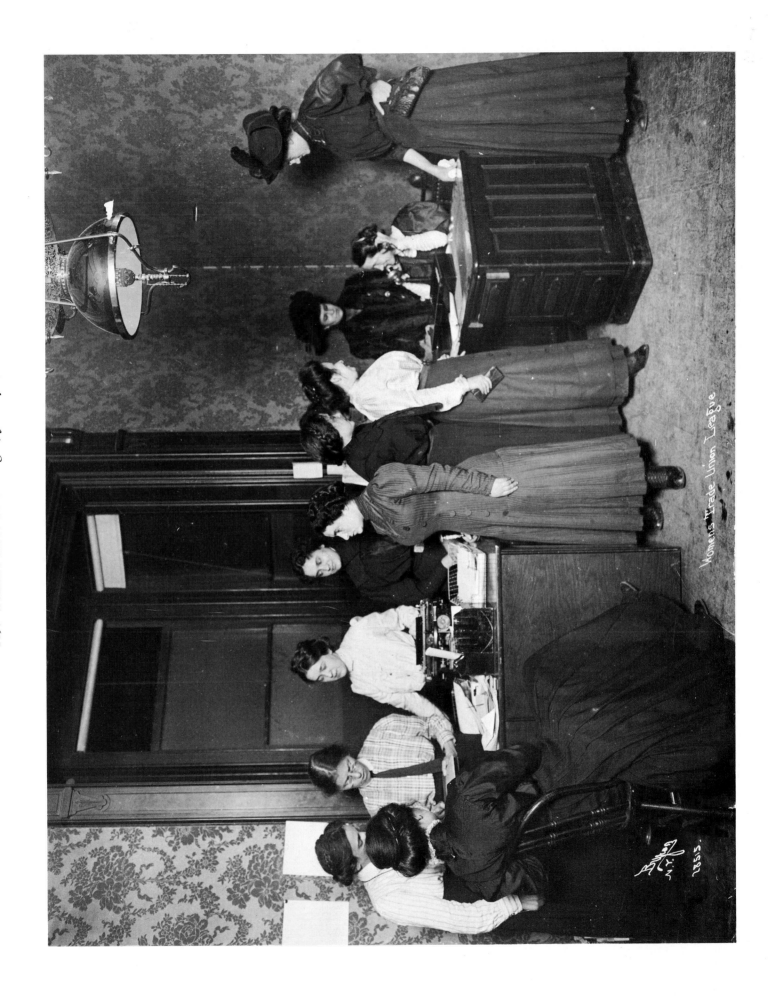

118. ABOVE: Office of the Travelers' Aid Society, 1909.
119. Women's Trade Union League, January 1910.

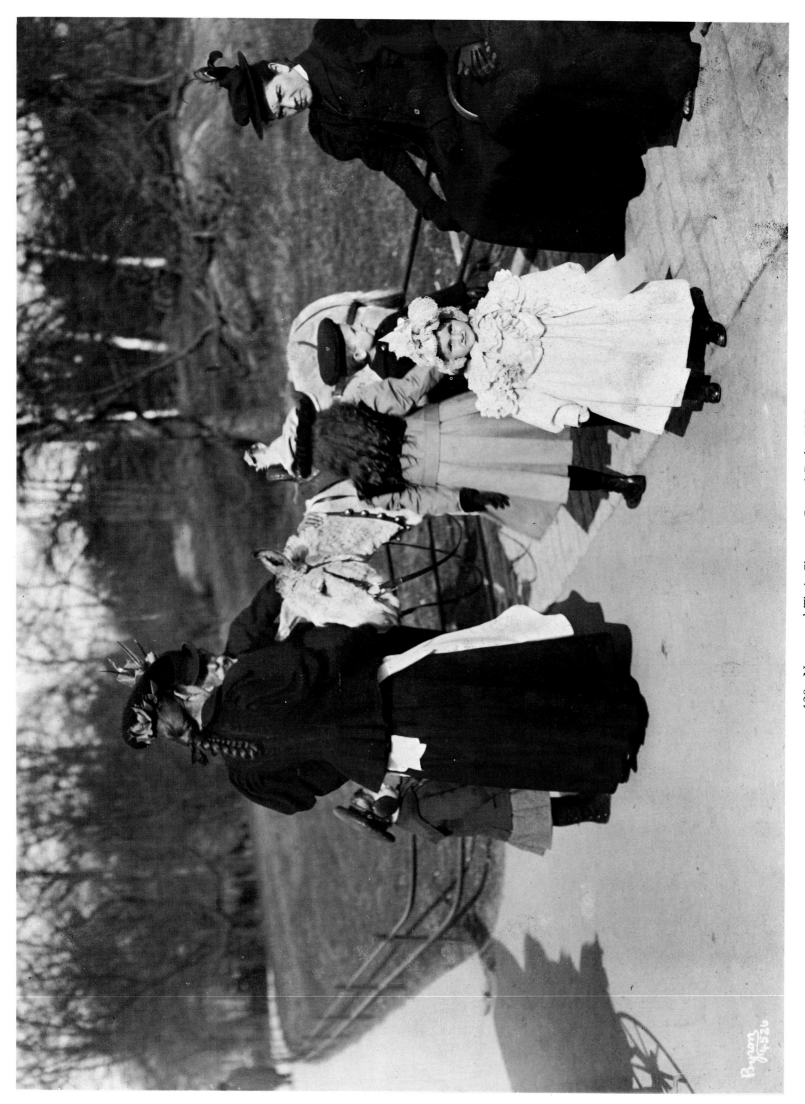

120. Nurses and Their Charges, Central Park, 1898.

121. Central Park, Winter, 1898.

122. Cooking Class, 1905.

Notes to the Plates

1. **The Eastern Hotel, Whitehall Street, ca. 1906.** The large hotel at the corner of Whitehall and South Streets had a remarkable history. Built by Captain Coles in 1822, it was first called the Eagle Hotel. When the first successful Atlantic cable was laid in 1858, the hotel was renamed the Great Eastern, after the ship that laid the cable. The name was later shortened to Eastern. Among the famous guests who stayed here were Jenny Lind and P. T. Barnum. Daniel Webster "took unto himself a second wife" in its parlor. The Eastern survived for 98 years, Prohibition finally sealing its doom in 1920. An interesting footnote to this scene: There are more than 75 persons visible, but only one is a woman (the right foreground).

2. **The Broadway Squad, Broadway and Fulton Street, ca. 1898.** A large number of Byron photographs were used in *The New Metropolis,* edited by E. Idell Zeisloft in 1899. This one appears with the caption "Directing a Stranger." Zeisloft states in the text:

> The great pressure of the traffic is along Broadway. There is a constant stream of vehicles and cars, and thousands hourly trying to cross. This has led to the "Broadway Squad," the finest body of special police ever called into being. . . . From Bowling Green to Forty-second Street, at every important corner—sometimes two and three at a corner—these men are placed, sixty-four in all. . . . The minimum height of a "Broadway Squad" man, according to regulations, is six feet one inch.

3. **Park Row, 1895.** Park Row gained the familiar name of "Newspaper Row" because the *World, Sun, Journal, Tribune, Times* and *Press* all had buildings on the street. In the left foreground is the New York Times Building, erected in 1888 on the site of an older structure of the same name, completed in 1858. To the right of this are the offices of the *New York Press,* a strongly Republican journal. The peddlers, offering fruit and nuts, have a favorable location just outside City Hall Park.

4. **South Street, 1895.** In this summer view, taken at Moore Street, South Street is shown curving in the distance at Coenties Slip. Although the bustling activity of the clipper-ship era was past, the heavy sailing ships, whose masts line the shore, still brought their cargoes to the East River piers. The buildings at the left, extending from Moore to Broad Streets, were occupied principally by rooming houses, saloons and billiard parlors. A few, probably dating from before 1850, survived until the 1960s, when the building complex known as One New York Plaza obliterated them, along with this section of Moore Street itself.

5. **Grand Theatre, 1905.** Byron climbed to the roof of a three-story wooden building to capture this panorama, showing Grand Street extending to the left and Chrystie to the right,

with the focus on Jacob P. Adler's Grand Theatre. Adler, one of the great actors of the Yiddish stage, can be seen with his wife standing at the right-hand entrance. The large group of people has apparently gathered in connection with an appeal for assistance for Russian Jews "murdered and plundered" in recent pogroms. Signs in Yiddish and English ask for help and announce a benefit performance by Adler in *The Yiddish King Lear,* to be held on November 23.

6–9. **Hester Street, 1898.** It has been estimated that 225,000 Jewish families left Russia during the persecutions by Alexander III between June 1881 and July 1882. It is difficult to determine how many of them settled permanently in New York City, but the Russian-born population of Manhattan jumped from 4,551 in the 1880 census to 48,790 in 1890. The greater number of the new immigrants settled in the Lower East Side, where a Jewish population already existed. These four photographs of the pushcarts in the Hester Street area emphasize the crowded living conditions of the Lower East Side. In *The New Metropolis,* E. I. Zeisloft described typical scenes:

> The push-cart flanks both sides of the streets for half a dozen blocks on Hester Street, and to the north and the south. To venture into the district means to be surrounded, crowded, jostled, and tripped up by carts. The inexperienced eye reels back thwarted from the attempt to judge the number. It seems as if they were countless. They are well-nigh that. It has been ascertained that fifteen hundred families on the East Side are dependent upon the push-cart for a living.

10. **Fourth Avenue and East 14th Street, 1907.** The German atmosphere of the neighborhood is evident in this photograph: There is the German Savings Bank, *The Prince of Pilsen* playing at the Academy of Music, a rathskeller at the left and Lüchow's Restaurant (a few doors east of the bank). The restaurant, opened at this site in 1882, operated there until 1982 as one of New York's landmark establishments. The elegant, chauffeur-driven touring car, with New Jersey plates, seems to be attracting considerable attention.

11. **Sixth Avenue, North from West 15th Street, 1895.** By 1895 Sixth Avenue from West 14th to 20th Streets had become one of the principal shopping centers of the city. B. Altman had been expanding his dry-goods store, erected at Sixth Avenue and West 19th Street. Other famous department stores were soon to be established: Siegel-Cooper's ("The Big Store") opened on the east side of the avenue opposite Altman's; Simpson, Crawford & Simpson's opened in 1900 on the block north of Altman's. O'Neill's occupied the next block. In this view the throng of shoppers has attracted many street vendors. The popcorn wagon, just beyond the lamppost, is horse-drawn.

12. The Fifth Avenue Hotel, West 23rd Street and Fifth Avenue, ca. 1897. Although the intersection of 23rd Street, Broadway and Fifth Avenue, seen here looking west along 23rd Street, was one of New York's busiest locations in 1897, in 1859, when Amos Eno opened the Fifth Avenue Hotel (right) it was dubbed "Eno's Folly" because it was thought to be too far uptown. The hotel, famed for its "Amen Corner," where notables met, contained 530 rooms and was the largest hotel in the world for 15 years. A great political and fashionable center in the city was destroyed in 1908, when the hotel was torn down to make room for a 15-story office building. The building on the opposite corner of Fifth Avenue was erected by Western Union about 1883. Since an establishment on the upper floor is seen selling monuments, Western Union must have vacated at least part of the building by the time this photograph was taken. It and many of the other buildings seen in the background are still standing.

13. The Fifth Avenue Hotel, 1896. When Percy Byron was asked in the 1950s how he managed to retain an unposed quality in so many of his photographs, he replied that it took him so long to set up his camera and to get ready that he tended to blend into the scenery—people usually were not aware of the time of actual picture taking. The two elegant young ladies are oblivious of his camera, but not the young boy on the right.

14. East 23rd Street, East from Fifth Avenue, 1898. The two buildings in the background have had a complex history. The Madison Square Presbyterian Church (left) was built on the southeast corner of Madison Avenue and East 24th Street in 1854; from it Dr. Parkhurst waged his campaign for reform. The first Metropolitan Life Insurance building (right), on East 23rd Street and Madison Avenue, was completed in 1893. In 1906, in order to erect the Metropolitan Life tower, the church was razed and a new church, designed by McKim, Mead and White, was erected on the opposite side of East 24th Street. This landmark in turn was torn down only 12 years later, when the Madison Square Presbyterian Church merged with the First Presbyterian Church. An additional building for the Metropolitan Life Insurance Company was put up on the site.

15. Broadway and West 28th Street, 1898. By the time this photograph was taken, West 28th Street had already been dubbed "Tin Pan Alley." Since the girl in the hansom cab appears to be posed, it is probable that this was an early publicity shot, taking advantage of the area's renown. The round sign at the curb on the right, reading "5th Ave. Theatre," stands in front of that theater. Run by the famous playwright and producer Augustin Daly, it was built to replace the New Fifth Avenue Theatre, which had burned down in 1891.

16, 17. Seventh Avenue and West 30th Street, 1904. Until 1910 the center of black life in New York was in "Black Bohemia," an area on the West Side stretching from about the West 20s to 50s. The black population was on the increase, more than doubling between 1900 and 1920 (60,666 to 152,467). The total population of New York City in 1900 was 3,437,202. There was overcrowding in the tenements and the streets and sidewalks tended to be choked with vehicles and pedestrians. With packed tenements over stores and typical corner bar, the street did not change much in appearance until the garment industry invaded the area in the 1920s to become the city's most important industry.

No. 17, looking north, captures a vignette of this environment: a saw sharpener plying his trade on the sidewalk. He was one of dozens of types of itinerant tradespeople in the tradition, soon to fade, of the eighteenth-century street cries. Still seen and heard were ubiquitous and noisy street merchants, including the old-clothes man ("cash—clothes"), the chair mender, the vegetable hawker, the fishmonger ("fresh fish today"), the iceman and the newsboy ("Extra! Extra!"). Their callings and bells, the clop of horses' hooves, the creaking of the ancient wagons and pushcarts were a familiar strain in the sounds of the city.

18. Broadway, North from West 34th Street, 1909 and 1910. On June 18, 1910, the Rice Electric Display Company first flashed its electric sign with an animated scene inspired by the popular play version of *Ben-Hur*. Byron was hired by the company to photograph its masterpiece, but his attempts were obviously not entirely successful, for he superimposed his photograph of the sign on one of the area which he had taken a year earlier. The giveaway: the advertisement for comedian Jefferson De Angelis in *The Beauty Spot*, playing at the Herald Square Theatre (left). The play ran only during the spring and early summer of 1909. In the midst of the traffic stands McKim, Mead and White's New York Herald Building, constructed in 1893. In the distance on Broadway is the Times Tower. To the left of it is the old Metropolitan Opera House; to the right, faintly visible, the Hotel Astor. All of these structures have either been demolished or altered beyond recognition. Macy's Department Store, seen at the far left, continues to flourish.

19. Peddlers, Sixth Avenue and West 34th Street, ca. 1898. Peddlers have been conspicuous on New York streets from the early 1800s. Here two men push their selection of trimmings. In the background is the Broadway Tabernacle on the northeast corner of Sixth Avenue and West 34th Street.

20. Greeley Square, 1898. On this summer morning Greeley Square at Broadway and West 33rd Street has not yet reached its peak of activity. Hansom cabs wait patiently and the people have taken advantage of the shadow of the Sixth Avenue el station (designed 20 years earlier by the Hudson River School artist Jasper F. Cropsey). The advertisements on the billboards in the background give an accent to the period: "Chew Navy Fine Cut" (a tobacco), Fitzgerald Beer, Boro-Lithia Table Water, "Kremonia is Better than Ammonia," "Pine-apple Lung Balsam, 'God's Remedy,'" "Egyptian Tea for Constipation and Headaches." The statue of Horace Greeley (*The Printer*) by Alexander Doyle, unveiled in 1890, was moved to the southern end of the square when the el was demolished in 1939.

21. West 36th Street, between Broadway and Sixth Avenue, 1900. The shadow in the photograph is cast by the Herald Building. It is quite possible that the boys are newsboys having a quick snack before they pick up copies of the *Evening Telegram*, the afternoon edition of the *New York Herald*, popularly called "the pink sheet" because of the color of the paper on which it was printed.

22. Advertising Coach, Broadway and West 39th Street, 1896. The use of a coach was a dramatic form of advertising. This one brings to public attention *The Knickerbocker*, a new periodical (apparently short-lived) that claimed to be

"the largest illustrated publication in the world" and sold for 5¢ a copy or 50¢ for a year's subscription. Appropriately, the coach began its journey near the Knickerbocker Theatre (far right, at Broadway and West 38th Street). The eye-catching vehicle went down Broadway, across the Brooklyn Bridge and then proceeded all the way to Coney Island. The Casino Theatre is behind the coach at the West 39th Street corner.

23. Milbank Memorial People's Bath, No. 327 East 38th Street, 1904. Children wait for their turn to go into the bath. As a result of the Tenement House Commission report issued in 1895, greatly increased attempts were made to remedy the lack of sanitary facilities for the hundreds of thousands of New Yorkers living in the tenements. Public baths were built with city funds and private institutions raised considerable sums to erect similar establishments, called People's Baths. Mrs. Elizabeth Milbank Anderson donated funds to the New York Association for the Improvement of the Conditions of the Poor for the construction of this one, named in memory of her mother.

24. Interior, Milbank Memorial People's Bath, 1904. For an exhibition mounted by the Charity Organization Society in 1900 on the problems of tenement houses, a typical block, bounded by Chrystie, Forsyth, Canal and Bayard Streets, was studied closely. This block contained 39 tenement buildings, which housed a total of 2781 inhabitants. These people shared only 264 water closets and they did not have access to a single permanent bathtub. Only 40 apartments were provided with hot running water. To help alleviate this severe sanitary problem, the city increased its construction of public baths, appropriating $1,050,000 for this purpose in 1904.

25. Stage Door of the Criterion Theatre, West 44th Street, 1904. An employee of the Criterion (formerly the Lyric) is seen at the stage door, just east of Broadway, engaged in conversation while viewing the passing parade. The two workmen, resting from their labors of digging up the street, are looking at the photographer, rather than ogling the fashionable lady.

26. The Windsor Arcade, 1902. Standing on the east side of Fifth Avenue between East 46th and 47th Streets, the arcade was built in 1900 on the site of the famous Windsor Hotel, which had been destroyed by fire the previous year. Designed by Charles I. Berg as a gallery for "arts and displays by merchants," this Beaux-Arts structure cost the builder, Elbridge T. Gerry, $300,000. It disappeared by halves in 1912 and 1920. An interesting group of vehicles is seen here: a delivery wagon, two hansom cabs and a horse-drawn public coach (with four passengers perched aloft) of a type which passed from the scene in five years.

27. West 59th Street and Fifth Avenue, 1905. Workmen complete the demolition of the first Plaza Hotel (opened in 1890) in preparation for construction of the Plaza Hotel that stands on the site today, designed by Henry J. Hardenbergh and opened in 1907. On the east side of Fifth Avenue flanking 59th Street are: on the north, the Netherland Hotel (1892–1925), which was succeeded by the Sherry-Netherland in 1927; on the south, the Savoy Hotel, opened in 1894 and replaced by the Savoy-Plaza in 1928. In 1968 the General Motors Building was erected on this site.

28. Fifth Avenue, 57th to 59th Streets, ca. 1898. This view, taken in front of the first Plaza Hotel, captures one of the most elegant panoramas to be found in the city at the turn of the century, one almost out of place in this commercial city. The two buildings on the east side of Fifth Avenue between 59th and 58th Streets are the Savoy Hotel and the then recently erected Balkenhayn apartment house. The impressive group of five houses on the next block, copied after the château of Fontainebleau and designed to resemble a single structure, was built in the 1860s by Mrs. Mary Mason Jones, known to her intimates as "Lady Mary," who occupied the house at the south corner until her death in 1891. This so-called "Marble Row" was not fully demolished until 1929. The building on the right, opposite the "Marble Row," is the Cornelius Vanderbilt mansion. Inspired by the château of Blois, it was built in 1880 and enlarged in 1893.

29. Brooklyn, 1899. New York's Lower East Side, with its teeming Jewish population at the turn of the century, tends to overshadow many other areas of the greater metropolis in which immigrants settled. One might easily conclude that this photograph was taken in the neighborhood of Hester Street were it not for the fact that Byron has labeled it "Jewish District of Brooklyn," and that one of the Horton ice-cream signs lists the supply depot as being at Fulton Street and Brooklyn Avenue, Brooklyn. One of the most fascinating items in the scene is the marble and brass soda-water dispenser with a Yiddish sign advertising the price of one cent a glass.

30. Herman B. Marinelli's Office, 1907. The theatrical agency of Herman B. Marinelli occupied offices in the Holland Building on Broadway near West 40th Street. Judging from the photographs on the wall, the metal box on the door jamb used to signal a Western Union messenger, and the three "out" boxes labeled "Paris," "London" and "Berlin," the firm did quite a number of international bookings. A license to operate an employment agency, issued by the City of New York, hangs over the door to the inner office.

31. Siegel-Cooper's Bargain Counter, 1897. Siegel-Cooper opened its new premises at Sixth Avenue and West 18th Street to a crowd of 150,000 in September of 1896. *The New York Times* called it "the largest and finest building ever erected in New York City for the retail trade." It was also the city's largest dry-goods store. "The Big Store," as it was known, called itself "a magnificent temple of commerce" and even gave trading stamps with every purchase. The photograph shows the bargain counter about a year after the store's opening.

32. George Borgfeldt Company, 1910. In 1910 the wholesale importing company of George Borgfeldt moved into its new 11-story building at East 23rd Street and Fourth Avenue. On shelves stretching almost as far as one could see were collections of china, glass, bric-a-brac, toys, leather goods and toilet articles. In one photograph it is estimated that there are over 4000 cups and related items shown. In view of the size of this business, it is not surprising to see an office staffed by such a large number of employees.

33. *McCall's* Magazine, ca. 1912. Staff artists work on the drawings for current fashions to be translated into patterns. (Ten of the artists are women; 14 are men.) The firm's building at No. 236 West 37th Street housed the printing facilities, the pattern-division offices and the mail-order department. The magazine, founded in 1876 by James and Laura Bell McCall

to promote their dress-pattern business, began as *The Queen: Illustrated Magazine of Fashion* and took its present name in 1893.

34. Smith & Mobley Company, 1905. These automobile dealers opened their new showrooms and garage at No. 1765 Broadway on October 17, 1905. Claiming to be the "finest motoring shop in the world," the new quarters boasted space for storage of 450 automobiles and even club rooms for chauffeurs. In this photograph of the opening festivities one can spot two Mercedes, a Simplex and a Panhard. (The company had started in 1902 with the American manufacture of the French Panhard.)

35. J. Ehrlich & Sons, Opticians, 1894. The company was founded in about 1868. This photograph shows their establishment at No. 686 Sixth Avenue. On the left is a perimeter, used to measure peripheral vision; the lady in the center foreground is about to check new frames in the mirror. In the display cases are pairs of opera glasses.

36. Moe Levy & Co., 1911. Six large signs ("Moe Levy & Co."), two of them featuring portraits of Levy himself, adorned the four-story building complex on the corner of Baxter and Walker Streets containing both the factory that made the clothes and the store in which they were sold. Here are the sweatshop conditions of which one writer said: "Hours were frightfully long and irregular; starvation wages were paid; the places in which the worker toiled were filthy and unsanitary, and in general it was claimed that the worker was a helpless victim, exploited and oppressed by those above him."

37. The Studio of Richard Hall, 1903. Reginald Claypoole Vanderbilt paid $6000 to the artist Richard Hall for a portrait of his fiancée, Cathleen Gebhard Neilson. Vanderbilt also conceived the idea of having Joseph Byron photograph sitter, artist and painting together. *The New York Herald,* which reproduced this photograph on March 15, 1903, commented on the faithfulness of the likeness, but a modern critic might not agree.

38. Maillard's Chocolate Factory, 1902. In 1848, at the age of 32, Henry Maillard left France to establish his confectionery business in New York. By 1902, Henry, Jr., had taken over the establishment, which had already become one of the country's outstanding candy manufacturers (still bearing the family name today). The main retail shop was located in the Fifth Avenue Hotel at Broadway and West 24th Street. The factory, shown here, was at Nos. 116–118 West 25th Street and extended through to 24th Street. The fanciness of the delicious candy contrasted with the general sanitary conditions of the factory.

39. The Pump Room of the Equitable Building, 1902. The old Equitable Building at No. 120 Broadway, completed in 1870, was one of the first buildings in the city to have an elevator. Enlarged and remodeled in 1886, the structure was considered one of New York's finest office buildings, "solid and fireproof as a rock." On January 9, 1912, it was destroyed in one of New York's most spectacular fires. In this photograph Byron has captured the functional beauty of the Equitable Building's pump room, which contained nine steel boilers with a 900-horsepower capacity and three Worthington pumps, at the time believed to be the largest in any building in the world.

40. Laundry Room, Down Town Association, 1902. The Down Town Association was founded in 1860 to "furnish to persons engaged in commercial and professional pursuits in the City of New York facilities for social intercourse and such accommodations as are required during the intervals of business while at a distance from their residences." Their new building, erected at No. 60 Pine Street in 1887, remains the club's home.

41. Boxing at the Broadway Athletic Club, 1900. The Broadway Athletic Club was located in a gymnasium at No. 728 Broadway, on the east side of the street, opposite Waverly Place. Here, four years after it was established and two years before the building was demolished, we see a fight in progress on the rather crudely built ring. The smattering of shirt-sleeved spectators and the number of straw hats in evidence suggest that the match was in the late spring or summer. This all-male audience was typical of the period. The varied social and economic backgrounds are pointed up by the type of hat worn. There are even two top hats in the crowd.

42. The Mark Twain Dinner, Delmonico's Restaurant, 1905. Delmonico's was not only a fashionable eating place for the general public, but also the setting for innumerable sumptuous private dinners. On December 5, 1905, George Harvey, president of Harper & Brothers, hosted a dinner for Mark Twain to celebrate Twain's seventieth birthday (five days late). Over 150 renowned literati were invited to the gala affair. Byron recorded everyone at the dinner by moving the guests, table by table, into an antechamber set up for this purpose. The photographs were published in a special supplement to *Harper's Weekly* on December 23rd. This photograph has the star seated at the left center, staring defiantly at the camera.

The Delmonicos had ten restaurants in New York, the first opening in 1827 on William Street. Their most famous establishment, however, was the one on Fifth Avenue and 44th Street which began its illustrious career in 1898 and was forced to close in 1923—done in by Prohibition, increased costs and "a deterioration of dining habits."

43. The Kitchen, Delmonico's Restaurant, 1902. This photograph suggests the size of the restaurant. The chief chef, shown on the left, had 42 assistants and believed that "culinary art should be the basis of all diplomacy."

44. "The Chinese Delmonico's," 1905. E. Idell Zeisloft comments in *The New Metropolis:*

> Situated in old, tumble-down rookeries, they [Chinese restaurants] give but slight hint of the culinary delights that are to be found in them. While the furniture is meager enough, consisting merely of small round deal tables and four legged stools, with the aid of elaborate though cheap screens and brilliant paper decorations of the kind so dear to the Celestial heart a certain Oriental air is imparted to them.

The restaurant shown here in 1905 was dubbed the Chinese Delmonico's and was located at No. 24 Pell Street.

45. American Theatre Roof Garden, 1898. When the American Theatre was erected on Eighth Avenue near West 41st Street in 1893, it followed the new vogue by including a resplendent roof garden, which claimed to be "by far the best of the open air entertainment." Vance Thompson, discussing roof gardens in *Cosmopolitan* for September 1899, said of the one at the American Theatre: "It is conducted on the Aristophanic principle that 'No country's mirth is better than our own.' It is to this roof-garden that the inquiring foreigner should give his nights." This Byron photograph accompanied the article.

46. Sherry's Restaurant, 1902. Beginning his career as a busboy in a large hotel, Louis Sherry opened his first restaurant in New York in 1881, when he was 25. In 1898 he opened his most famous establishment, at Fifth Avenue and 44th Street, having invested $2 million in paintings, tapestries and a cellar of fine wines. This landmark fell victim to Prohibition; Sherry disposed of his wine stock to favored customers and closed in 1919. His motto was: "Never disappoint a customer." This scene shows the area in the basement of the restaurant where his famous ice cream was made. Note the wooden-soled shoes for partial protection against slippery floors.

47. Hotel Astor, 1904. Shortly after the completion of the Hotel Astor at Broadway and West 44th Street in 1904, Byron took more than 150 photographs of the hotel, showing areas including the ballrooms, suites, kitchen and roof gardens. Even the dish-washing area, shown here, was recorded by his camera. (This is the only Byron photograph we have found in which the camera view includes one of the two flashes, which used open flash powder and were synchronized electrically by a system devised by Byron.) The Astor, a truly grand hotel, fell to "progress" in 1966—the thirty-third New York hotel to close since World War II.

48. T. E. Fitzgerald's Bar, 1912. If one wished to depict a typical New York bar of the period, it would be difficult to outdo this photograph of Fitzgerald's at Sixth Avenue and West 44th Street. The time is 12:06 P.M. and a widely varying group of men has assembled to drink and partake of the "businessmen's lunch." Almost all economic and social strata are represented. The cooks and bartenders all have "TEF" monogrammed on the collars of their white jackets. There does not seem to be much conviviality—perhaps it has been dampened by the presence of the photographer.

49. Spanish Restaurant, 1904. During 1904 Byron took a series of interiors of restaurants that catered to particular nationalities, including Greek, German, Hungarian and Chinese. No names or addresses were recorded.

50. Greek Restaurant, The Bowery, 1904. The 1910 census listed the population of New York City at 3,747,844. Of the almost two million foreign-born, there were 8038 from Greece. With this relatively small number (compared with the 733,924 born in Russia), a restaurant such as this became much more than a mere place to eat.

51. "Harrison Grey Fiske Dinner," Winter, 1900–01. Among the many areas on which Byron focused his camera were public dinners, large private gatherings and more intimate family parties. In researching her superb book *Once upon a City,* Grace M. Mayer struggled desperately to uncover the story of this dinner and the names of the participants. Only Harrison Grey Fiske, to the right of the elderly gentleman with the white beard, has been identified. Miss Mayer even did detective work on the M and C intertwined as a monograph on the glasses and on the glass shades of the chandelier. She reports: "I have been unable to discover anything about these sober gentlemen crowned with wreaths of laurel." Fiske was the editor of the *New York Dramatic Mirror,* a theatrical producer and husband of the brilliant actress Minnie Maddern Fiske.

52. Bridge Party, 1901. Mr. and Mrs. John Farley moved into their new home at No. 303 West 90th Street near West End Avenue in 1901. In this scene they are entertaining the auction-bridge club as someone plays the banjo (far left). Why each member is wearing a white tag is not clear. The gentleman closest to the camera bears a star on his card.

53. Children's Party, 1906. Friends and relatives of the Veith children have gathered for a birthday party at the home of Edward G. Veith at No. 67 East 80th Street. Veiths also lived on East 82nd, 88th and 89th Streets in this year. The children did not leave hungry, for there are at least five cakes on the table. Byron's flash (off-camera to the right) has not been as successful as usual in catching his subjects without making them blink.

54. Birthday Party, 1897. A number of the family gatherings photographed by Byron have no data as to names or places but stand, nevertheless, as fine documents of home life at the turn of the century.

55. The Boardwalk, Coney Island, ca. 1897. After Broadway and the Statue of Liberty, the most famous landmark for New Yorkers in 1897 was probably the Boardwalk at Coney Island. A contemporary account speaks of its "cooling breezes from the breast of the broad Atlantic" and adds that Coney Island "is the most popular and most democratic summer resort in the world."

56. Surf Avenue, Coney Island, 1896. This, the main thoroughfare of Coney Island, featured food, entertainment and bathing pavilions. Some of the products advertised, such as Hire's root beer and ice-cold lemonade, still endure, but the excitement of "20,000 Feet Below the Earth" and Edison's "improved" Kinetoscopes of Corbett's "greatest and last" fight, were transitory.

57. Amusement Ride, Coney Island, 1909. In a contemporary guidebook this scene of the ride "Coasting thro' Switzerland" in Dreamland, a major amusement park, is described: "Swelterers in Manhattan's summer sun direct their steps to Dreamland's pleasing confines and find relief in a visit to the cooling, ice-tipped Alpine Mountains of 'Switzerland.' Fronting on Dreamland's East Avenue, a picture of snowy peaks indicates the pleasures to come as you step into the little red sleigh." The sleigh was made by the American Amusement and Construction Company of Philadelphia and its driver, working the brake and bells, wears a cap emblazoned with "Mt. Blanc." Rides depicting scenic vistas and catastrophes of nature such as the Johnstown flood and the Galveston flood were very popular attractions.

58. Ferris Wheel, Coney Island, 1896. While on his honeymoon in 1893, George C. Tilyou visited the World's Columbian Exposition in Chicago and was fascinated by the wondrous invention of G. W. G. Ferris. On returning to Coney Island he rented some land between Surf Avenue and the ocean and put up a sign that unblushingly announced: "On this site will be erected the world's largest Ferris wheel." By 1894 his wheel, 125 feet in diameter, was in operation—the island's first big, glittering attraction.

59. "Shoot the Chutes," Coney Island, 1896. The "Shoot the Chutes" was one of the most popular rides at Coney Island. A boatlike vehicle traveled down inclined tracks and hit the water at the bottom with a fine splash. In this photograph we see a load of passengers being towed to the top of the ramp in a car constructed to be level while being hoisted up. The

boat is also being pulled up. At the summit the car passengers will board the boat and make their exciting descent. From the expressions of the onlookers it would appear a boat has just gone by.

60. The Beach, Coney Island, 1896. From a song of 1907:

> Coney Island, happy old merry old smileland.
> Could you blame me if I took Mamie to Coney every day.
>> Switch backs, those are to Mamie's taste.
>> My strangle hold on her Sunday waist;
>> Mame goes swimming, say, hold your breath.
>> She's got Venus all skinned to death;
>> Then Mame and me, we shake the sea,
>>> And lay upon the sand.

61. Picnicking, Coney Island, 1896. Picnic-basket lunches from Ravenhall's were a popular diversion on the beaches of Coney Island in the 1880s and 1890s. Peter Ravenhall, a Brooklyn harness maker, built his restaurant on the beach in 1863. It soon became one of the most fashionable eating places in the area.

62. Upper Iron Pier, Coney Island, 1897. Side-wheel steamboats took Coney Island visitors from West 22nd Street and Pier 1 on the Hudson River to the Upper Iron Pier at Coney Island for 25 cents a trip. A contemporary guidebook states: "Two piers, each about 1,300 ft. long, constructed of tubular iron piles, run out from West Brighton. On them are various buildings, used as saloons, restaurants, concert halls, etc., and hundreds of bath-houses. Steamboats from New York land at the piers hourly." For this view, the photographer stood on the deck of the boat looking over the gangplank to the entrance to the pier.

63. Manhattan Beach, 1897. Manhattan Beach, nearer the eastern end of Coney Island, catered to the more affluent. Among its famous hotels was the Oriental, seen in the background. Opened in 1880 and farthest removed from the hubbub, this establishment was filled with wealthy, sedate families who came for the whole summer season.

64. Going to the Brighton Beach Racetrack, 1897. A happy throng of "improvers of the breed" jam the electric trolleys of the Coney Island to Brooklyn Railroad line which will take them to the Brighton Beach Racetrack. The line, operating from 1890 to 1955, was the second oldest on Long Island. The *Tribune* of July 22, 1901, commented: "The people who travel on these trolley lines to and from the beaches should not be harsh or impatient toward the conductors, whose evident sufferings are frequently pitiable while the rush in each direction is at its worst. They are human beings, anyway. But they are often treated as if they were no better than the beasts which perish."

65. Rowing on the Harlem River, 1895. On a pleasant fall day numerous sculls and shells dotted the Harlem River. It was reported that the annual regatta the following spring numbered 400 boats. Judging from their striped jerseys, these two gentlemen are from the Nonpareil Rowing Club. Their names may have been Jack Nagle and Fred Hawkins as penciled on the back of one of the prints. On the Bronx shore near the Third Avenue Bridge are New England two-masted and three-masted schooners, probably unloading cargoes of Maine lumber.

66. Sledding, Central Park, 1898. As Henry Hope Reed,

Curator of Central Park, has stated: "Of all the city's wonders, Central Park ranks first in the affection of New Yorkers." Designed in 1858 by Frederick Law Olmsted and Calvert Vaux, this remarkable park of 840 acres in the middle of Manhattan Island is wholly man-made. Before their "Greensward Plan" was implemented, the area was little more than a barren wasteland marked by rock outcroppings. Work on the park, although still in progress in 1876, was officially completed in that year. When nature bedecks the park in white, usually three or four times a winter, the landscape takes on a particular beauty.

67. On the Ice, Central Park, 1898. Skating has been a popular winter pastime with New Yorkers since the Dutch introduced the sport in New Amsterdam in the early seventeenth century. Plans for skating areas were incorporated in the original plans for Central Park and, on a wintry day in 1858, even before the Lake was completed, a little water was let in so that skating could begin. After the completion of the Lake, skating became a favorite leisure activity. In an early annual report of the park it was estimated that about 40,000 persons visited the ice areas during one day.

Nonskaters could rent skate chairs and be pushed about. New York's most famous apartment building, the Dakota, is seen in the background at West 72nd Street and Central Park West. The building was so named because the area nearby was so sparsely settled when it was built in 1884 that skeptics joked that, had it been a little farther from town, it would have been in the Dakota Territory.

68. Curling, Central Park, 1894. Teams compete on the frozen Conservatory Water near 72nd Street. The game had been brought to New York by enthusiasts from Scotland, where it was played as early as the sixteenth century. In play, the curling stone, weighing 38 pounds, is sent toward a tee with closeness scoring. Team members used brooms to sweep the ice in front of the swerving stone.

69. The Menagerie, Central Park, 1895. In the second annual report of the Board of Commissioners of Central Park (1859) mention was made of the need for a "zoological garden," but it was not until the summer of 1870 that some buildings were constructed near the Arsenal to house about 800 species. Olmsted and Vaux were against the presence of a menagerie within the grounds of their park, but New Yorkers' abiding interest in zoos won out. The Menagerie did not become the Central Park Zoo until a brick complex was built behind the Arsenal at Fifth Avenue and 65th Street in 1934. It, in turn, was closed for extensive renovation in 1983.

70. Hudsonbank Playground, 1898. This playground on the Stryker estate at West 53rd Street and Eleventh Avenue was used by boys and girls from the Hell's Kitchen neighborhood, a community noted for its roughness. It was created by the Outdoor Recreation League, formed in 1898 for the purpose of establishing "proper and sufficient exercise and recreation places, playgrounds and open-air gymnasiums for the people" of New York. A few years later the playground was taken over by the city as DeWitt Clinton Park.

71. Tompkins Square Park, May 6, 1904. Taking its name from the square honoring Governor Daniel D. Tompkins and opened in 1834, the park is the largest such area on the Lower East Side, extending from East 7th to 10th Streets and from Avenues A to B. Byron captured this vignette while he

was photographing Arbor Day ceremonies. For a picture of the ceremonies themselves, see No. 87.

72. Madison Square Park, 1898. The park at Madison Square, which extends from East 23rd to 26th Streets and from Fifth to Madison Avenues, was officially opened in 1847, having already been used as a paupers' burying ground and later accommodating an arsenal with a parade ground and the House of Refuge. It is also remembered in baseball lore as the playing field where the Knickerbocker Club, New York's first baseball team, was organized in 1845. In this view of mothers taking their babies for an outing, we are looking northeast toward Madison Avenue and East 25th Street from the southern end of the park. The lofty tower of Madison Square Garden, erected eight years before at East 26th Street, is barely visible left of center.

73. Madison Square Park, ca. 1901. Looking north on Fifth Avenue where it borders Madison Square Park just below East 25th Street, one senses a serene mood on a sunny afternoon. The meticulously attired cabmen await fares for their polished hansoms. This hackstand was usually much more active, since some of the city's most impressive hotels, the Fifth Avenue Hotel, the Victoria Hotel, the Albemarle and the Hoffman House among them, were in the area.

74. Ferryboat *John G. McCullough*, 1896. New Jersey morning commuters arrive at the New York slip of the Pavonia Ferry Company of the Erie Railroad. The *John G. McCullough* was named for the man who reorganized the Erie Railroad and later became governor of Vermont. Launched in 1890, the boat was the second screw-propelled ferry to appear in New York harbor. After several structural changes and renaming, it was sold to the U.S Government in 1943.

75. Pavonia Ferry, 1896. Early morning commuters disembark from the ferry. Established in 1866, it ran from Pavonia Avenue in Jersey City to the foot of West 23rd Street on the Hudson River. Prior to the opening of the Hudson River railroad tunnel in July 1909, travel by boat was the only method of reaching Manhattan from New Jersey. A sartorial note: 120 gentlemen can be counted in this scene and each one wears a hat.

76. Brooklyn Trolley Strike, 1899. At 2:30 A.M. on July 16, 1899, the Brooklyn trolley workers went on strike. Owing to the threat of violence, 1000 additional police officers were sent to Brooklyn from Manhattan. During the 13 days of the bitter strike there were many incidents of sabotage to the equipment and incidents of violence resulting in injuries to the passengers and substitute crews. As can be seen in the photograph, policemen rode the trolleys to protect the travelers and the motormen.

77. Coach in the City Beautiful Campaign, 1900. A group of coaching enthusiasts have put their sport to a civic use by touring in behalf of "city beautification" sponsored by *The New York Herald* in April 1900. The party is shown pausing in Hell's Kitchen, on Tenth Avenue at West 54th Street. Coaching had become more and more popular with those who could afford it ever since Colonel DeLancey A. Kane revived it in 1876. Four-in-hand drags were even being used commercially.

78. Steerage on the S.S. *Pennland,* 1893. One of the ear-liest photographs in the Byron Collection, this is considered by many to be among the most sensitive Byron made. The composition created by the single young girl and her tired fellow passengers seems to epitomize the immigrant.

79. Immigrants at Battery Park, 1901. By 1890 Castle Garden at the Battery could no longer cope with the successive tidal waves of immigrants landing at New York, and therefore construction of an immigration station on Ellis Island was undertaken. In January 1892, the station went into operation. In 1907, the station's peak year, 1,285,349 immigrants were processed there. In this scene a small group of immigrants has been brought from Ellis Island to the Barge Office in Battery Park and is probably being taken to Grand Central Station for transportation to an upstate destination. Each immigrant is tagged.

80. Easter Parade, Fifth Avenue, 1898. On April 11, the day following Easter Sunday, *The New York Times* wrote concerning the "Dress Parade": "Succeeding generations have supplied the processions of fashion and of beauty on this famous avenue, and eager thousands have hastened thither from the four quarters of Manhattan Island to gaze upon it." Although dates given for the origin of the Easter-parade tradition have differed, Meyer Berger, noted commentator on the New York scene, states that 1881 was the first year in which Easter Sunday strollers "made the front page." The imposing Egyptian Revival structure on the left in this view looking north on Fifth Avenue from below East 41st Street is the Croton Distributing Reservoir, completed in 1842 and demolished in 1899–1900 to make way for the New York Public Library.

81. Unveiling of the Lorelei Fountain, July 8, 1899. To honor German poet Heinrich Heine, Ernst Herter sculpted a fountain depicting the Lorelei, described by Heine in one of his most famous poems. When Düsseldorf, Heine's birthplace, could not find a location for the statue, a group of German-American societies decided to offer the work to New York City. This scene shows the crowd gathered at the unveiling ceremony in what is now Joyce Kilmer Park, at the Grand Concourse and 164th Street in the Bronx. The base of the statue is visible in the distance in the center of the photograph; the rest is obscured by a flag. Randolph Guggenheimer, President of the City Council, accepted the work for the city. Although the statue simply depicts the Lorelei, fully clothed, combing her tresses, some of the local clergy denounced the statue "from a moral standpoint as unfit for public view."

82. Return of the 71st Regiment, August 29, 1898. When the 71st Regiment New York Volunteers left New York on May 12, 1898, during the Spanish-American War, they numbered about 1000 men. By the time hostilities ceased in Cuba in August of that year, 16 men had been killed in action, 16 were dead from miscellaneous diseases and 64 had died from fever. Here we see a detachment of the regiment being ferried from Long Island City to South Ferry, having previously been at a quarantine station at Montauk, Long Island. One of the officers on board the ferry reported: "Our own band stood on the shore trying to blow the lining out of their instruments if they could not otherwise be heard above the shouting of the people."

83. The Dewey Parade, 1899. On September 30, 1899, the last day of a three-day celebration in New York in honor

of Admiral George Dewey, "chief among the naval heroes of the world," and the man whose guns in Manila Bay "raised in a moment's time the prestige of American arms throughout the world," and the victor "in the most wonderful sea fight in either ancient or modern history," Byron photographed a section of the parade as it moved down Fifth Avenue past 42nd Street. Although this contingent of members of Squadron A is minute considering the 31,000 men of the army, navy and state militia who took part, Byron's late-afternoon impression somehow captures the entire mood of this famous parade.

84. St. Patrick's Day Parade, March 18, 1895. Although festive gatherings to honor the patron saint of Ireland are recorded in New York City as early as 1756, the first mention of a parade was in 1779. By 1895 it had become a New York tradition. In this parade (held a day late because the 17th fell on a Sunday) three changes occurred: the parade took place in the afternoon rather than in the morning, it was mainly on the West Side and fewer marchers than usual participated because that year the Ancient Order of Hiberians felt that funds were better spent "for benevolence than pageantry." The view is on West 57th Street looking east from Broadway.

85. Police Parade, 1898. This view, looking south on Broadway from 23rd Street, shows the annual police parade, which was frequently held on June 1. The Hotel Bartholdi is on the left and Brooks Brothers men's clothing store can be seen at the southeast corner of East 22nd Street. Established in 1818, the firm occupied this building from 1884 to 1915.

86. Funeral Procession, Fifth Avenue and 14th Street, 1903. On the evening of October 28, 1903, Mrs. Emma Booth-Tucker, Consul of the Salvation Army and second daughter of the founder, William Booth, was killed in a railroad accident in Missouri. Her funeral, held the next day at Carnegie Hall in New York City, was reported to be one of the largest in years. Consul Booth-Tucker lay in state at the Salvation Army headquarters at No. 122 West 14th Street on November 2, and the following day burial services were held at Woodlawn Cemetery. This photograph shows the procession as it turned from 14th Street into Fifth Avenue. The solemn marchers continued up Fifth Avenue, over to Grand Central Terminal and thence by train to the cemetery. The Salvation Army mourners wore white arm bands—instead of the more usual black—for one of its members "promoted to Glory."

87. Arbor Day, May 6, 1904. The tree-planting ceremony is shown taking place in Tompkins Square Park on the Lower East Side (see also No. 71). A few weeks later, on June 15, the excursion steamer *General Slocum* caught fire and sank, drowning more than 1000 passengers, many of them children from this neighborhood, some of them doubtless in this photograph. A monument was erected in the park to commemorate this tragedy.

88. Opening of the Harlem Ship Canal, June 17, 1895. Crowds gathered near Macombs Dam Bridge at 155th Street in the Bronx to watch the ceremonies marking the opening of the Harlem Ship Canal. After a number of years of work the U.S. Army Corps of Engineers had completed dredging, making it possible for ships to travel directly from the Hudson River to Long Island Sound, thus avoiding a trip around the tip of Manhattan. The national importance of the occasion was emphasized by the presence of President Grover Cleveland, among many other notables.

89. New York–Paris Auto Race, February 12, 1908. Byron captured one of his most tumultuous scenes as 150,000 people packed Times Square to witness the beginning of the famous New York–Paris auto race. Six cars, representing France, Italy, Germany and the United States, crossed the continent to Alaska, then traveled through Siberia, Russia, Germany and Belgium to Paris. On the evening of July 30—170 days after it had left Times Square—the American car, a Thomas roadster with George Schuster at the wheel, reached Paris and was declared the winner. (A German contender had arrived earlier, but was disqualified.)

90. The Blizzard of 1899. Although 23 inches of snow fell during the blizzard of mid-February 1899, paralyzing all traffic and creating a state of emergency, the storm has not attained the legendary status of the Blizzard of '88, which had a snowfall of 20.9 inches. The storm of 1899 is not remembered to the same degree as the earlier one for several reasons: the snowfall was extended over a longer period with some breaks; the overhead system of power and communication wires, which had been completely disrupted in the Blizzard of '88, was now to a large extent underground; most important, the city had developed improved methods of dealing with such a storm. Here, looking south on First Avenue from below East 36th Street, we see tenants and shopkeepers digging out.

91. The Green-Wood Cemetery, Memorial Day, May 30, 1899. The visitors to Brooklyn's Green-Wood Cemetery are perhaps more numerous than on an ordinary Tuesday as they "decorate the graves of comrades who died in defense of their country during the late rebellion," but the cemetery had already become a popular area for bucolic strolling. Opened in 1840, its 478 acres include the graves of such notables as DeWitt Clinton, Henry Ward Beecher, Peter Cooper and Horace Greeley, among almost 512,000 interments.

When trespassers became a problem at the far northwest part of the cemetery, it was decided to erect gates at Fifth Avenue and 25th Street. They were completed in 1861 and subsequently became the main entrance. The structure, of Belleville stone, was designed in English Gothic style—often called "Victorian Gothic"—by Richard Mitchell Upjohn, son of Richard Upjohn, the leading architect of the Gothic tradition in New York. The sculptured groups over the gateways, depicting biblical scenes, are the work of John M. Moffitt.

92. Madison Square Garden Cattle Show, November 1895. One does not think of cattle shows as taking place in the heart of the metropolis, but this innovation occurred at the old Madison Square Garden at Madison Avenue and East 26th Street. Under the auspices of the Live Stock Society of America, a total of $16,000 in prize money was offered, the largest premium list to that time for such a show. In a preview, *The New York Times* wrote: "This will be a novel show for New Yorkers, but one that is likely to be very successful."

93. Dog Show, 1897. The 21st Annual Bench Show of Dogs of the Westminster Kennel Club was held at Madison Square Garden during the week of February 22. According to the show's catalogue, there were 151 Saint Bernards entered in 18 different classes.

94. Wanamaker's School for Cash Boys, 1899. Cash boys receive instruction at the John Wanamaker Commercial Institute, established by the great merchant "to enable the students while earning a livelihood to obtain by textbooks, lectures

and by the schools of daily opportunity such a practical and technical education in the arts and sciences of commerce and trade that they may be better equipped to fill honorable positions in life and thereby increase personal earning power." The Institute was founded in 1896, the year in which Wanamaker bought the A. T. Stewart store at Broadway and East 10th Street. It was there that the cash boys were employed. They were given a customer's cash by a salesman, ran with it to the cashier and then returned with any change. The store was closed in 1954; a fire destroyed the cast-iron building two years later.

95. Columbia University Commencement, June 12, 1901. The 147th commencement for Columbia took place in the gymnasium of University Hall. Seven hundred degrees "in course" were awarded; 4000 "obtained attendance in the gymnasium while nearly as many were turned away." On this warm spring day Seth Low, president of Columbia since 1890 (and mayor of New York the following year), gave the commencement address. University Hall, begun in 1896, was never completed. In 1964 Uris Hall, designed for the Graduate School of Business Administration, was built over University Hall, which retained its well-remembered gymnasium.

96. Teachers College, 1904. In 1894 Teachers College moved from University Place to its new buildings on Morningside Heights between Broadway and Amsterdam Avenue and West 120th and 121st Streets. Four years later it became a part of the educational system of Columbia University. Since it lacked separate physical-education facilities, funds were donated by Mrs. Frederick Ferris Thompson for a gymnasium, which was completed in 1904. The main gymnasium, with equipment valued at $50,000, was reported by *The New York Times* as the "finest of its kind in the world." Different styles of gym costumes are worn by the girls; the one having a massage sports a middy blouse.

97. Life Class at the Chase School of Art, 1896. The Chase School, at No. 57 West 10th Street, was one of New York's most famous art schools; Parsons School of Design is descended from it. Walter Pach said of William Merritt Chase: "Others have achieved great distinction through their own productions, or have been eminent as teachers, or have brought to this country the fruit of their study abroad . . . but it would be difficult to find another example of a man combining all these qualities. . . ."

Chase said of himself: "I believe I am the father of more art children than any other teacher." There is no doubt he was one of the greatest teachers in the history of American art. He also taught at the Art Students League of New York from 1878 to 1912 (with a gap of 11 years). In this photograph of his skylit studio, Chase can be seen bending over a student at the left. Men and women attended the school but, for reasons of propriety, life classes were sexually segregated.

98. The R. Hoe & Co. Apprentice School, 1904. R. Hoe & Co. traced its origin to 1805, when Robert Hoe joined with Peter and Matthew Smith to establish a carpentry shop specializing in wooden handpresses. In 1858 the son, Richard March Hoe, inaugurated classes for apprentices, teaching them such subjects as English, mathematics and mechanical drawing. The firm was one of New York's oldest and best-known manufacturers of printing machinery.

99. Sheriff Street School, 1898. Although Byron labeled

this photograph as the Stanton Street School, the view shown is on Sheriff Street, where the main entrance was located.

100. Salvation Army Kettle, 1906. The Salvation Army, started in England by William Booth in 1865, began its operation in this country in 1880. Its New York headquarters on West 14th Street, west of Sixth Avenue, was opened in 1895 and was replaced on the same site by the present building in 1930. Here a worker is shown nearby, at Seventh Avenue and West 13th Street, collecting for the organization's Christmas dinner fund. The trademark kettle was first introduced in San Francisco in 1891.

101. Salvation Army Headquarters, 1897. The building was not only used for offices, but also provided makeshift sleeping arrangements for the homeless, as shown here. A guidebook of the period mentions that, in various locations about the city, the Salvation Army had "a large Food and Shelter Depot, and three Slum Posts, a Slum Creche, and a Rescue Home for fallen women. The Army is doing energetic and blessed work in its hearty fashion among classes of people who most need help."

102. Kings County Almshouse, 1900. The Kings County Hospital was established in 1831 on Clarkson Avenue in Flatbush, Brooklyn. The almshouse, with accommodations for men, dated from 1869, when it shared the property with other county institutions. The quiet mood of this photograph gives no hint of the wretched conditions within the institution. In 1898, $2.71 was the reported figure for the weekly expense per inmate.

103. Bide-A-Wee Home for Animals, 1906. The Bide-A-Wee Home Association was founded in 1903 by Mrs. Flora D'Auby Jenkins Kibbe based on her observances of the operations of the Baronne d'Herpont's dog refuge in France. From the beginning, the principal aim of the Bide-A-Wee Association was to find homes for stray cats and dogs rather than having them destroyed. Today the association is the largest private organization of its kind in the country. This photograph, taken outside their new headquarters at No. 145 West 38th Street, was probably intended to publicize their work, which included improving the treatment of horses.

104. Virginia Day Nursery, 1906. The Virginia Day Nursery was founded in 1879 to care for fatherless children whose mothers had to work. In 1901 a new nursery was built on East 5th Street, where this photograph was taken. The association, still in existence, remembers when this area was "crowded with tenements, housing thousands of Jewish and Italian immigrants trying to earn a living in the strange New World. Mothers, deserted or widowed, who had to earn their livelihood often were forced to leave their children unattended in locked rooms or on the streets during the long working day."

105. Bellevue Hospital Ambulance, 1895. Beginning in 1736 as an infirmary located where City Hall now stands, in 1816 Bellevue Hospital formally opened its new establishment on the site of the Belle Vue Farm on the East River at East 26th Street. Horse-drawn ambulances were first kept "at the ready" at Bellevue Hospital as early as 1869; by 1892 there were nine in service, answering 4858 calls that year. The vehicle shown here, with hard rubber-rimmed wheels, must have been less than salubrious for a patient as the horse trotted along the streets paved with Belgian blocks.

106. Harlem Hospital, 1896. In 1887 a homestead at East 120th Street and the East River was converted into Harlem Hospital with bed facilities for 20 patients. Twelve years later a doctor on the staff, in a plea for improvement of conditions, stated: "The hospital is as crowded at times as the lowest tenement. . . . We are compelled to treat fifty thousand or more patients annually in the miserable outhouse on the pier. I have seen hysterical women awaiting care there while great ugly wharf rats played in and out of the holes and crevices." It was not until 1902 that the present Harlem Hospital was opened. This scene shows patients waiting in a section of the dispensary.

107. Roosevelt Hospital Amphitheater, 1900. During his residence with Roosevelt Hospital, from 1888 to 1901, Dr. Charles Burney developed his operating clinics, such as this, in which he operated and discussed surgical problems with medical students and colleagues. Will Mayo, founder of the famous Mayo Clinic, spent many hours watching Dr. Burney. When President McKinley was fatally wounded in Buffalo, Dr. Burney was called in consultation.

By present standards this operating room is fairly simple but, only 50 years before, an operating room would have more closely resembled a slaughterhouse. There are several women viewers (it is reasonable to assume that they are students or doctors since nurses, seen in the top row, dressed as such) showing that women were making their presence felt in medicine by the turn of the century. Roosevelt Hospital was opened in 1871, occupying the block from East 58th to 59th Streets and from Ninth to Tenth Avenues, where it stands today.

108. Dr. John Allan Wyeth's Clinic, 1902. Dr. Wyeth, who came to New York in 1872 at the age of 27, founded the New York Polyclinic Medical School and Hospital at No. 214 East 34th Street in 1881. Dr. Wyeth later commented that this "marked the introduction of systematic postgraduate medical instruction in America" and revolutionized the teaching and practice of medicine and surgery. He remained with the hospital for 40 years, serving as president and professor of surgery. In this photograph Dr. Wyeth is explaining the step-by-step procedures in an operation.

109. Hahnemann Hospital, 1905. Named after Samuel Hahnemann, the Leipzig doctor who founded the medical system of homeopathy in 1796, the Hahnemann Hospital was established in 1875 by the union of the New York Homeopathic Hospital for Women and Children and the New York Homeopathic Surgical Hospital. Three years later their building on Park Avenue from East 67th to 68th Streets was opened with facilities for 70 patients. The hospital closed in the mid-twenties. Masks and gloves are being worn in this 1905 operating scene; the 1902 photograph of Dr. Wyeth's clinic shows none.

110, 111. Turkish Bath Club, 1904. Byron photographed a number of scenes in the Turkish Bath Club for ladies, a converted brownstone on West 23rd Street. Surprisingly enough for the times, when such pictures were deemed somewhat risqué, these were published in *The New York Herald* on November 6, 1904. In the photographs shown here we see the ladies preparing for the pool and relaxing in the "reposing room," where a young black girl in a white dress and white apron is using a buttonhook to fasten the shoes of one of the patrons. Note the Turkish decor in the "cozy corner."

112. Barnard College, ca. 1900. Frederick August Porter Barnard, president of Columbia College in 1864, had long championed "equal opportunity in higher education for both sexes." It was therefore fitting that this institution, a part of Columbia, should bear his name. Barnard College opened at No. 343 Madison Avenue in 1889 with a roster of nine female students. In 1892 Columbia moved to Morningside Heights and five years later Barnard followed to its new building at Broadway and West 119th Street. In this photograph four collegians are enjoying a sip of afternoon tea. From a notation on the back of the original photograph it is probable that one of them is a Miss Newcomb.

113. Telephone Exchange, 1896. The first New York telephone exchange opened on Nassau Street in 1879. Subscribers were charged $60 a year and the directory contained 252 names. The early switchboards were attended by young men and boys but by 1888 all the operators were women. On June 18, 1896, the New York Telephone Company came into being and shortly thereafter this photograph was taken of the switchboard at the Cortlandt Street company headquarters. From a more recent company pamphlet: "The long line of busy operators at the famous Cortlandt central office . . . was a 'sight worth seeing.'. . . People of note from all parts of the world, and of course telephone people too, came to see 'Cortlandt' in action."

114. Siegel-Cooper's Sales-Checking Department, 1906. The department of 61 girls and one male supervisor checked the sales slips against the merchandise tags that had been collected in "Cashier's & Inspector's Stubs" envelopes. Three calendars display April 1906, and one shows March, so the season is early spring. It is interesting that there is somewhat of a lack of conformity in hair styles, but a bow worn at the back of the head is prevalent. In spite of poor lighting and uncomfortable chairs, the management probably felt quite proud of the environment.

115. Ladies' Luncheon at Delmonico's Restaurant, 1902. This scene captures what is apparently a ladies' organization having a special luncheon. Byron recorded it at the same time he took photographs of the exterior of the restaurant, group portraits of the waiters and chefs and a number of the special dining rooms.

116. Daughters of the American Revolution, 1898. The New York chapter of the Daughters of the American Revolution received official sanction in 1890. Mrs. Donald McLean was the second regent, heading the chapter from 1895 until her death in 1916 except for five years when she was president of the parent organization. Mrs. McLean described the society as "the purest, truest, finest organization of women in existence." She is unquestionably among this gathering.

117. The League for Political Education, 1899. Organized in 1894, the league had its origins in an informal meeting at the home of Mrs. Henry M. Sanders, in which six ladies discussed the failure of legislature to pass a law allowing women to vote. The *Herald* claimed that "The League for Political Education is perhaps one of the most interesting and instructive clubs in the city." By 1937 the League had become the influential organization The Town Hall. This meeting of the league on a rainy day in 1899 was probably held at the Berkeley Lyceum, No. 23 West 44th Street, which had become its headquarters in 1895.

118. Office of the Travelers' Aid Society, 1909. Founded

as the Travelers' Aid Committee of New York City in 1905 by Grace Hoadley Dodge, the Travelers' Aid Society was dedicated to help all travelers in need, but special attention was given to the young woman whose "innocence, instead of being her safeguard, may prove to be her worst enemy." Byron photographed this view of the Society's office at No. 238 East 48th Street to illustrate their *Fourth Annual Report*. It is interesting to note the ties, shirts and stiff collars worn by some of these ladies to show they can take their place in a man's world. The modern telephone and typewriter were probably there to point up to those whom they are helping the need to "get with it" or, as the sign warns, "Grow or Go."

119. **Women's Trade Union League, January 1910.** This photograph of the small but busy headquarters of the league, at No. 43 East 22nd Street, was taken during the shirtwaist strike, which lasted from November 22, 1909 until February 15, 1910. The League had been founded in 1903 to "assist in the organization of women wage workers into trade unions." During the strike one court magistrate is reported to have told a striker: ". . . you are on strike against God and Nature, whose prime law it is that man shall earn his bread by the sweat of his brow."

120. **Nurses and Their Charges, Central Park, 1898.** Without question, at this period the most ubiquitous sight on a sunny afternoon in Central Park was the nursemaid with her charge. The more "aristocratic" governesses were French

and usually wore a gray uniform. More usual, however, were nurses of Irish descent. In this scene the nurses have gathered with the children who are awaiting the thrill of a short ride on the donkey.

121. **Central Park, Winter, 1898.** This charming photograph provides interesting examples of the style of clothes and vehicles of the period. Although the mother and the nurse or maid are wearing the same type of woolen winter jacket over a heavy skirt, the former is more stylishly dressed. Even without the nurse's apron, worn as a badge of service, it would be easy to distinguish the two women. The children are heavily dressed, as was the custom. This formal clothing probably hampered them in fully enjoying the snow. The carriage is made of fashionable wicker and boasts shiny steel wheels. The sled, with a silhouette higher than the modern version, was designed to be ridden in a sitting position, even when coasting downhill. The age of the "belly flopper" was still to come.

122. **Cooking Class, 1905.** Among the many educational and training activities given by Christ Church for neighborhood children were classes in sewing, carpentry, military drill, gymnastics, basket weaving, caning and laundering (with miniature washboards). Although the church opened its new Memorial Building at No. 334 West 36th Street in 1905, some activities, such as this cooking class, continued at the old Parish House on West 35th Street.